Also by John Updike

Still Looking

JOHN UPDIKE

Still Looking

ESSAYS ON AMERICAN ART

Alfred · A · Knopf New York

2 0 0 6

THIS IS A BORZOI BOOK
PUBLISHED BY ALFRED A. KNOPF

Knopf, Borzoi Books, and the colophon are registered trademarks of Random House, Inc.

Library of Congress Cataloging-in-Publication Data
Updike, John.
Still looking / John Updike.
p. cm.
Includes index.
ISBN 1-4000-4418-9
1. Art, American. I. Title.
N6505.U64 2005
709′.73—dc22

2004061568

Manufactured in the United States of America
Published November 11, 2005
Second Printing, February 2006

to Robert Silvers
editor, enabler, connoisseur

Contents

Acknowledgments

Of these reviews and essays, thirteen were originally published in *The New York Review of Books*, between 1990 and 2004. "Epic Homer" and "Whistler in the Dark" first appeared in *The New Republic*. "An Oil on Canvas" appeared in *The American Scholar*, and "Iconic Andy" in *Rolling Stone*, for its special issue "American Icons." "The American Face" was written as a foreword to the catalogue for the English exhibition *American: Paintings and Photographs from the National Portrait Gallery, Washington, D.C.* (London: National Portrait Gallery, 2002). The essay on Edward Hopper's *Early Sunday Morning* was a contribution to *Frames of Reference: Looking at American Art, 1900–1950*, edited by Beth Venn and Adam D. Weinberg (New York: Whitney Museum of American Art in association with the University of California Press, 1999); the Hopper quotes were taken from Gail Levin's *Edward Hopper: A Catalogue Raisonné* (New York: Whitney Museum of American Art in association with W. W. Norton & Company, 1999). Ken Schneider and Karen Broderick carried out the extensive task of securing permissions for the reproductions of artwork; special help in contacting private collectors was kindly provided by Elizabeth Broun, Andrew Dintenfass, Anita Duquette, Barbara Weinberg, Christine Riding, and Eric Denker.

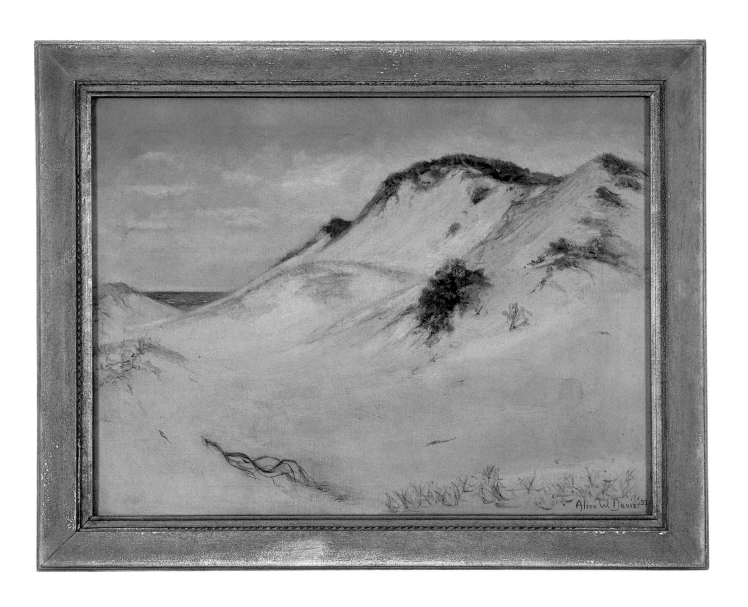

Alice W. Davis '33

Introduction: An Oil on Canvas

THIS PAINTING has been with me almost since my birth. It bears a date, 1933, a year after I was born, and it hung in my childhood home as our family's most conspicuous gesture toward the visual arts—our sole purchased, painted canvas. I seem to remember that my mother paid thirty-five dollars for it, but where she bought it, and how she found the money for it at that low point of our family fortunes (my father had no job and was scrambling to acquire a schoolteacher's credentials, my grandfather had lost most of his investments in the Crash), are details that, if I ever knew them, have vanished, with so much of the oral lore whose sources are now silent. Thirty-five dollars in the Depression was several weeks' wages; my mother as a saleswoman in the drapery department of Pomeroy's Department Store in Reading, Pennsylvania, was paid fourteen dollars a week. She took the trolley car to work, three miles and twenty minutes from our town of Shillington, until, one morning, I ran down Philadelphia Avenue crying after her, and she quit the job. So much for being a working mother in the 1930s.

Pomeroy's had many departments, including one for works of art. Possibly she bought the painting there, at an employee's discount. What possessed her, in circumstances so straitened? Her father had been affluent for a time, and to her last days she had a taste for "nice things" which would manifest itself as Christmas gifts of Steuben glass and cashmere sweaters when she was living on next to nothing—my father's schoolteacher's pension and a bit of Social Security. We had had, in our Shillington house, an upright piano and some good china and a brass tiger and a few other knickknacks to amuse a child's eye, but the painting was something apart. It hung above our living-room bookcase. It was a cultural presence come from afar, whence the sea could be glimpsed. An aura of high culture clung to it and made it holy.

When, thirteen years after my birth, we moved eleven miles south to a farmhouse, the painting received a spot worthy of it, a broad niche to the right of the sandstone fireplace, above some waist-high cabinets an Amish carpenter had built for us. Our radio rested in this niche, and in

ALICE W. DAVIS *Untitled [Cape Cod Dune]*, 1933
Oil on canvas, 18 × 24″
Private collection

the rocking chair beside it I listened, those first country summers, to many a baseball broadcast, while over my head, as I fanatically kept the box scores for Philadelphia's pair of last-place teams, the painting spoke of distant freedoms, of giant dunes it would be bliss to run up and down, inhaling great gasps of salt air. No human figures in the vista competed with the viewer for enjoyment of it; this sandy valley seemed both vast and intimate in its loneliness.

My mother died after forty-four years in the little farmhouse, and the painting passed to me. It hangs in a guest room, on a wall with a view of Massachusetts Bay. When I sleep, on occasion, in the spare bed, the first thing I see on awakening is this old friend from my childhood. Slowly, having early absorbed its mysterious emanations of reckless expenditure and romantic solitude, I am learning to look at it with the eyes of an art critic, and judge that it possesses not just sentimental value but real merit. My mother had good taste. The painter's skill shows in the inventive bluish tone, not quite shadow, which covers the foreground and lifts the high dune into sunny prominence, and in the stabbing, dabbling energy with which the sparse dune vegetation is rendered. Not only skill, but excitement: an adventure lurked in the painting's execution as well as in its purchase.

The painter, Alice W. Davis, who signed herself clearly, in the same ochre with which she brushed in strands of beach grass, proves to be not quite beyond the reach of modern research. She can be found in the compendious pages of the multi-volume *Who Was Who in American Art,* as **"DAVIS, Alice** *[Painter, educator]* b. 1905, Iowa City, IA." She was a year younger than my mother, as her painting is a year younger than I. She was twenty-eight when she painted it. In her life she was as loyal to Iowa as my mother was to Pennsylvania. Davis received a bachelor's degree from the University of Iowa in 1926 and a master's in 1932. She left the state to study painting at the National Academy of Art and Design in New York and at the Provincetown School of Art in Provincetown, Massachusetts. Except for a two-year stint (1945–47) at Lindenwood College in St. Charles, Missouri, her teaching career was purely an Iowa matter: she taught in the Iowa City elementary and high schools from 1926 to 1928, then at the University of Iowa, in the department of graphic and plastic arts, from 1929 to 1945. She was an assistant professor at Grinnell College from 1947 to 1951, and an associate professor of applied art at Iowa State University from 1951 to 1970. She exhibited at

the Iowa State Fair, and in Des Moines and Omaha, Kansas City and Denver. She died in Ames, Iowa, in 1995, aged eighty-nine. She never married, and she served on the altar guild of the Episcopal church in Ames. A "reference specialist" at Iowa State University, answering a request for information, reports that the initial "W." so firmly brushed into my painting does not appear in her faculty information sheets: "in fact on one of them 'none' is written in the middle initial slot." The report confirms that "she did spend time in Cape Cod," and her sole mention on the Web states that a painting done in Chatham sold for $786 in 1986. I have always imagined, or perhaps was told, that our family painting was of Provincetown, though I suppose such a great dune could be found elsewhere on that dramatic Cape coast. The previous owner of my present house, on Boston's North Shore, once assured me that from its third floor in winter he could see the Provincetown light. And Davis was born on April 1, fifty years to the day before my first child, a daughter, was born.

Of such tenuous threads are our relations to art fondly woven. I drew as a child, and my mother, that big spender, arranged for lessons with the artist across the street, Clint Shilling. The linear shorthand of comic strips interested me more than the elusive tints of shadow he claimed to see and the color charts he had me fill in; but something stuck. When placed in proximity with the paintings in the nearby Reading Museum or, as my scope widened, those in the grand hilltop Philadelphia Museum of Art or in New York's Museum of Modern Art, I didn't shy away but looked, as if I were entitled to look. An art course in high school, a few more at Harvard, and a year unexpectedly spent at the Ruskin School of Drawing and Fine Art in Oxford all enlarged my acquaintance with the practice and appraisal of the fine arts. When I, well advanced into a writing career, was invited to review an art show or compose a brief essay on a certain image, I didn't doubt my competence. For hadn't I grown up with a bonafide landscape, an "oil on canvas"? Didn't I feel at home, even when jet-lagged and footsore, in art museums? A fledgling magazine, an elegant but doomed American version of the French *Réalités*, extended an invitation to write bimonthly *feuilletons* on various images; *The New Republic,* when its cultural section was managed by the effervescent Leon Wieseltier, invited me to review some shows; and, above all, Robert Silvers, of *The New York Review of Books,* has persistently trusted me to provide, once or twice a year, an account of an exhibition. It has been gratifying thus to participate, in however modest a degree, in the art

world—conscientiously squinting at each work, scribbling my notes, attempting afterwards to phrase the story that any exhibition, especially a retrospective, silently tells.

In the sixteen years since Knopf published my volume *Just Looking: Essays on Art* (1989), upwards of fifty more art pieces of mine have appeared in print, some as short as the remarks on Andy Warhol that end this new volume, but most of them three-thousand-word-long reviews of temporary shows, and most of *them* for *The New York Review of Books.* Almost half of the fifty dealt with American art and artists, and these have been collected here. I feel surer of my footing on American terrain, and, this terrain having supported formal art for scarcely more than two centuries, collected observations gain an effect of concentration, with ample opportunity for cross-reference. The dots can be connected from Copley to Pollock: the same impassioned engagement with materials, the same demand for a morality of representation, the same aversion to what Marsden Hartley called a "compromising softness," can be discerned in both. John Singer Sargent is missing here, and Erastus Salisbury Field and Andrew Wyeth, Richard Estes and Richard Diebenkorn, Fairfield Porter and the great caricaturist Ralph Barton; but they are present in *Just Looking.* More American caricaturists, and Andy Warhol and Saul Steinberg and Roy Lichtenstein and Claes Oldenburg and the painter of miniatures on ivory Sarah Goodridge appear in *More Matter* (1999), with a few black-and-white illustrations.

Editors and their minions are at the mercy of what exhibits happen along, and the coverage is to that extent random. Still, the American vistas surveyed here add up, I would like to think, to a panorama, if not quite as continuous and seamless a one as the painted cycloramas of a pre-electronic age, when the paying customer was encircled with an illusionistic description, exquisite in its details, of an entire environment. Painting used to be admired for its mimetic efforts: that lifelike Madonna in her cathedral niche, that vivid aurochs on the cave wall, that huge heroic mural by David or Tintoretto, that trompe-l'oeil card rack or cupboard door by William Michael Harnett, and, even now, the uncanny hyperrealistic street scenes and still lifes that some post-abstractionists, like Estes and William Bailey and Michael Tompkins, render, with or without irony. There is a fervor in mimesis as intense as that which drives the giant smears of gestural expressionism.

The illustrations included herein are meant to serve as a check on the

text; I tried to supply one wherever an assertion of mine cried out for visual verification. Not every work cited could be reproduced, of course, and generally I preferred those I admired to those I complained of. An exemplary as well as a representative sampling was intended. The effort of an art critic must be, in an era beset by a barrage of visual stimulants, mainly one of appreciation, of letting the works sink in as a painting hung on the wall of one's home sinks in, never quite done with unfolding all that is in it to see. In Alice Davis's oil on canvas, for instance, I have just recently noticed how the big blue shadow in her sandy foreground mirrors the blue arch of the sky, and how the absence of human figures spills vitality into the gallantly struggling patches of vegetation, and how the biggest patch suggests a pubic bush and the rise of the dune the swell of a female hip. When a painter acts upon a flat surface, harmonies and balances, congruences and semblances flock into being out of thin air. Gertrude Stein, amid the mind-numbing repetitions of her *Lectures in America* (1935), spoke from the heart in her lecture on "Pictures":

> Everybody must like something and I like seeing painted pictures. . . . There is no reason for it but for some reason, anything reproduced by paint, preferably, I may even say certainly, by oil paints on a flat surface holds my attention. . . . In short anything painted in oil anywhere on a flat surface holds my attention and I can always look at it and slowly yes slowly I will tell you about it.

Still Looking

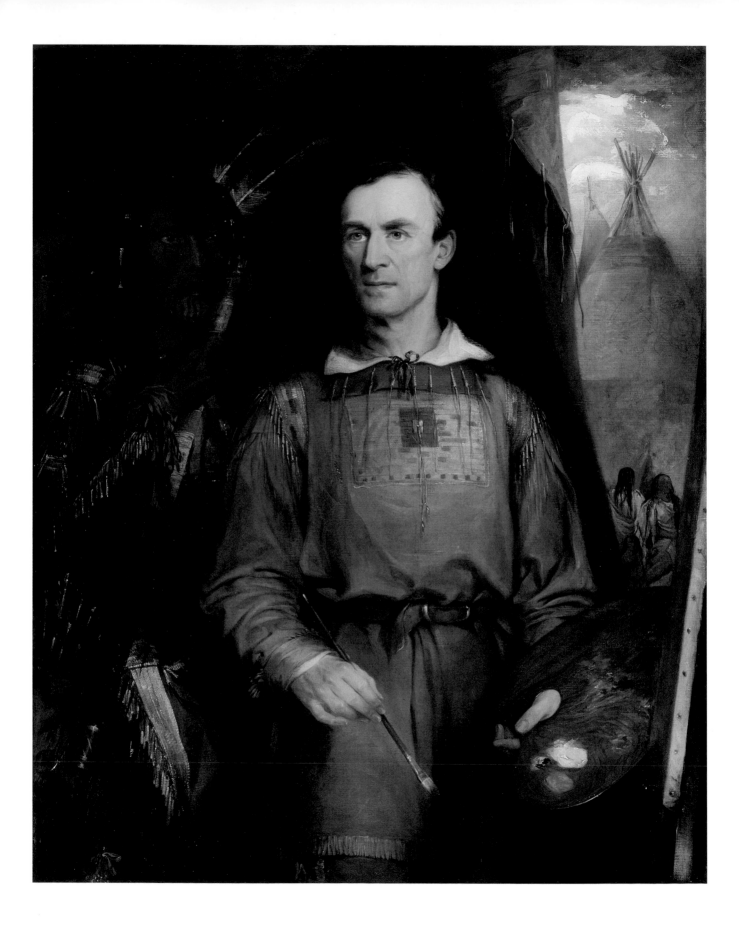

The American Face

Is there an American face? If so, it began to form when those stern-visaged English Puritans landed in New England and improvised arrangements with the rocky, forested land and the population of Native Americans, as they have come to be, correctly, called. A few so-called Indians have made it into this London array of portraits, painted and photographed by palefaces whose ethnography was animated by a rueful awareness that the vanquished race and its ruddy, unsmiling warriors embodied something—a shadowy history, a patient lifestyle—lost when Europeans invaded the continent. An Indian stoicism in turn invaded the European faces; the frontier, whether in central Massachusetts or far Montana, was a hard place, demanding of its settlers practical resolve and ascetic virtue. We find in these portraits little of the pampered cheek and arrogant downward glance of English aristocrats as rendered by Van Dyck and Gainsborough, and little of the robust lower-class jollity recorded by the genre painters of the Lowlands. Dickens in his *American Notes* of 1842 wrote of my fellow countrymen:

> They certainly are not a humorous people, and their temperament always impressed me as being of a dull and gloomy character. . . . I was quite oppressed by the prevailing seriousness and melancholy air of business: which was so general and unvarying, that at every new town I came to, I seemed to meet the very same people whom I had left behind me, at the last. Such defects as are perceptible in the national manners, seem, to me, to be referable, in a great degree, to this cause: which has generated a dull, sullen persistence in coarse usages, and rejected the graces of life as undeserving of attention.

The first American that Dickens's Martin Chuzzlewit meets in the New World is indeed unprepossessing, "a sallow gentleman, with sunken

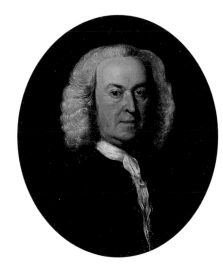

John Singleton Copley
Andrew Oliver, c. 1758
Oil on copper, 4¾ × 4"
National Portrait Gallery,
Smithsonian Institution,
Washington, D.C.

(Opposite)
William Fisk
George Catlin, 1849
Oil on canvas, 50 × 40"
National Portrait Gallery,
Smithsonian Institution,
Washington, D.C.

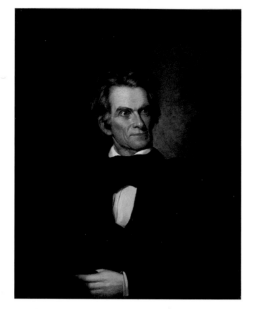

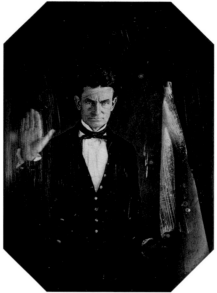

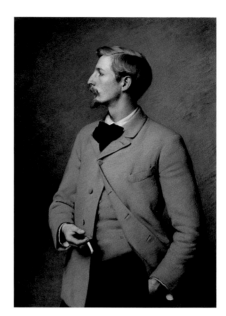

(Left)
GEORGE PETER ALEXANDER
HEALY *John C. Calhoun,*
c. 1845
Oil on canvas, 45⅜ × 38½"
National Portrait Gallery,
Smithsonian Institution,
Washington, D.C.

(Middle)
AUGUSTUS WASHINGTON
John Brown, c. 1847
Daguerreotype, 4 × 3¼"
National Portrait Gallery,
Smithsonian Institution,
Washington, D.C.

(Right)
CHARLES SPRAGUE PEARCE
Paul Wayland Bartlett, c. 1890
Oil on canvas, 42¾ × 30"
National Portrait Gallery,
Smithsonian Institution,
Washington, D.C.

cheeks, black hair, small twinkling eyes," wearing a broad-brimmed hat and an expression between a leer and a frown—"a mixed expression of vulgar cunning and conceit." Americans took root by an effort of will; they came to make themselves anew, and high hopes and practical shifts narrowed their faces, perhaps, to a certain fierceness—see Calhoun and Sherman in this exhibit, for example. Or John Brown's photographed glare, a contrast with Lincoln's weary smile. The laborious settlement of the endless territories, the bloody war to purge slavery from the American system, the ascent of industrialism with its wage slavery—these worked to keep our expressions stern, though, as with peoples everywhere, moments of joy, of song, of love, of family cherishing lightened the travail of living. A dominant Calvinism minimized "the graces of life" while, paradoxically, it esteemed worldly prosperity as a hint of heavenly election. Enterprise was given a blessing, and the freedom to extend itself as best it could.

And yet what could be more dandified than Copley's languid, red-lipped, silver-haired self-portrait (page 14), or Charles Sprague Pearce's profile of his fellow Parisian, the artist Paul Wayland Bartlett? Expatriatism in Europe, beginning as soon as the Revolution's dust settled, created a tribe of hyper-aesthetic Americans, who, while the nineteenth century waned, lived pleasantly on their strong dollars and helped hatch

modernism. The staid, pinched faces of colonials and immigrants took on a tested national confidence; Hawthorne, as his own portrait was being painted (by Emanuel Gottlieb Leutze, in the shadow of the raging Civil War), saw in art itself a refutation of whispers "that the nation would exist only a little longer." In this array of physiognomies preserved and displayed in the national capital, the portraits that most deserve the overused epithet "iconic" are those of Franklin and Washington, engraved versions of which are enshrined on our paper currency; they remind us that the United States was the political creation of the eighteenth-century Enlightenment, embodying its liberated thinking and its unblinkered yet not unhopeful appraisal of human nature.

By the twentieth century, popular culture promoted the spread of images of elegance and sensuality. Movies out of Hollywood, on a new scale of art manufacture, flickered above the formerly dull and gloomy citizenry; we are left with stills of Greta Garbo's unfocused gaze, Audrey Hepburn's focused one, Louis Armstrong's laugh, and Marilyn Monroe's rising skirt. Jean Harlow and Clark Gable (once elected the King of Hollywood, in our nearest approach to royalty) forever take the light full on their wide brows. Lena Horne, Michael Jackson, Lincoln Kirstein,

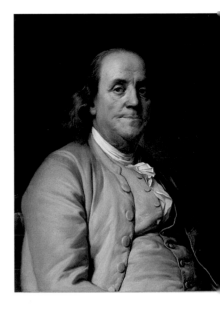

JOSEPH SIFFRED DUPLESSIS
Benjamin Franklin, c. 1785
Oil on canvas, 28 × 23"
National Portrait Gallery,
Smithsonian Institution,
Washington, D.C.

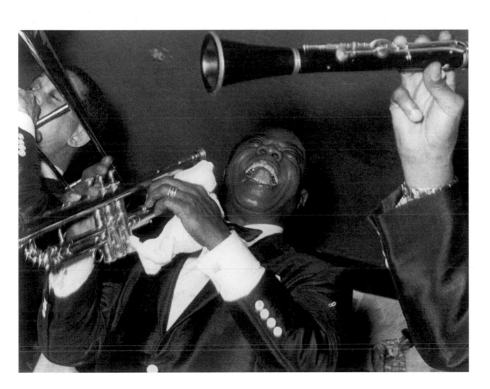

LISETTE MODEL
Louis Armstrong, c. 1950
Gelatin silver print, 10 × 13⅜"
National Portrait Gallery,
Smithsonian Institution,
Washington, D.C.

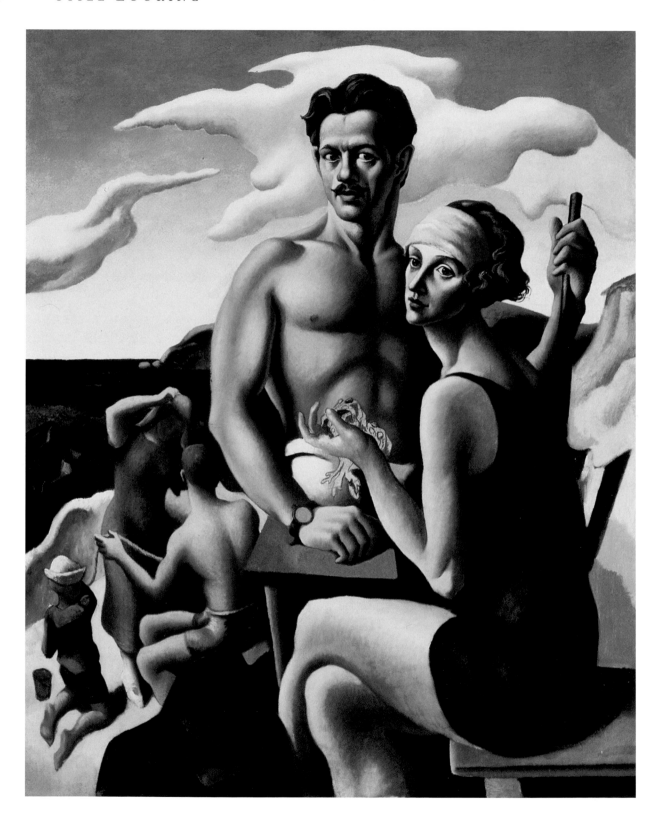

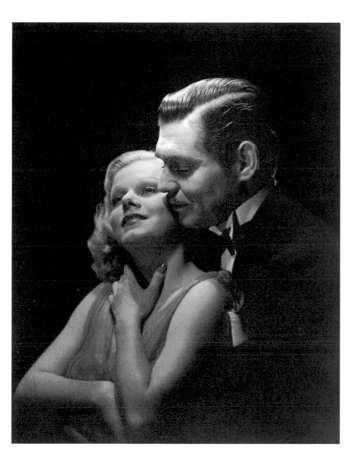

Thomas Hart Benton and his wife—their painted portraits attain a certain Apollonian grandeur, built of all-American materials. The native Puritanism lingers, perhaps, as an aura we might call spiritual: such grave and distinguished portraits as those by Eakins and Sargent strive, like the heads of medieval statuary, to read a soul into the human visage, and appear not merely to offer a depiction of their subjects but to render a judgment upon them.

(Opposite)
THOMAS HART BENTON *Self-Portrait with Rita*, 1922
Oil on canvas, 49 × 40"
National Portrait Gallery, Smithsonian Institution,
Washington, D.C. Gift of Mr. and Mrs. Jack H. Mooney

(Left)
CLARENCE SINCLAIR BULL
Jean Harlow and Clark Gable,
1937
Gelatin silver print, 15⅜ × 10⅜"
National Portrait Gallery,
Smithsonian Institution,
Washington, D.C.

(Right)
THOMAS EAKINS
Talcott Williams, c. 1889
Oil on canvas, 24½ × 20"
National Portrait Gallery,
Smithsonian Institution, New
York. Gift of the Kate and
Laurens Seelye family and the
James Smithson Society.

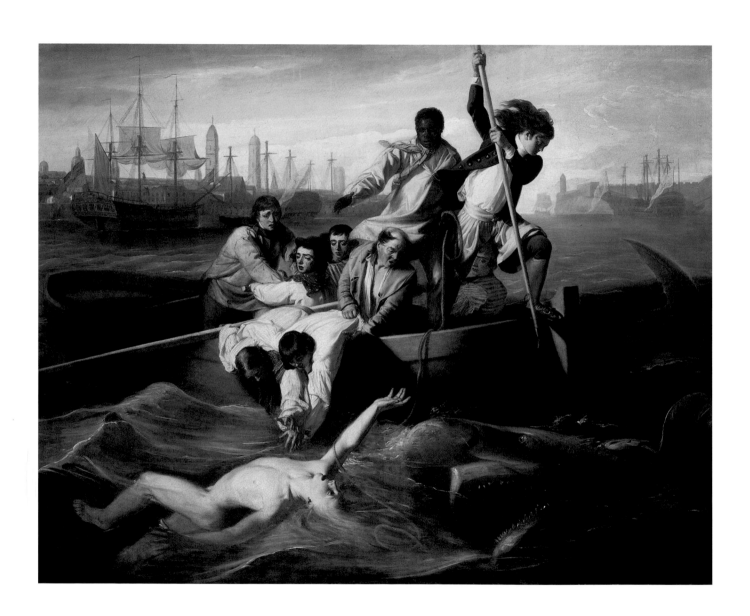

Nature His Only Instructor

AN ART-LOVER peripatetic enough to journey, in late 1995, from New York's Metropolitan Museum of Art to the National Gallery in Washington could survey, in one day, the two sides of John Singleton Copley: the American and the English. Copley, born in 1738 of humble Irish parents on Boston's Long Wharf, achieved rapid prosperity as the Bay Colony's pre-eminent portraitist, rendering, with a precocious and assiduous skill, the local merchants and landowners and their wives in settings and poses flatteringly suggestive of the English aristocracy. He married, as part of his assimilation into the New England upper classes, Susanna Farnham Clarke, whose father, Richard, was the wealthy, Anglophilic Boston agent for the British East India Company. It was, in large part, his tea that was famously dumped, in December of 1773, into the harbor, by revolutionaries painted up as Mohawk Indians. Copley, who had written to Benjamin West of "Political contests being neighther pleasing to an artist or advantageous to Art itself," had earlier repaired the damage done to his portrait of Governor Francis Bernard during the Townshend Acts crisis: radical activists had entered Harvard Hall in Cambridge, where the canvas hung, and sliced out the area of the image's heart. The breach in the colonies, however, became irreparable, and the tactful painter, unable finally to straddle it, emigrated—followed by his family and Tory in-laws—to London in June of 1774. He had long felt the "shackels" of pursuing artistic ideals in a mercenary land that offered him "neither precept, example, nor Models"—just the handsome annual income of three hundred pounds, accumulated at the rate of twenty guineas a portrait.

Copley's breakthrough into the world of art had come under the tutelage of his émigré English stepfather, Peter Pelham, an engraver and schoolteacher, who married Copley's mother in 1748, when the boy was

(Opposite)
JOHN SINGLETON COPLEY
Watson and the Shark, 1778
Oil on canvas, 71¾ × 90"
National Gallery of Art, Washington, D.C. Ferdinand Lammot Belin Fund

COPLEY
Reverend William Welsteed,
1753
Mezzotint, catalogue raisonné:
St.440, 13⅞ × 9¹³/₁₆″
Museum of Fine Arts, Boston.
Gift of Mrs. Frederick Lewis
Gay, M27849

ten, his own father having died in the mid-1740s. Pelham himself died in 1751, but not before giving his stepson some training in the technique of the mezzotint and the fundamentals of the art business. Copley's earliest surviving work is a mezzotint portrait of the Reverend William Welsteed, which the teen-ager achieved by substituting Welsteed's head on an engraving Pelham had executed after another divine's portrait, by John Smibert, an émigré Scotsman and the leading Boston artist during Copley's childhood.

The trades of engraver, silversmith, goldsmith, clockmaker, japanner, joiner, upholsterer, miniaturist, and art-supplies vendor mingled their shops in the commercial hurly-burly of New England's foremost port—a mere town, by today's standards, of fewer than sixteen thousand. Young Copley put himself to school as a painter by copying into oils the prints of European mythological paintings that arrived on the New World shores. The exhibit at the Met shows a breathtakingly swift progress from primitive stiffness of drawing and timidity of color to a marvellous mastery of textures, whether of skin, wood, velvet, or satin, along with a delicate vivacity of countenance and pose. Even his earliest portraits, of his step-brother Charles Pelham (c. 1753–54) and of four of the thirteen children born to John and Frances Pinckney Gore (c. 1755), display a dark-eyed vitality and passages of fine detail. The heads of Ann Tyng (1756) and Theodore Atkinson, Jr. (1757–58), have the linear, not-quite-three-dimensional look of heads by a gifted folk artist like Erastus Salisbury Field; but Atkinson's vest of white silk embroidered with silver is rendered with a meticulous, dazzling vividness, and in the portrait of the two young Royall sisters (c. 1758), the superb treatment of the girls' radiant silks is matched by a confident psychological differentiation of their faces and bearings. Copley at the age of twenty has a mature style that leaves the portraits by Smibert—to judge by the examples reproduced in the exhibition catalogue—far behind.

If one attends sufficiently to the surfaces, the interior takes care of itself: this could be the moral of Copley's American portraits. They rarely strive for expressiveness and hold to the restraining contemporary standards of polite behavior, which proposed to the genteel classes a "moderately cheerful" demeanor discreetly enlivened by a "gentle and silent smile." Exceptions, perhaps, are the celebrated images of Paul Revere (1768) and Sam Adams (1770–72), in which, respectively, a workman's garb and tools and an orator's pugnacious forefinger seem to proclaim democratic

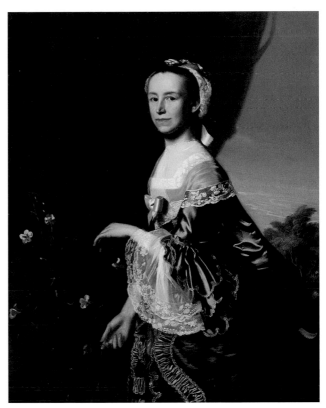

vigor and the coming Revolution; Revere's gaze, however, though direct, is more meditative than combative, and even Adams wears a kind of smile above his table of combustive documents. Both these brownish portraits of blunt men have a certain Puritan woodenness, and neither is typical of Copley, who was and is celebrated for the splendor of raiment in which he posed his provincial gentry. The gray silk vest of Moses Gill (1764)! The blue satin *sacque* dress of Mercy Otis Warren (c. 1763)!!

The catalogue, itself sumptuous, carries a heavy swath of individual essays—eight, plus the sometimes lengthy individual texts for the eighty-one paintings, pastels, and miniatures. One essay, by Aileen Ribeiro, eruditely inventories the clothes in Copley, as he strove to keep up with Old World fashions, with all their proprieties of wig and décolletage, goffered frills and *broderie anglaise*. Another essay, by Paul Staiti, deals with "Character and Class" and the pictorial reassurances sought by Boston's rich but embattled merchant class. Some of Copley's subjects, such as Nathaniel Sparhawk (1764), look merely incongruous, regally posed in a many-buttoned velvet suit amid pillars and arches of a Roman grandeur, while some, like Mrs. Jeremiah Lee (1769), seem downright ridiculous: she gingerly balances a lapful of fruit while trailing an ermine-trimmed

(Left)
COPLEY
Theodore Atkinson, Jr., c. 1762
Oil on canvas, 50 × 40″
Museum of Art, Rhode Island
School of Design, Providence.
Jesse Metcalf Fund

(Right)
COPLEY *Mrs. James Warren
(Mercy Otis),* c. 1763
Oil on canvas, 49⅝ × 39½″
Museum of Fine Arts, Boston.
Bequest of Winslow Warren,
31.212

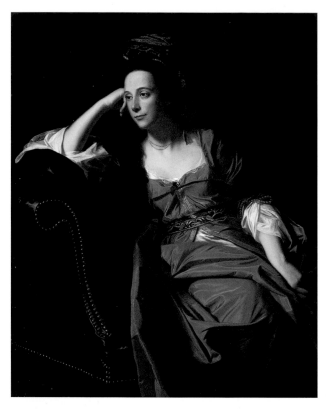

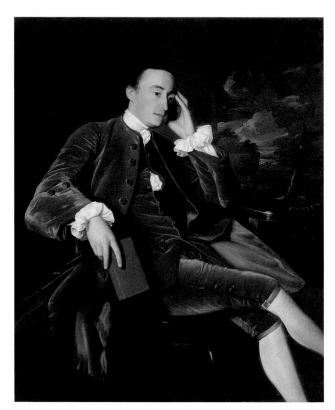

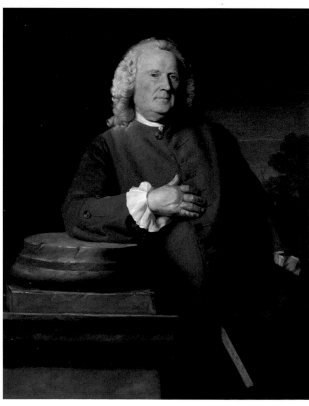

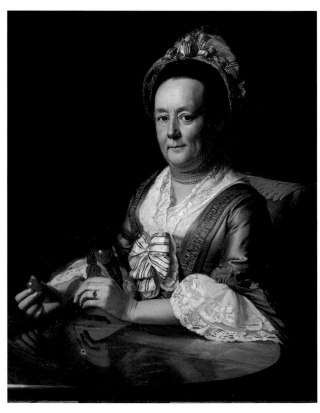

pelisse over a pumpkin-colored caftan. "This is not the kind of outfit," the catalogue mildly comments, "that an American woman would have worn in public; rather, it is like a masquerade costume, intended as part of a Turkish fantasy." "Turquerie" was evidently as fashionable for Copley's generation as japanoiserie was for Whistler's. It is right and proper to study the material and sociological accoutrements of Copley's portraits, but surely their essential feature is the sitters' alert human presence. If the honest merchants and their plump, long-suffering wives appear uncomfortable in upper-class masquerade, it is because Copley has put enough of their real selves on view to register their discomfort.

Some of his subjects, such as the flamboyant textile importer Nicholas Boylston (painted in 1767 and repainted around 1769) and the beautiful English wife of General Thomas Gage, the commander-in-chief of the British forces in North America, do live up to their dress-up and appear dashing. The portrait of Mrs. Gage (1771), née Margaret Kemble, is one of Copley's most splendid canvases, and one of the few where his honest eye has found a woman he can render as other than plain. Another is Sarah Langdon, the young wife of a wealthy Portsmouth, New Hampshire, merchant, Woodbury Langdon; he exudes self-esteem in his gold-embroidered maroon coat and a generalized setting of Arcadian artifice.

Like an old-time studio photographer, Copley posed his clients in their best clothes and among props suggesting social aspiration; but, like the camera, he could not lie. The tricks of English glamorization were not in his American nature. His old people, like Epes Sargent (c. 1760) and Mrs. Humphrey Devereux (1771), have bloated, wrinkled hands and bags under their eyes. His fat people, such as Moses Gill (1764) and Reverend Myles Cooper (1768–69), *look* fat, and those with pox scars and hair moles—Professor Staiti assembles a quartet of details to demonstrate—are rendered moles and all. What Copley's many female subjects lack in conventional beauty they make up in nervous energy, expressed as a certain alert tension when young (Mrs. Richard Skinner, 1772; Mrs. Samuel Quincy, c. 1761) and as a collusive wryness when older (Mrs. John Winthrop, 1773; Mrs. Isaac Smith, 1769). While the clouds of rebellion and war were lowering, Copley's backgrounds darkened and simplified, emphasizing the inner lives of these descendants of the Puritans. As Theodore E. Stebbins, Jr., points out in his essay "An American Despite Himself," Copley adopted, in such a portrait as that of John Bours (c. 1770), the dreaming, introspective attitude reserved, in European por-

(Opposite)

(Top, left)
COPLEY *Mrs. Thomas Gage (Margaret Kemble),* 1771
Oil on canvas, 50 × 40″
The Putnam Foundation, Timken Museum of Art, San Diego

(Top, right)
COPLEY *John Bours,* c. 1770
Oil on canvas, 50 × 40⅛″
Worcester Art Museum, Worcester, Massachusetts

(Bottom, left)
COPLEY
Epes Sargent, c. 1760
Oil on canvas, 49⅞ × 40″
National Gallery of Art, Washington, D.C. Gift of Avalon Foundation

(Bottom, right)
COPLEY *Mrs. John Winthrop (Hannah Fayerweather),* 1773
Oil on canvas, 35½ × 28¾″
The Metropolitan Museum of Art, Morris K. Jessup Fund, 1931, 31.109

traiture, for distinguished philosophers and poets, and extended this thoughtful pose to women—a considerable innovation in a pre-feminist era.

His mercantile clients must have liked his honesty as well as his skillful social catering. Copley observed, in one of his complaining letters to artists abroad, that likeness was the "main part of the excellency of a portrait in the oppinion of our New England Conoseurs." (Copley's spelling, like his sometimes awkward drawing, betrays the gaps in his self-education: commenting on the war, he wrote of "tassit disapprobation" and "Ocians of blood.") Staiti speaks of the portraits in terms of accurate audits: "Since it claimed identity through an assemblage of discrete elements, Copley's representation of a person's character could be disassembled by a viewer into an inventory of an individual's appearances and possessions." Other art critics have posed a connection between realism and Puritanism, those dominant American modes; Barbara Novak, in her *American Painting of the Nineteenth Century,* links Copley's painting with the theology of Jonathan Edwards, both devoted to the "clarity of 'things.'" The inherited shroud of classical and medieval ideas did not conceal, in the New World, the clarity of things; for both Puritanism and realism, the altar was swept clean and intermediaries were removed.

Copley, writing to Benjamin West, a fellow-American who had already made the escape back to England, yearned "to acquire that bold free and gracefull stile of Painting that will, if ever, come much slower from the mere dictates of Nature, which has hither too been my only instructor." Brushstrokes are almost invisible in his early work, submerged in the sought-for texture of skin, silk, fur: the idea of painting which confessed itself as painting, which invited the connoisseur to enjoy the bravura flourishes of a Velázquez or a Gainsborough, was at this point un-American, as was the concept of a personality subsumed in his or her rank and social station. Copley's subjects by and large remain individuals, and their spark of homely, nervous, embarrassed, stubborn, perky individuality strikes the viewer as forcefully as the paintings' gorgeous material literalism.

The American Copley worked hard. Though his self-portraits show him in the fine clothes and impeccable wig of a gentleman, an observer of him, newly arrived in Rome, said, "He was very thin, pale, a little pock-marked, prominent eye-brows, small eyes, which, after fatigue, seemed a day's march in his head." He pursued his business—and in his

COPLEY
Portrait of the Artist, 1780–84
Oil on canvas, diameter 18″
National Portrait Gallery,
Smithsonian Institution,
Washington, D.C.

milieu art had to be a business before it could be an art—with the driven zeal and ingenuity of an older Boston-born entrepreneur, Benjamin Franklin. Nature being his only instructor, he knew no shortcuts: a client complained of having to sit for him "fifteen or sixteen times! six hours at a time!!" Another said that he made her sit twenty times for the hands alone. He himself wrote that his portraits were "almost allways good in proportion to the time I give them provided I have a subject that is picturesk."

Realizing that pastels, at the height of their fashion in Europe, were much faster than oils, he taught himself the skills—in many ways the opposite of those of oil painting—in a city that lacked other pastellists and even an adequately full set of crayons. Having mastered the art of painting miniature portraits on copper in oils, he shifted to the notoriously tricky, but more luminous and fashionable, method of painting in watercolors on thin pieces of ivory. In all these side arts, he did beautiful work, work that excelled the standards being pursued about him. As Stuart P. Feld remarked apropos of a 1983 exhibit, Copley "painted far better than his society had any right to expect." A member of that society, John Adams, travelling in 1776 to Philadelphia and viewing the work of Charles Willson Peale, pronounced him inferior to Copley, "the greatest Master that ever was in America." High art in America began with Copley, and—a bit disconcertingly—he knew it: "It is a pleasing reflection," he wrote his half-brother in 1775, "that I shall stand amongst the first of the artists that shall have led that Country to the Knowledge and cultivation of the fine Arts."

A CONSUMMATE and versatile professional, who even took a hand and a profit in the framing of his pictures, Copley held an exalted idea of art, of Art—"that Mighty Mountain," he wrote a fellow artist, John Greenwood, in 1771, "where the Everlasting Lauriels grow to adoarn the brows of those Elustrious Artists that are so favoured of Heaven as to be able to unravel the intricate mazes of its rough and perilous Asent." With a push from political developments, he went, three years later, to the Old World in pursuit of those everlasting laurels. After arriving in England, he promptly toured the Continent to see the paintings he had idolized in colonial isolation. He settled and painted for a year in Italy, and then returned to London to secure a place in the English art establishment, wherein "history painting"—large tableaux on elevating subjects drawn from the Bible, the Greek lengends, and European history—was consid-

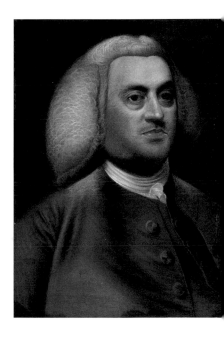

COPLEY
Joseph Green, c. 1764
Pastel on paper mounted
on canvas, 22¾ × 17⅞"
Museum of Fine Arts, Boston.
Gift of Dr. Samuel Abbott
Green, 10.34

ered the highest genre, and the measure of a painter's greatness. The trouble was, the rewards for history paintings existed mostly in the immaterial realms of prestige. In his forty years in England—he died in 1815, poor—Copley sold only two history paintings that had not been commissioned, though he reaped some reward from exhibition admission fees and the sale of prints based on the paintings. He did portraits, but with nothing like the steady success of his colonial heyday. Though a member of the Royal Academy, he had several quarrels with it, and in terms of British acceptance always lagged behind his fellow-émigré and exact contemporary, the Pennsylvanian Benjamin West. West had come to England a dozen years earlier, helped found the Royal Academy, became its second president, and was appointed historical painter to the King. A third American artist in England, the very facile and popular Gilbert Stuart, spoke patronizingly of Copley as an industrious worker in paint, whose finicking at skin tones produced "labored flesh" that resembled "tanned leather." Another younger painter, Samuel F. B. Morse, visited Copley in 1811 and observed, "It is really a lamentable thing that a man should outlive his faculties." The ascent to the everlasting laurels had indeed proved to be rough and perilous.

In three stately walnut-panelled rooms of our National Gallery, a choice selection of Copley's English works invites reconsideration of the frequently expressed view that he painted better in America: Marsden Hartley wrote that "a kind of compromising softness" crept into his work, and Lloyd Goodrich claimed that Copley "exchanged the integrity of his American style for the graces of a decadent tradition." When Copley had written from the uncouth colonies for advice, West criticized the specimen work "as being to liney, which was judged to have arose from there being so much neetness in the lines," and Sir Joshua Reynolds pointed to "a little Hardness in the Drawing, Coldness in the Shades, An over minuteness." Copley was advised to feather his brushstrokes and avoid what Thomas Sully called his "hard terminations." These critics had seen *Boy with a Squirrel* (1765), which Copley had submitted to the London Society of Artists show in 1766. The painting is a bit schizoid: the mahogany tabletop, the water glass, the pet flying squirrel with his gold chain, and the subject's cuffs and collars are all done with a literalist "neetness" and glistening minuteness, whereas the profiled head of young Henry Pelham, the painter's half-brother, has an English softness, with an ideal complexion, plump pink lips, and a raptly staring eye. *The Copley*

(Opposite)
COPLEY *Boy with a Squirrel (Henry Pulham),* 1765
Oil on canvas, 30⅜ × 25⅛"
Museum of Fine Arts, Boston. Gift of the artist's great-granddaughter, 1978.297

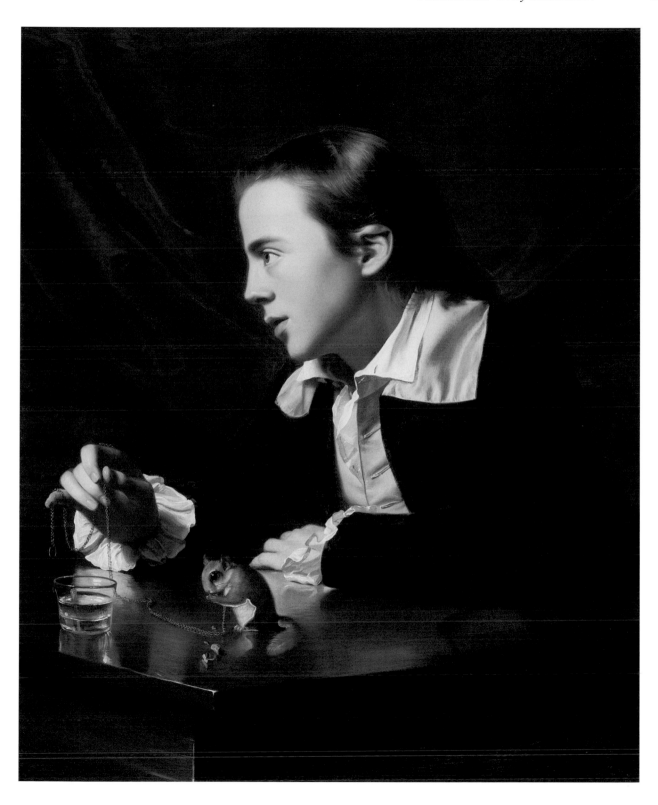

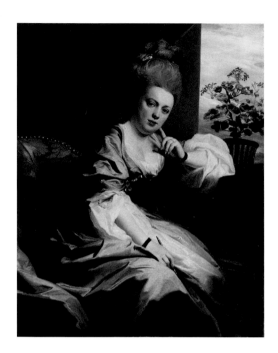

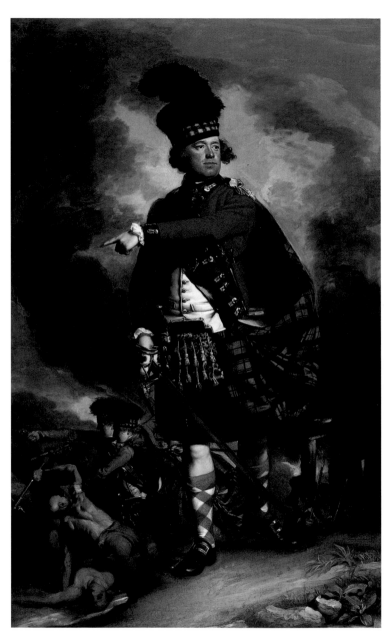

(Above)
COPLEY *Mrs. Clark Gayton*, 1779
Oil on canvas, 50 × 40"
The Detroit Institute of Arts.
Gift of Mrs. D. J. Healy

(Right)
COPLEY *Portrait of Major Hugh Mont-
gomerie, Later Twelfth Earl of Eglinton*, 1780
Oil on canvas, 94½ × 59¾"
Los Angeles County Museum of Art. Gift of
Andrew Norman Foundation and Museum
Acquisition Fund, M.68.74

Family (1776–77), the large, self-celebrative canvas with which Copley
announced his arrival on the London art scene, shows an American liter-
alism in the Oriental rug, the embroidered silk footstool, and the creased,
brown, sour face of Copley's father-in-law, and an English mistiness
in the heads of the children and their mother. The rather touchingly
crowded figures—a heap of reunited Copleys—do not seem to be all
breathing the same atmosphere.

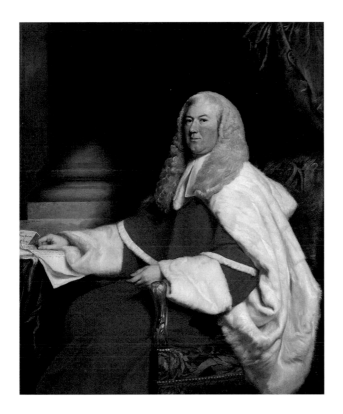

COPLEY
Baron Graham, 1804
Oil on canvas, 57 × 46¾"
National Gallery of Art,
Washington, D.C. Gift of
Mrs. Gordon Dexter

By the time he painted *Mrs. Clark Gayton* (1779), Copley had the flowing brushstrokes and implied swagger of British high style under thorough control, though the Yankee in him could not quite ignore the subject's double chin or avoid a botanical detailing of the potted geranium on her windowsill. The portraits of her husband, in his opulently embroidered admiral's uniform, and of a kilted Major Hugh Montgomerie (1780), are magnificent, against their stormy backgrounds of martial activity, yet—dare one say it?—charmless. Only in the background figures of half-naked Indian braves does the obsequious painter seem to be indulging his own interests. Entering the exhibit's main salon, I winced to see so many bright redcoats and pompous lords rendered immortal by an Irish son of Boston's waterfront. Copley's subjects no longer sit with that disarmingly embarrassed air of his New England merchants. *John, 2nd Viscount Dudley and Ward* (1781–1804) and *Baron Graham* (1804), by a painter now firmly ensconced in the grand manner, fill their large canvases with red robes, ermine trim, and miens of authority. The works are magnificent but faintly oppressive and slick, in their theatrical handling of requisite elements.

COPLEY
John Quincy Adams, 1796
Oil on canvas, 30⅛ × 25″
Museum of Fine Arts, Boston.
Bequest of Charles Francis
Adams. 17.1077

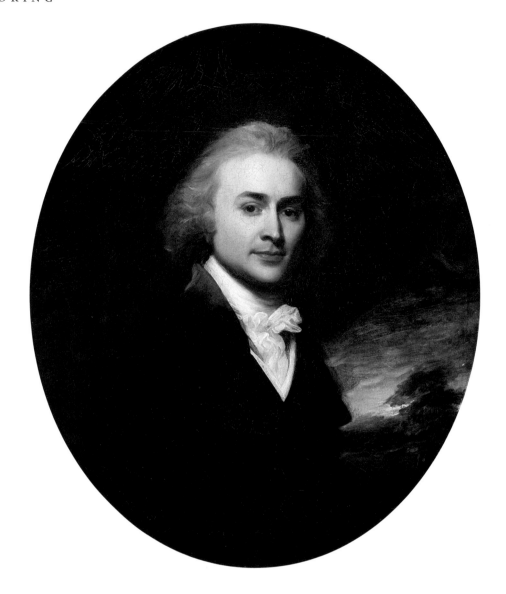

Not slick is the ethereal, noble portrait of the young John Quincy Adams, who looks as though he might have the beginnings of a cold. Adams, a punctilious diarist, noted the seven London sessions in 1796, and conversations with the painter, now nearing sixty, whose Loyalist political opinions the future President found "not accurate" and "almost intolerable." Yet Copley's views on the Revolution were ambiguous. Another American, the twenty-four-year-old merchant Elkanah Watson, received the full redcoat treatment, heroically leaning against a pillar while his face is bathed in light and his vest stretched by a fashionably big

belly. As Watson—abroad during much of the war but no Loyalist—was posing in late 1782, King George III formally recognized the United States of America. In Watson's telling, Copley, "with a bold hand, a master's touch, and I believe an American heart," painted the Stars and Stripes onto the mast of a ship in the background. Yet the portrait is so full of flair and bravado as to lack the intimacy of the anecdote; the males of Copley's English portraits tend to present an opaque and intimidating front.

The women, whether ancient like the probably misidentified Mrs. Seymour Fort (c. 1778) or in the prime of mature bloom like the breeze-whipped, grandly behatted Mrs. Daniel Denison Rogers (c. 1784), do have a gaze, though it comes from within a well-fortified sense of their own status. In this latter portrait, and in that of the two Western brothers (1783), English breeziness seems caricatured, by a stranger to the climate. Of the many intensely skilled portraits on display, only the shadowy, jaunty *Midshipman Augustus Brine* (1782) and Copley's loosely painted head of himself (1780–84) escape into an unstudied liveliness; both are painted dashingly, and the facial expressions call for second looks—the Brine boy is elfin and challenging, and Copley off in a sad reverie, as if contemplating the sacrifices it takes to make an artist a gentleman. This was a hotly debated issue, in the wake of the Earl of Shaftesbury's carefully reasoned verdict, early in the eighteenth century, that painters, because they used their hands, could never rise above the status of "mechanick."

And, in an age when painting performed tasks now assigned to photographs and newspapers, and tried to provide rallying-points for the populace, the art did have a mechanical aspect. Copley's religious paintings left me unmoved. Mary's clean white garb and antiseptically pillowed infant in *The Nativity* (1776–77) seemed incongruous even to the contemporary critics, and the most successful, *Samuel Relating to Eli the Judgments of God upon Eli's House* (1780), is also the most textural and least populated; Eli's white beard and the hand suspended before his bejewelled bib are marvels of "liney" minuteness. Copley perhaps should not be blamed for the resistance that meticulously staged reconstructions of the past set up in a late-twentieth-century breast. History paintings are, like verse epics and M-G-M musical comedies, built on conventions

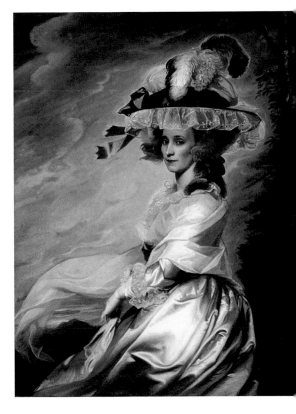

COPLEY
Mrs. Daniel Denison Rogers (Abigail Bromfield), c. 1784
Oil on canvas, 50 × 40″
Fogg Art Museum, Harvard University Art Museums. Gift of Paul C. Cabot, Treasurer of Harvard University, 1948–1965, and Mrs. Cabot

based on suppositions to which we have lost the key. The two big jewels, or baubles, of the exhibit, much admired and discussed in their times and a source of pride to the painter, shatter our attention into a restless search for redeeming details.

The Death of Major Peirson (1782–84), which Emily Ballew Neff describes in her catalogue essay as "the climactic work of Copley's En-

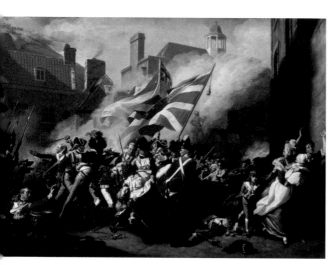

glish career, his greatest success both artistically and commercially," is here displayed, on loan from the Tate Gallery, along with seventeen preparatory drawings and an oil sketch from a total of seven collections. It is hard to see it, despite Ms. Neff's sympathetic enthusiasm, as other than a spectacular expenditure of skill in a jingoistic cause, a celebration, in the teeth of British defeat in the American colonies, of British valor and sacrifice elsewhere—on the island of Jersey, which the French had invaded in 1781. At least Benjamin West's *Death of General Wolfe* (1770), though posed with a melodramatic nicety that now seems unreal, alluded to a pivotal historical moment whose consequences, as it happens, reverberate in today's Canadian headlines.

(Above, and detail opposite)
COPLEY
*The Death of Major Peirson,
January 6, 1782,* 1782–84
Oil on canvas, 97 × 144"
Tate Gallery, London

Major Peirson's distinction was to have rallied British troops after the captured and none-too-brave lieutenant governor had surrendered the island. In Copley's painting, the central group clusters an excessive number of men in a campy clot of solicitude around the inverted figure of the major, slain by a French bullet in the moment of victory. His long fair hair flows down; a drop of his blood can be seen suspended in mid-air next to his limp hand. A black soldier is intently shooting the Frenchman who fired the perfidious bullet; a giant Union Jack waves above; a group of distressed women and children on the right register the horror of war. The painting of the rifles and bayonets, and the details of the officers' uniforms, is amazingly crisp, picked out in linear white highlights, but the emotional highlight is, at the crammed center of the canvas, amid much furious gesturing, the tender embrace and loverly gaze being bestowed by a comrade upon the female beauty of the relaxed, upended major.

A cascade of blond hair also distinguishes the central figure of *Watson and the Shark* (1778) (page 8), but this is far from the only thing queer about it. Watson, fourteen years old at the time of the actual incident— bathing in Havana Harbor, he was attacked by a shark, but was res-

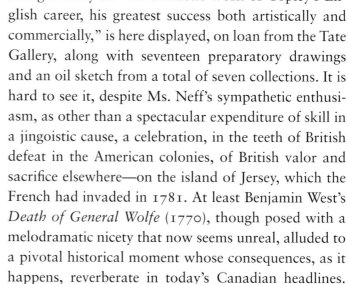

cued—is naked, with the build of a mature man. He and the shark, who share the watery foreground in exactly equal proportions, both have similarly gaping mouths, and appear equally at a loss as to the next step in their relationship. Above them, a small boat has somehow not yet sunk under its load of nine alarmed passengers, who variously reach, stab, and stare. Above *them,* the harbor of Havana, which Copley took from prints, presents a towered silhouette under a sweeping Gainsborough-esque sky. Watson's right leg, which was historically bitten off below the knee, discreetly trails off the painting's lower edge; whether we are witnessing the shark's assault or Watson's rescue is unclear. This picture, probably commissioned by Watson, who since his misfortune had prospered as a merchant in Canada and then in London, made Copley's reputation in England and is probably his best-known canvas. He copied the original and exhibited it in his London studio; the original is owned by our National Gallery and the replica by Boston's Museum of Fine Art. Its naïve weirdness lodges it in the mind: the water is diaphanous and transparent, like a set of veils; the shark is oddly dignified, with the bulging brow and watchful eye of a senior statesman; and Watson's nudity, though explicable as the contemporary male swimming uniform, is a shocker. American literalism meets European history-painting in a Gothic, virtually Boschian dream. Romanticism was on the way. Copley's placement of a black man (brother to an excellent oil sketch, *Head of a Negro,* from the same time period) set a precedent not only for the black soldier in *The Death of Major Peirson* but for the Negro figure in Géricault's *Raft of the Medusa* (1817).

Dreamlike, too, but with a firmer grip on nature, is Copley's flowery, doggy, parrotty *The Three Youngest Daughters of George III* (1785). The profusion of the painting roused criticism at the time, but the lavish outpouring of embowering natural detail forms a homage to the richness of royal blood, and the three princesses with their cavorting pets make a bright and coherent group at the center of it all, a pale swirl of pink-and-white girlhood, with very precise hands and feet. It is pleasant to read that when the girls and dogs became "wearied" during the many sittings Benjamin West went to the monarch with assurances "that Copley must be allowed to proceed in his own way, and that any attempt to hurry him might be injurious to the picture, which would be a very fine one when done." The King and the weary princesses acceded, and the beautifully completed painting now adorns the collection of Queen Elizabeth II. The

Englishing of John Singleton Copley, in some ways a disappointing process, attains a triumph here, as well as in certain heartening posthumous developments: his son John, Jr., a chubby, smiling pre-schooler in *The Copley Family,* and the model for the woeful boy in *The Death of Major Peirson,* became a lawyer, a member of Parliament, and, in 1827, Baron Lyndhurst, three times appointed Lord High Chancellor of Great Britain.

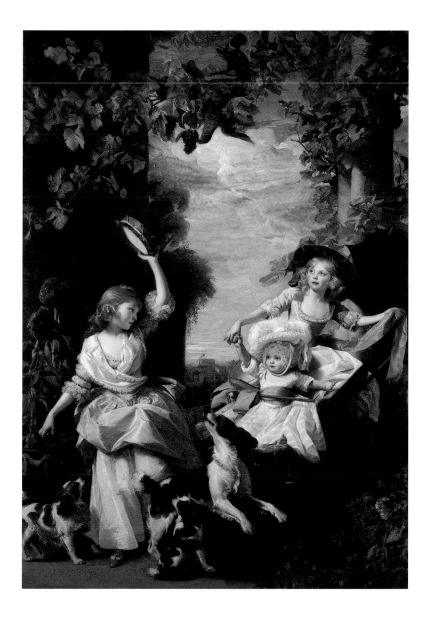

COPLEY *The Three Youngest Daughters of George III, 1785* Oil on canvas, 104 × 73″ Collection of Her Majesty Queen Elizabeth II

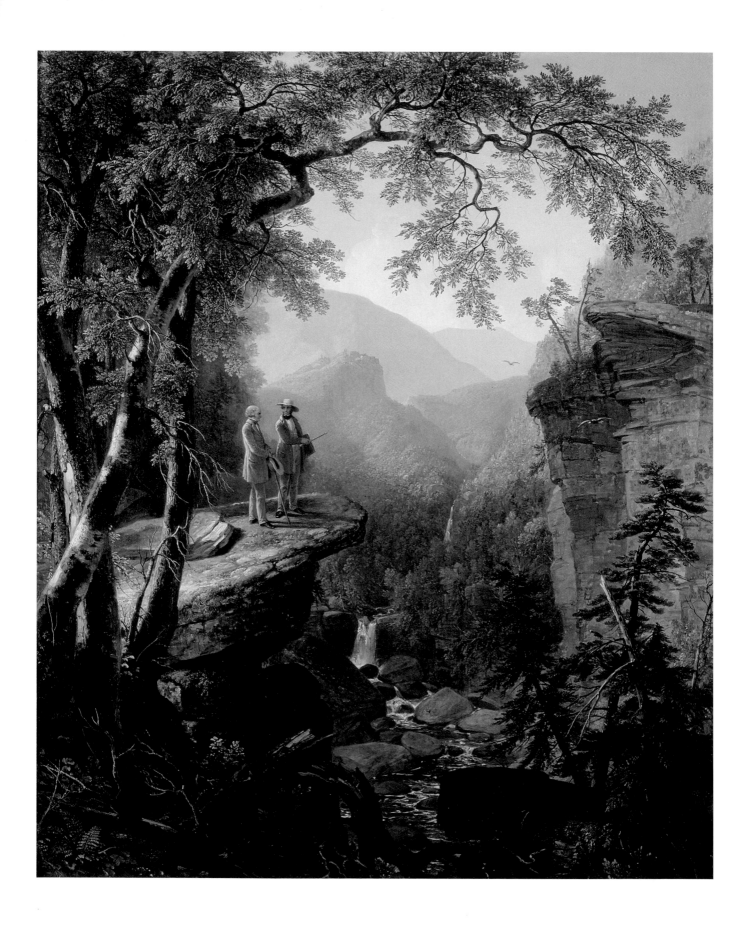

"O Beautiful for Spacious Skies"

THE SPLENDID SHOW *American Sublime*, which originated at London's Tate Museum early in 2002 and has come to spend the summer in Philadelphia before moving on to Minneapolis in the fall, raises, with its article-free title, the question "Why does one hear often of the American Sublime but never of, say, the French or Chinese Sublime?" The very word, from Latin meaning "under the lintel"—i.e., as high as one can go in a constructed opening, just under the upper limit—is a roomy and aspiring one, "sublimation" having precise senses in chemistry and psychiatry related to the vaporization of solids and the taming of instinctual desires. In philosophy, too, the concept is subject to close definition, we learn from Andrew Wilton's authoritative catalogue essay, "The Sublime in the Old World and the New." Critical minds of the eighteenth century distinguished the Sublime from the merely Beautiful: "Addison, for instance, found it natural to refer to the Sublime of Homer and the Beautiful of Virgil." The Alps, one supposes, were sublime and the verdant landscapes of England's home counties merely beautiful. Edmund Burke, in 1757, put the distinction on a firm footing in his *Philosophical Enquiry into the Origin of our Ideas of the Sublime and Beautiful*. In Wilton's paraphrase, Burke relegated the Beautiful to our human function of "generation," or sex: "In a male-dominated society, beauty is governed by what men find desirable in women: smoothness, gentleness, softness and so on." Distinct from this startlingly genderized category (do women, then, find hardness and roughness beautiful or, imitating men, only other women?), the Sublime has to do with "the other basic human instinct, that of self-preservation." And here Burke is quoted directly:

> Whatever is fitted in any sort to excite the ideas of pain or danger, that is to say, whatever is in any sort terrible, or is conversant with terrible objects, or operates in a manner analogous to terror, is a source of the

ASHER BROWN DURAND
Kindred Spirits, 1849
Oil on canvas, 44 × 36"
Collection of the New York
Public Library, Astor, Lenox,
and Tilden Foundations.
Gift of Julia Bryant

sublime; that is, it is productive of the strongest emotion which the mind is capable of feeling.

For examples of "whatever is in any sort terrible," Wilton lists "darkness, obscurity, privation, vastness, succession, magnificence, loudness, suddenness." In passing he cites three natural phenomena that in fact are more than once depicted in the works on display: "the storm, the precipice, the waterfall."

All three natural manifestations, it will be noticed, dwarf Man and render him helpless. Immanuel Kant, commenting at the end of the eighteenth century upon Burke's concept of "a sort of delightful horror, a sort of tranquillity tinged with terror," defined the Sublime as "that, the mere capacity for thinking which evidences a faculty of mind transcending every standard of sense." The Sublime is "absolutely great" and "comparable to itself alone"; comprehending it places the mind under extreme tension. Of course, the attempt to include the terrible and menacing in objects of aesthetic representation is ancient, to be found in the idols of Africa, Mesopotamia, and Central America; if such are sublime, the Beautiful is the younger and more parochial concept. The eighteenth century, having taken reason, order, balance, prettiness, and civility as far as they could momentarily go, was ready to look into the chasm and appreciate wildness. The Gothic novel and Romantic poetry arose to express unmapped depths within the psyche; Napoleon swept all of Europe into a storm of political revolution; science was inexorably rendering nature more and more alien, mechanical, and vast; imperial exploration had annexed strange territories to the European consciousness.

In the Western Hemisphere, European immigrants and their slaves grappled with the New World. If vastness and danger produced sublimity, then the Sublime was to be found where nature reigned untamed, in the thunder of Niagara Falls, the shaggy mountains of the Northeast, the deserts and peaks of the Far West, the volcanoes of Ecuador and Mexico. Frederic Edwin Church, in one of his most heroic attempts to portray transcendent, inutile grandeur, rendered with his painstaking brilliance the icebergs of the North Atlantic. Now, with Greenland crisscrossed by commercial air routes and the Himalayas littered with empty oxygen canisters, Antarctica is the Sublime's last stronghold, where Man can still be cowed by the inhuman.

The excellent catalogue texts by Wilton and Yale professor Tim Bar-

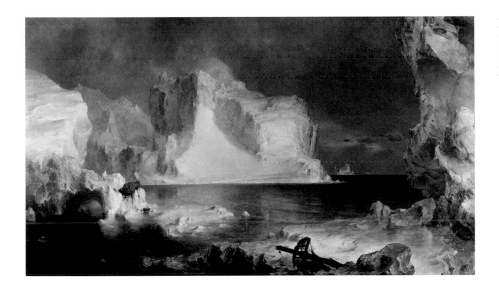

FREDERIC EDWIN CHURCH
The Icebergs, 1861
Oil on canvas, 64¾ × 112½″
Private collection

ringer tell us little about American landscape painting before 1820. Until Romantic developments in theology cleared the ground for Divine occupation of the wilderness, Nature was in a sense invisible. The Puritans averted their eyes from the forest, with its red-skinned deviltry, and their pragmatic successors like Benjamin Franklin were concerned with lightning's harnessable power but not its thrilling scenic value. Full of inconvenient distances and obstructive underbrush, American Nature was the dreadful Other, barely peeping into the windows of the staid indoor portraits of the upstanding citizenry of the colonies and then the enterprising young republic. Who would want to buy a picture of trees, rocks, and poison ivy when the reality stretched for miles on all sides? America needed Wordsworth, and his native apostles William Cullen Bryant and Henry Wadsworth Longfellow, to begin to love their rugged and interminable land.

American Sublime, thematically arranged ("Wilderness," "The Still Small Voice," "'Awful Grandeur,'" etc.) in the polychrome, neo-Arabic rooms of the venerable Pennsylvania Academy of the Fine Arts, opens with a canvas, by Asher Brown Durand, showing his friends Bryant and Thomas Cole, the father of American landscape painting, posed in frock coats upon a stagelike, sunlit platform of natural rock amid a precipitous landscape derived from sketches that Durand made in the Catskills. The painting's date is 1849, the year after Cole's sudden death at the age of forty-seven, and its title, *Kindred Spirits,* was taken from a sonnet by

Keats extolling the joys of "Solitude" in "Nature's observatory." An early patron, a dry-goods merchant, commissioned the work after Bryant had lengthily eulogized Cole before the National Academy of Design, in New York City, as one who "copied the forms of nature . . . and made them the vehicle, as God has made them, of great truths and great lessons." Nature as the God-designed vehicle of great truths was the pious idea, or hope, behind much of mid-century landscape painting: Nature is our friend and looking-glass, our bigger, wordless Bible. Bryant's most famous poem, "Thanatopsis," written when he was seventeen, begins,

> To him who in the love of Nature holds
> Communion with her visible forms, she speaks
> A various language . . .

Furthering such a communion was, then, the ethical purpose of American landscape painting, mixed, at times, with the commercial aim of creating a saleable souvenir of an especially prized sight, such as—within this exhibit—Maine's Mount Ktaadn (Church, 1853), New Hampshire's Crawford Notch (Cole, 1839), and New York's Niagara Falls (Church, 1856–57, 1867; Albert Bierstadt, c. 1869; John Frederick Kensett, c. 1851–52). In Europe, landscape painting *per se* was a relatively recent, early-sixteenth-century development, spreading south from the Danube, the Netherlands, and northern Italy. Two seventeenth-century masters of interest to the English, and thence to Americans, were Salvator Rosa (1615–73), whose turbulent and theatrical *mises en scène* were thought

CHURCH *Horseshoe Falls, Niagara,* 1856–57
Oil on two pieces of paper, joined together, mounted on canvas, 11 × 35⅝"
Olana State Historical Site, New York State Office of Parks, Recreation and Historic Preservation

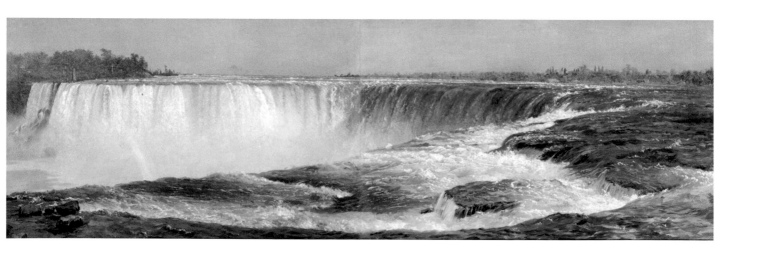

to exemplify the Sublime, and Claude Lorrain (1600–82), a Frenchman, born Claude Gellée, who spent most of his life in Rome, and whose representations of Italian scenery were taken to epitomize the Beautiful. Claude's careful arrangements, wherein gracefully leaning foreground trees frame a misted distant vista, create the impression of a wide garden, in which some structure—a viaduct, a ruined temple—confirms humanity's nearby presence. Durand's pristine Catskills have the same decorum, with their quiet dull color and a leaf by leaf stillness, as if fading under glass; though precipitous, the landscape feels subdued. Durand's later work *The American Wilderness* (1864), though formally composed, with its dark arboreal shapes drawing back the curtains, as it were, on the faraway blue mountains, renders a gashed trunk and fissured rocks with a precision possibly owed to John Ruskin's admonitions to observe nature closely, especially its geology. The wilderness, examined with the proper intensity, shows itself to be compacted of many small violences.

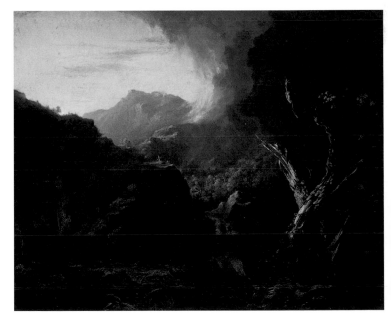

THOMAS COLE
Landscape with Tree Trunks,
1828
Oil on canvas, 26⅛ × 32¼″
Museum of Art, Rhode Island
School of Design, Walter H.
Kimball Fund

In Durand's master, Thomas Cole, violence enters the paint: in *Mountain Sunrise, Catskill* (1826), the tortured shapes of blasted trees are highlighted by wormy lines of white, like congealed lightning, and rocks and clouds share a scrabbled shapelessness; two tiny, clay-colored figures hurry away in the shadows below. In his *Landscape with Tree Trunks* (1828), the shattered trunk in the foreground fairly shrieks, and a cloud lifts up in the middle distance like a crashing wave. Motifs and a mood imitated from Rosa shed their mythological playfulness in a land whose visible population is a lone Indian brave—a touch of wistful fancy in a region from which Native Americans had already been successfully eliminated. Cole's painting of Crawford Notch (1839) introduces, under the frothing sky and tawny mass of Mount Washington, a few fragile houses of settlement, seen just above the foregrounded symbol of a wilderness being tamed: a sawn tree trunk. The stump, and the vivid red splashes of turning maples in the woods, mark the landscape as distinctly American. Queen Victoria, on viewing the violent reds in the work of Cole's follower Jasper Francis Cropsey, doubted aloud that such

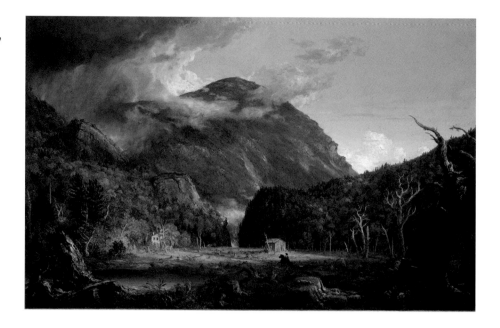

colors existed in nature, and Cropsey, in England at the time, sent home for some autumn leaves to prove his veracity.*

A Cropsey canvas like *High Torne Mountain, Rockland County, New York* (1850) carries Cole's agitated impasto a step further, into a clotted mass of color touches. Cropsey, who after his marriage in 1847 lived some years in Rome and England, came under the influence of Turner; paintings like *Starrucca Viaduct* (1865), *Dawn of Morning, Lake George* (1868), and *Greenwood Lake* (1870) bathe in sunlight. The time of day—noon, dawn, and twilight respectively—becomes one of the picture's subjects. In each, the still waters of a lake collect reflections, and the small figures present are there as viewers of natural splendor, rather than as actors in a Rosaesque melodrama. Cropsey came to the verge of Impressionism and Luminism without quite stepping over. His two Arcadian canvases, *The Spirit of Peace* (1851) and *The Millennial Age* (1854), influenced by Cole's overtly Christian, allegorizing tendencies, seem

* An alternative, and perhaps more plausible, version of this anecdote has it that Cropsey and his wife, who pressed flowers and leaves as a hobby, travelled to England in 1847 to meet Ruskin; after surveying Cropsey's autumnal landscapes, the great critic doubted the veracity of his colors, and Cropsey was able to produce in refutation the scrapbook of leaves and flowers that his wife had brought along to occupy her time on the long transatlantic boat journey. Even this version seems a bit far-fetched.

primitive and garish in execution, their implausible landscapes littered with palm trees and imaginary monuments.

This sort of allegorical painting deflects a contemporary eye. But one of the curators' centerpieces is Cole's five-part series, *The Course of Empire* (1834–36), borrowed from the New-York Historical Society, where the five big (39¼ by 63¼ inches) canvases have been gathering dust since 1858. James Fenimore Cooper called the sequence "the work of the highest genius this country has ever produced." With Gibbon's *Decline and Fall of the Roman Empire* plainly in mind, Cole follows the same picturesque bayside acreage—cleverly identified, in slightly differing perspectives, by a mountain topped by a rectangular boulder— through five stages of population: *The Savage State,* with wigwams, sparse bands of bow-and-arrow hunters, and a fleeing deer; *The*

Pastoral or Arcadian State, with sheep, chiton-clad shepherds, and an intact replica of Stonehenge, evidently still in service; *The Consummation of Empire,* with more figures than the most fanatic bean-counter could count overflowing all the terraces and rooftops of a marble metropolis; *Destruction,* with slaughter, rape, collapsing bridges, victims drowning of

their own decadence, and lots of smoke; and *Desolation,* with crumbling pillars and arches, a lowering sun, and two distant tiny deer, no longer hunted. Be warned, O land of Manifest Destiny: thus is the course of empire.

No amount of conceptual ambition and patient dabbling at details quite annuls the touch of absurdity, of innocent concoction, when an American attempts the Grand Manner. The daily data of American life belong to a raw, evolving present, and not to the circumambient remnants of the past that a European can draw upon when he undertakes a historical landscape in the manner of Poussin or David. The stately vagueness of the genre, its generalizing suppression of incidental details, goes against our native particularist grain. In Durand's portentous *God's Judgment upon Gog* (1851–52), the tossing clouds are real, the flocking gulls are real, the cliffs of stratified rock are real, even the spotlit, gesturing Moses is real, but the central incident, out of the book of Ezekiel, is a muddle. Nor does Cole's *Expulsion from the Garden of Eden* (1827–28) do much for Adam and Eve; the poignance of their cosmic exile is lost in the painter's phantasmagoria of a putting-green Eden set beside the brown, craggy, intimidating rough of the outer world.

No, the American Sublime must be taken straight, without even a

JOHN FREDERICK KENSETT
A Reminiscence of the White Mountains, 1852
Oil on canvas, 35½ × 50″
Manoogian Collection

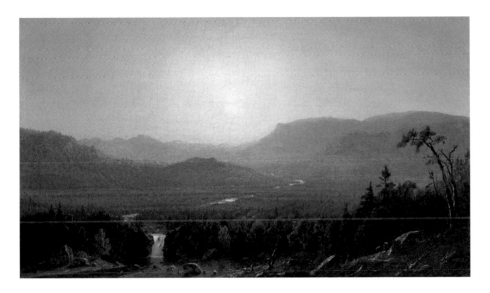

SANFORD ROBINSON
GIFFORD
Autumn in the Catskills, 1861
Oil on canvas, 14¼ × 24"
Private collection, New York

Hiawatha (see Thomas Moran's surreal *Hiawatha and the Great Serpent, the Kenabeek,* of 1867) to act as guide. America was where Western Man discovered, not for the first time, that what is, is. In the opening rooms of the Pennsylvania Academy's setting of this show, the unmediated note, with no hint of a moral or strained preachment, arrives in John Frederick Kensett's *A Reminiscence of the White Mountains* (1852). Cooler in palette than Cole's autumnal shades, the painting has for its foreground no writhing tree but, from one edge of the canvas to the other, an extent of placid riverine water; in receding to a distant succession of mauve mountains, the work brims with a sense of transparent atmosphere. It has the quiet presence, the casual overall focus, of a plein-air meditation, though, like most of the works on exhibit, it was produced in a studio, from sketches made on the spot. Kensett's refreshingly calm and noncommittal manner is carried into a more horizontal format in the glowing, golden landscapes of Sanford Robinson Gifford; Gifford seems to have stepped a considerable distance back from even the nearest objects in his paintings, and expands his misted spaces with the level monotony of undifferentiated treetops (*Autumn in the Catskills,* 1861, and *Catskill Mountain House,* 1862). The pleasure of flat expanses—so different from the vertical unrest of German Romantics like Caspar David Friedrich or the German-American Albert Bierstadt—returns in the salt-marsh meadows of Martin Johnson Heade and certain canvases by Church. In con-

trast to Church's crowded, luridly ruddy skies, Gifford's tend to be cloudless, or lightly flecked. *Hunter Mountain, Twilight* (1866) shows a sliver of new moon and a speck that must be Venus; his *Autumn in the Catskills* holds a barely perceptible white blur that must be the sun—a striking number of these American landscapes stare, in fact, into the sun, as if looking for Godhead there. In Gifford we encounter, with some relief after the energetic natural tangles of Cole and Cropsey, the restraint of the exquisite, and the possibility that less might be more.

Church is perhaps the star of the show; he is represented by the most paintings, and he is the best-known of nineteenth-century landscape artists, neglected by many modern reputation-makers but never quite forgotten. A number of his most spectacular paintings are absent in Philadelphia: *The Heart of the Andes* (1859) has remained in the Metropolitan Museum, and *The Icebergs* (1861) in the sweltering heart of Texas, at the Dallas Museum of Art,* which had loaned it to the Tate for the London show. But the Pennsylvania Academy does display a number of impressively virtuosic landscapes, culminating with *Twilight in the Wilderness* (1860), its spectacularly flaming sky tinging with red the foreground rocks and trees, as God's glory is shed upon our earthly plane. Church became, toward the end of Cole's life, his one and only formal pupil; descended from a long line of Congregational clergymen, he was a fit soulmate of the enthusiastic Episcopal convert Cole. If anyone could extract a religious message from the American landscape, it was the auspiciously named Church. He not only read the German naturalist and explorer Alexander von Humboldt, whose work *Cosmos* presented scientific knowledge as part of a theistic order, but, like Humboldt, he travelled to Latin America; at the foot of his huge showpiece *Heart of the*

* Its arrival in Dallas, in 1979, through the gift of an anonymous donor, is described in a brand-new book, *Voyage of the Icebergs: Frederic Church's Arctic Masterpiece*, by Eleanor Jones Harvey, with contributions by Gerald L. Carr, published jointly by the Dallas Museum of Art and Yale University Press. The painting was originally unveiled in Manhattan, with the pomp and publicity usual for Church's major productions, twelve days after the bombardment of Fort Sumter and, possibly because of the Civil War's distractions, went unsold when displayed in New York in 1861 and in Boston in 1862, though it was enthusiastically viewed by crowds at a quarter a head. In London, in 1863, it was purchased by Edward William Watkin, an English railway mogul and member of Parliament; *The Icebergs* (originally titled, with unintended partisan significance, *The North*) remained in Watkin's country house outside Manchester while he was alive and for nearly eight decades after his death in 1901; in 1979 the painting was discovered in the building, by then owned by the Manchester City Council and most recently used as a home for troubled boys. Auctioned off at the New York Sotheby's in the fall of that year, it went for $2.5 million, a record for an American artist, and was quickly loaned and then given to the Dallas Museum by its unknown purchasers.

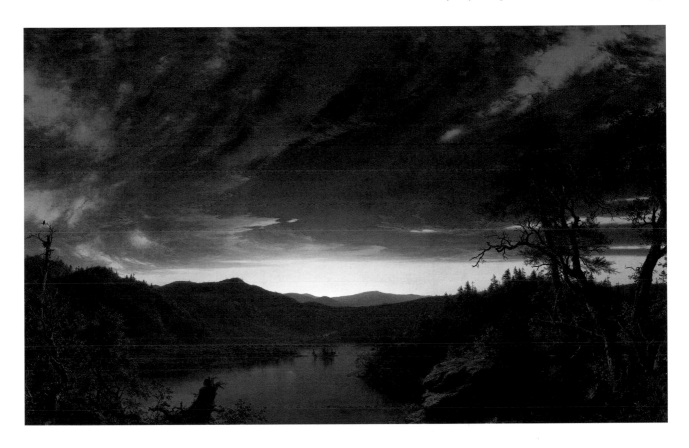

Andes he planted a small but spotlit cross—Christian imperialism by panorama. The late Stephen Jay Gould, in a catalogue essay for a 1989 Church retrospective at the National Gallery,* detected a connection between the drying-up of Church's most grandiose inspirations and the publication, in 1859, of Darwin's spiritually desolating *The Origin of Species.* Certainly something has gone flat in Church's large painting of 1866, *Rainy Season in the Tropics;* its murky stone spires are crowned with a vast double rainbow that looks as opaque as cardboard.

Yet in his prime Church, at full reach, was superhuman. *The Andes of Ecuador* (1855) dissolves a mammoth terrain in the sun's head-on radiance; *Cotopaxi* (1862) gives us a distant, spouting volcano in a sunset terrain red as hot lava; *Coast Scene, Mount Desert* (1863) has breaking, sunshot waves that make Winslow Homer's look schematic; and

CHURCH *Twilight in the Wilderness,* 1860
Oil on canvas, 40 × 64"
The Cleveland Museum of Art.
Mr. and Mrs. William H.
Marlatt Fund, 1965.233

* *Frederic Edwin Church,* by Franklin Kelly, with essays by Stephen Jay Gould, James Anthony Ryan, and Debora Rindge (Washington, D.C.: National Gallery of Art, 1989).

Church's overwhelmingly original (in its close, compressed view of the falls' full curve) and skillful (in its depiction of hurrying, agitated, then smoothly hurtling and airily frothing water) *Niagara* (1857) pronounces the last word on the ultimate sublime subject, the North American epitome of force and danger. One marvels that mere brushstrokes can convey so precisely the visual quality of a transparent medium in motion, so variously penetrated by light. The oil, over seven feet wide, though not sent abroad to the Tate, has come up to Philadelphia from the Corcoran in Washington; on view also is the three-foot-wide oil study, on two pieces of paper, *Horseshoe Falls, Niagara* (1856–57) (page 30), which, at its smaller scale, is even more laterally elongated and more interesting, in the livelier flicker of its painting, than the epic final product. When the eye has rendered all homage to the magic illusionism of Church's racing water, it can rest on the modest far horizon of brown trees and houses (the United States, seen from the Canadian side) that ties the sweeping phenomenon to our stable, domestic earth.

The fifth room at the academy, labelled "Painting from Nature," holds a wealth of quick sketches and studies that American landscapists produced on the spot; most are by Church, and any museum-goer who thinks of him as a photographic copyist should linger with these dashing, attacking works on paper. His attempt, at the base of the falls, to capture the collapse of sheeted liquid and the simultaneous rise of vapor produces abstract, irradiated fury. The loose *Sunset Across the Hudson Valley* (1870), with its shocking golden clouds between layers of gray and blue-green, and its swiftly brushed blackish land-masses, has a vigor sometimes leached from his more painstaking studies of the protean cloud forms inhabiting our spacious skies. The little *Thunder Clouds, Jamaica* (1865) shows, above the green monotone of tropical forest, cumulus aspiring upwards with an ethereal majesty never enlarged upon in a fuller, more finished treatment. Church's unfinished sketches of volcanoes and icebergs have a scientific dignity: notes toward a supreme theory of being. Nevertheless, Church retains a touch of Cole's anxious

CHURCH
Sunset Across the Hudson Valley, New York, 1870
Oil and graphite on thin cream paperboard, 12¹⁵/₃₂ × 13²⁵/₃₂″
Cooper-Hewitt, National Design Museum, Smithsonian Institution. Gift of Louis P. Church. 1917-4-582-c

KENSETT *Eatons' Neck, Long Island,* 1872
Oil on canvas, 18 × 36″
The Metropolitan Museum of Art, New York. Gift of Thomas Kensett, 1874, 74.29

stridency—a sense, in his more ambitious canvases, with their sharp edges and clangorous colors, of his trying to do too much, of not quite relaxing into the process. Ruskin, in a frequently quoted letter, said that Church did "not know yet what painting means"; but, then, Ruskin did not like Whistler either, at the opposite pole of painterly finish and pre-Impressionist realism.

THE EXHIBIT'S sixth room, titled "A Transcendental Vision," is the largest, and the one where our sensibilities greet the most expansive, relaxed, and radiant mood. And it is perhaps the room that needs least comment; the so-called Luminists—Kensett, Gifford, Heade, Fitz Hugh Lane—have received plenty of modern approbation, and were handsomely commemorated in the National Gallery show of 1980, *American Light: The Luminist Movement, 1850–1875,* with its far-ranging catalogue by John Wilmerding. These painters worked in a kind of reverie, tranquillized by the sea's flat horizon and silvery becalmed surface, and delivered the numinous hint the wilderness painters were striving for. By the mid-nineteenth century the Eastern Seaboard had long ceased to be wilderness; Lane's and Kensett's sailing ships and Heade's haystacks and marsh punts testify to the ubiquitous presence of man. There is even evidence, in Kensett's seaward views around Newport and Long Island and northern New Jersey, of the coast's future as a vacation resort for the upper-middle class. His mature style, suppressing any trace of the brush, has an unearthly glaze; the radically simple beaches and islands painted in his productive last summer, that of 1872, strip the world to a few pel-

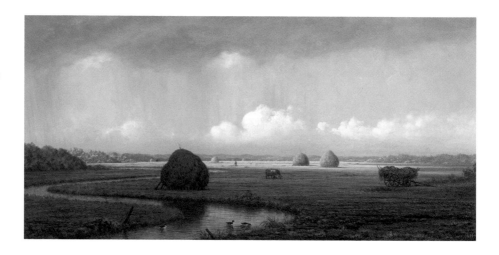

lucid elements. *Eaton's Neck, Long Island* (1872) shows a dwindling curved width of beach, a bank of indistinct vegetation, a section of waveless bottle-green sea, a cloudless sky more gray than blue; Milton Avery and Mark Rothko produced nothing more audaciously simple.

In recent years, Heade has emerged from obscurity to be the creator of a celebrity American landscape: *Approaching Thunder Storm* (1859) (page 46). Black clouds turn the waters of an inlet even blacker, but the rest of the shore world shines in sunny, pure colors. One can hardly help reading the advent of the Civil War into it; the halcyon antebellum world is about to be engulfed. Like Church, Heade travelled to South America to paint exotica, but his salt-meadow views, on canvases whose broad format was imitated from Church's *Niagara*, lyrically capture a now-vanished aspect of working American husbandry. Fitz Hugh Lane, the son of a Gloucester sailmaker, was crippled by polio and condemned to a life on crutches; his artistic leanings found commercial expression in lithographic illustrations, and only in his mid-thirties did he become a painter in oils, almost always of marine subjects. Mostly self-taught, he can be timid and awkward in his lesser work, but his meticulous portraits of boats, the sails and riggings scrupulously detailed, achieved, by the later 1850s, atmospheric effects of enchanting delicacy. The pink-tinged calm of *Owl's Head, Penobscot Bay, Maine* (1862), staining both sky and sea; the tawnier sunset of *Becalmed off Halfway Rock* (1860); the artfully diminished visibility of *"Starlight" in Fog* (1860); the contrast of bright white sails and darkening sky in *Schooners Before an Approaching Storm*

off Owl's Head (1860), as electric a contrast as in Heade's famous painting—these weather-conscious effects convey an uncanny patience, imbued not only with the cripple's humble literalism but with the great amount of patience, while wavelets slowly slap and oarlocks creak, exercised in maritime life.

A small adjacent room displays two big South American landscapes by Church as they were mounted, heavily framed and even curtained, for Victorian ticket-buyers. Paintings of this scale were show business, and, until photography gradually relieved the painter of reportorial duties, news from afar. Church's main competitor in this business was the German-born Albert Bierstadt, who came to this country when he was two but returned to Germany for formal art training in Düsseldorf; he took instruction and encouragement mostly from the other Americans in Europe, including Gifford. His talent was so potent that Church, a fellow-tenant of the Tenth Street Studio Building, ceded the American West to him; of all the American landscapes in this exhibit, only Bierstadt and the English-born Thomas Moran take us beyond the Appalachians. Bierstadt sketched, with a deft and translucent touch, the plains (*Surveyor's Wagon in the Rockies,* c. 1859) and the tawny hills (*Nebraska, Wasatch Mountains,* 1859) on the way to the Rockies. When the Civil War subsided, he ventured as far as the Yosemite Valley, whose needling stone spires gave him a heightened vision of grandeur; this vision flavors the gigantesque, rather fairy-tale splendor of *Rocky Mountains, "Lander's*

FITZ HUGH LANE *Becalmed off Halfway Rock,* 1860 Oil on canvas, 27¾ × 47½" National Gallery of Art, Washington, D.C. Collection of Mr. and Mrs. Paul Mellon

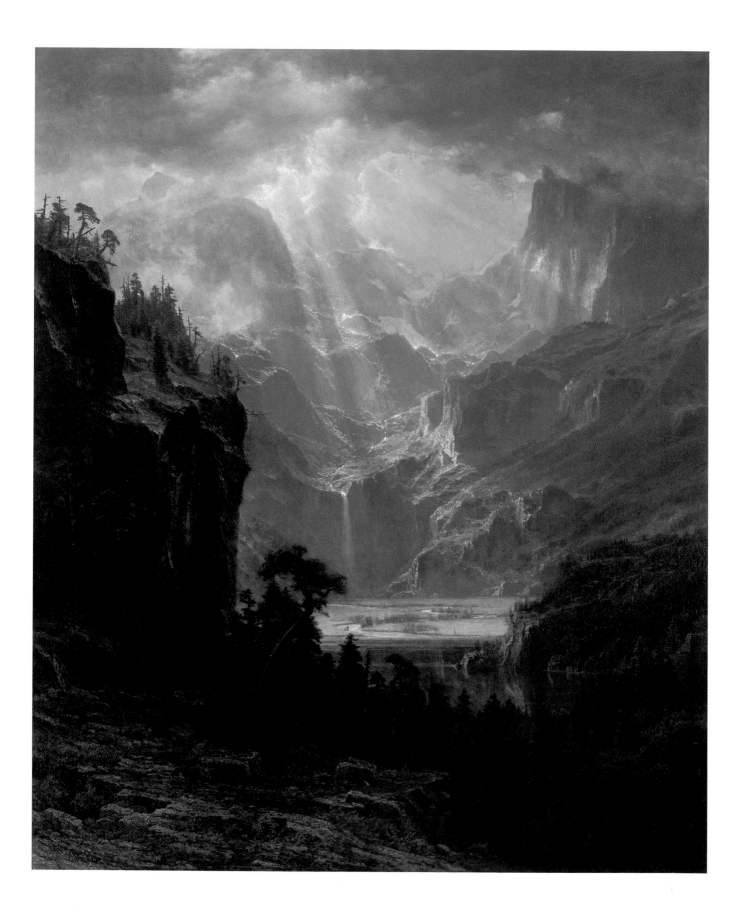

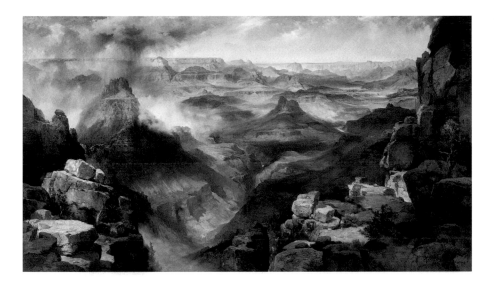

THOMAS MORAN
Grand Canyon of the Colorado,
1892 (reworked 1908)
Oil on canvas, 53 × 94"
Philadelphia Museum of Art.
Gift of Grame Lorimer, 1975

Peak" (1863) and, the show's culminating blockbuster, *Storm in the Rocky Mountains—Mt. Rosalie* (1866). In this last, a furry black storm cloud seems to be devouring a lower slope of the mountain even as sunlight beats upon the rocks; beyond a high boil of clouds a snow-covered peak measures a scale of breadth and height in which the tiny Indian horsemen and tinier tepees in a flat valley are reduced to the stature of microbes. The canvas overwhelms us with its towering vision and passionate detail; and yet there is something corrupt, something calculating and extreme in Bierstadt, a heightening of the already very high, an imposition of geological melodrama that closes the chapter on the exploration which began with Cole's and Durand's attempt to apply European proficiency to a landscape where men still scarcely figured.

The other very large canvas in this final room is Moran's *Grand Canyon of the Colorado* (1892, reworked 1908). The curious thing about it, to a tourist who has stood on the canyon's rim, is how little it conveys of the canyon's depth and breadth; we seem to be looking at a flat pattern of mesas and puffs of mist. Moran, as we can observe in an indistinct and tumultuous seascape like *"Fiercely the red sun descending Burned his way along the heavens"* (1875–76, an illustration of two lines from Longfellow's *Song of Hiawatha*), made the closest approach to Turner among American landscapists (as well as to, in his sinister Hiawatha illustrations, Fuseli). Lit by the stark sun of the West, with only a few clinging shrubs for foreground vegetation, his Grand Canyon has

(Opposite)
ALBERT BIERSTADT
Rocky Mountains, "Lander's Peak," 1863
Oil on linen, 43⅝ × 35½"
Fogg Art Museum, Harvard University Art Museums. Gift of Mrs. William Hayes Fogg

become a vision, a pattern, a great postcard in no sort terrible, remote from pain and danger, sublime only in its indifference to human measure.

When I tried to think of twentieth-century heirs of these landscapes, I netted a modest catch: John Marin's sketchy sea views; Marsden Hartley's glowering Maine mountains; Arthur Dove's semi-abstract suns; Georgia O'Keeffe's parched mesas, eroded and orange and littered with cattle bones. Perhaps Edward Weston's desert photographs and the John Ford movies set in Monument Valley most directly inherit the vision of a dwarfing, ineffable Nature. The Sublime, ignored by a modern art scaled to human pleasures and cultural cross-reference, was reborn in the mid-twentieth century in the oversize, utterly abstract work of Pollock and Kline, Motherwell and Still, Rothko and Newman. Newman, who had originally studied to become a philosopher, wrote learnedly and feistily on the question "What Is the Sublime in Art?" in a 1948 essay, "The Sublime Is Now." Now, and American: he explained that "the failure of European art to achieve the sublime is due to [a] blind desire to exist inside the reality of sensation (the objective world, whether distorted or pure) and to build an art within a framework of pure plasticity (the Greek ideal of beauty . . .)."* Only in America, he claimed, was the artist free of Europe's "moral struggle between notions of beauty and the desire for sublimity." In 1961, looking back upon a triumphant but exhausted

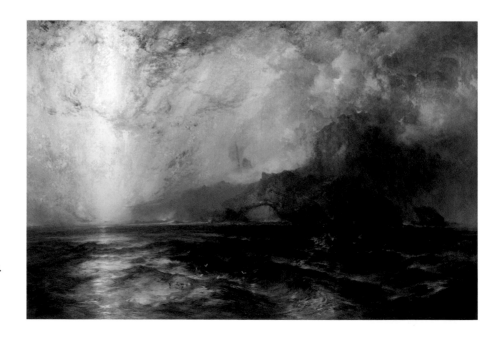

MORAN *"Fiercely the red sun descending/Burned his way along the heavens,"* 1875–76 Oil on canvas, 33⅜ × 5 1/16″ North Carolina Museum of Art. Purchased with funds from the North Carolina Arts Society, Robert F. Phifer Bequest

BARNETT NEWMAN
Vir Heroicus Sublimis, 1950–51
Oil on canvas, 7′11⅜″ × 17′9¼″
Museum of Modern Art, New
York. Gift of Mr. and Mrs. Ben
Heller

movement, the critic Robert Rosenblum, in his *ARTnews* essay "The Abstract Sublime," cited Burke, who said, "Greatness of dimension is a powerful cause of the sublime," and Kant, who located the Sublime in formlessness, "so far as in it, or by occasion of it, *boundlessness* is represented." Newman hastened to purge these vasty old notions of their traces of the Divine:

> During the Romantic era, the sublimities of nature gave proof of the divine; today, such supernatural experiences are conveyed through the abstract medium of paint alone. What used to be pantheism has now become a kind of "paint-theism."

One cannot read such statements and doubt that the American yearning for the Sublime stems from our assumption, since the Puritans, of a favored-nation status "under God," as the disputed phrase of the Pledge of Allegiance has it. Under God, under the lintel, as perilously high as possible: the danger and pain of the Abstract Sublime belonged to the painter, performing his high-wire act with only intuition and impulse to guide him across the immensity of canvas; the storm and precipice were purely within. The painter assumed the role of hero, not by virtue of what he witnessed and recorded but by all the traditional props and excuses that he disdained in his visible wrestle with paint itself. The episode was understandably brief, from 1943 to about 1960; we cannot take the sublime as a daily dose.

* This and the subsequent quotations can be found in *Abstract Expressionism: Creators and Critics,* edited and with an introduction by Clifford Ross (New York: Abrams, 1990).

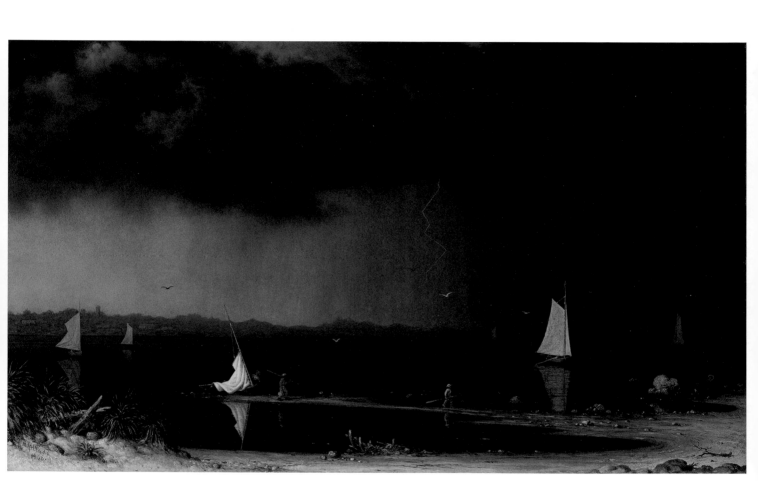

Heade Storms

───

ONE GOOD THING about nineteenth-century American painting is that there is a lot of it. The teeming schools of industrious, capable artists who catered to the romantic tastes of the burgeoning bourgeoisie held a number of odd fish that appeal, with the right critical sauces and careful filleting, to the stringent tastes of this later century. One such is Martin Johnson Heade, a not unknown but never highly successful colleague and friend of Frederic Edwin Church. Heade, who changed his last name from Heed, was born in 1819 along the Delaware, in Lumberville, Pennsylvania, and led a wandering life, with addresses in Brooklyn, Philadelphia, Rome, Paris, St. Louis, Chicago, Madison, Trenton, Providence, Boston, Rio, London, Nicaragua, Colombia, Jamaica, British Columbia, and California. The years, from 1866 to 1881, in which he lived in New York City, subletting at the outset Church's quarters in the Tenth Street Studio Building, were the most collegial and productive of his career. Nevertheless, almost alone among his peers, he never became even an associate member of the painterly Century Association. In 1883 Heade discovered Florida, and the next year he took up residence in St. Augustine, equipped for the first time in his life with a wife, born Elizabeth V. Smith of Brooklyn, and a patron, Henry Morison Flagler, a former partner in Standard Oil, who devoted his great wealth to loading Florida with hotels and railroads. Heade spent twenty apparently contented years in St. Augustine, painting the landscape and shooting the wildlife and writing conservation-minded letters to *Forest and Stream* (later *Field and Stream*) under the name of "Didymus," a.k.a. St. (Doubting) Thomas.

After Heade's death, in 1904, at the age of eighty-five, his modest reputation fell into total eclipse until 1943, when his masterly canvas *Thunder Storm on Narragansett Bay* (1868) was hung, under the geographically erroneous title *Storm Approaching Larchmont Bay*, in the

(Opposite)
MARTIN JOHNSON HEADE
Thunder Storm on Narragansett Bay, 1868
Oil on canvas, 32⅛ × 54¾"
Amon Carter Museum, Fort Worth, Texas, 1977.17

Museum of Modern Art's exhibition *Romantic Painting in America.* Since then, Heade has attracted a good deal of critical notice and scholarly delving—a number of his recorded paintings are still not physically located, and a very imperfect documentary light has been shed upon his restless life. *The Life and Works of Martin Johnson Heade,* by Theodore E. Stebbins, Jr. (1975), remains the fullest word on its subject. Though the painter wrote poems and sprightly letters to the editors, he confided little to paper concerning art; his letters to Church, where such matters were possibly discussed, were not preserved, though Heade kept many of Church's.

Like Vermeer, Heade blended into the art of his time and needed posterity to recognize the exceptional quality and concentration beneath his paintings' surface quiet. American analogies might be with Emily Dickinson, whose lonely oddity emerged as a profound integrity, or with Thoreau, who serves as a frequently quoted touchstone in Stebbins's biography—without any demonstration, however, that Heade ever read him. A kind of hermit on the move, Heade nonetheless engaged in the commerce of a professional artist, exhibiting and selling and painting series of similar canvases when their topics proved popular. He was best known in his lifetime for his luminous, horizontal, finely detailed paintings of coastal marshes—those of Newbury, Rowley, and Marshfield when he lived in Boston, and the Jersey Meadows when he lived in New York—and for his close and somewhat lugubrious studies of hummingbirds and orchids, the fruit of his three excursions into Latin America. He also executed, from 1859 to 1868, some arresting seaside vistas under dark or threatening clouds, and these are the substance of an exhibition, *Ominous Hush: The Thunderstorm Paintings of Martin Johnson Heade,* come to the Metropolitan Museum of Art in October of 1994 from Fort Worth's Amon Carter Museum. The Amon Carter owns the now-celebrated Narragansett Bay painting that in 1943 sparked Heade's revival; it serves as the centerpiece of a show consisting of a mere eight canvases, fleshed out with four preparatory sketches in pencil and a contemporary engraving of a painting of Point Judith, Rhode Island, whose original has vanished. These items, supplemented by two small canvases—one of marshes, one of orchids and hummingbirds—from the Metropolitan's collection, fit pleasantly into a single gray-painted room and its entryway. Amid the Met's plethora of treasures a small space of artistic contemplation has been carved, complete with a broad bench.

Studying the set of storm paintings, I could not bring myself to believe that they had much to do with the Civil War and Reconstruction, though the pretty catalogue, by Sarah Cash with technical notes by Claire M. Barry, devotes a good proportion of its text to citing storm references in contemporary sermons and poems and rhetoric. Undoubtedly the Civil War, with its suspenseful preamble and its morally compromised aftermath, bit deeply into the national soul; millions were passionately engaged. But Heade himself was sufficiently disengaged to take off for Brazil in 1863 and to stay a year or more, enjoying the royal favors of Dom Pedro II, who made him a Knight of the Order of the Rose. The delicate, wavery lightning stroke of *Thunder Storm on Narragansett Bay*— called by a critic in 1868 "about the weakest attempt that ever was made by an artist to represent the effect of the electric fluid on the clouds"— does not inevitably evoke "the fateful lightning of His terrible swift sword," as "The Battle Hymn of the Republic" has it, nor are the two diagonally crossed beams of driftwood in the lower left corner very suggestive of the Christian cross. By 1868—the painting is firmly dated, beneath the signature—the war was over, in any case; are we to believe that that year's impeachment of President Johnson and election of Ulysses S. Grant are the ominous referents?

The painting is, in fact, strangely idyllic and tranquil. The foreground, whose projecting arm of sand provides the center stage, is sunlit. The two figures walking upon the spit appear not to hurry from the coming storm but to saunter; a dim third figure is relaxing the white sail of a beached boat, whose reflection is calmly mirrored in still black water. The seven boats still at sea and the seven gulls suspended in air convey a sense of orderly homecoming; the lightning flash is distant, beyond the line of green hills, and the patch of light sky at the left implies that clearing will soon follow the dark clouds lowering their veils of rain harmlessly out to sea.

Heade *liked* the still, soft, electric atmosphere before a summer thunder shower, one supposes—else he would not have attempted to paint the moment so often. Storm clouds bring tension and temporal particularity to many of his vistas of flat marshes, such as *Gathering Hay Before a Thunderstorm, Marsh in a Thunderstorm,* and *Sudden Shower, Newbury Marshes* (page 40), all from the 1860s. The American landscape artists of the mid-nineteenth century, in seeking to possess their immense subject, broke it into moments: Church's *Twilight in the Wilderness* (1860) (page

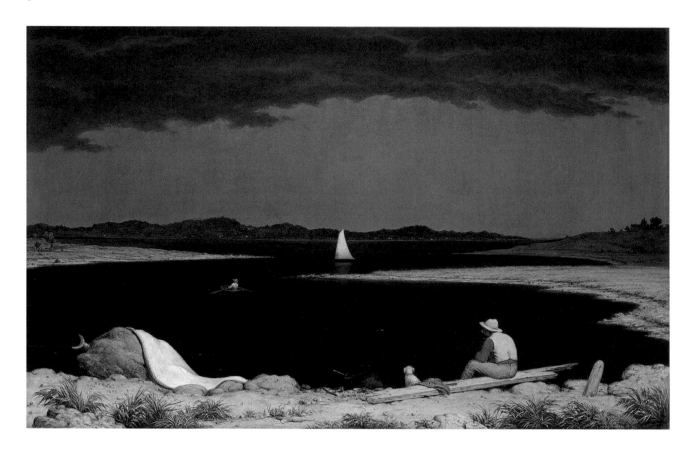

HEADE *Approaching Thunder Storm*, 1859
Oil on canvas, 28 × 44″
The Metropolitan Museum of Art, New York. Gift of the Erving Wolf Foundation and Mr. and Mrs. Erving Wolf. 1975, 1975.160

37) and his *Sunrise off the Maine Coast* (1863) are spectacular examples; in Fitz Hugh Lane's less flamboyantly ambitious canvases, the sky and its mirror the sea are made to yield the precise tints, pink or golden or blue, of a day's passing phase. The moment when rain approaches or recedes, like those of sunrise and sunset, is dramatically freighted with implications of a past and future, of a life in time that the landscape leads. Heade, a scarcely schooled painter whose representational technique can appear ungainly next to Church's or Lane's, taught himself how, with scumbling and stippling and streaking, to capture the evanescent atmospherics of rain. His bold use of black, in the relatively early *Approaching Thunder Storm* (1859), verges on the surreal. The band along the top has an uncloudy density; the felt-gray sky beneath it seems a liberty the painter has allowed himself; and the water is pure ink. Against the utter black, a sunlit man and dog have a cartoonish sharpness of shape and color, as if transposed from a Brueghel onto an American beach, whose

grasses are highlighted with stabs of the brush handle. It is a plangent but beautiful, firmly plotted picture—a rhythmic recession of alternating points of land around the white-sailed boat in the middle distance, its mast-tip lying in the exact center of the canvas.

From that same year, *Storm Clouds on the Coast* (1859) abounds with crudities: the sandpipers seem as small as sand fleas, the receding white-caps are too regularly spaced, and the spume of the crashing wave is a bit too obviously dabbled white paint. The sea, the sky, and the land on the left could each have been painted by a different man, the land-painter the most laborious. The painting is thought to have been first owned by Henry Ward Beecher; the popular Brooklyn preacher, later to be brought low by scandal, was a considerable collector, whose "extensive library," we are told, "included many volumes of poetry that contained thunder-storm metaphors for the Civil War."

So? The Victorians, for whom God had donned the stern and ambiguous face of Nature, saw portents and symbols everywhere. Creation's grandeur is clearly the subtext of Church's imposing panoramas, even without such helpful hints as the little spotlit shrine in a foreground corner of his stupendous *The Heart of the Andes* (1859). Albert Bierstadt's equally staggering rectangles of outdoor splendor take the sublime implications even further, into a kind of naturalist baroque, a veritable ecstasy of soaring crags and peaks dissolved in mist and light. But, though we

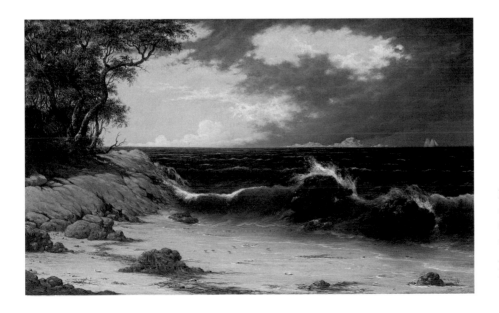

HEADE *Storm Clouds on the Coast*, 1859
Oil on canvas, 20 × 32¼″
Collection of the Farnsworth Art Museum. Museum Purchase, Charles L. Fox Fund, 1965

know that Heade wrote two hymns to Henry Clay and left an Episcopal *Book of Common Prayer* among his effects, his paintings do not register as ideological. *Coastal Scene with Sinking Ship* (1863), painted in the darkest year of the Civil War, comes closest, but the smallness of the ship, and the nearby presence in the sea of two sailing vessels erect and afloat, make it a very diffident illustration for (as the wall text suggests) Oliver Wendell Holmes's

> The good ship Union, southward bound:
> God help her and her crew!

One notices, instead, that the half-stormy, half-blue sky is lovely, and that in four years Heade has learned quite a lot about showing the flow and froth of agitated waves. His water, however, never quite attained the superb liquidity of, say, Church's *Horseshoe Falls, Niagara* (1857) (page 30) or of Alfred Thompson Bricher's *Time and Tide* (c. 1873) or of the mountainous, sliding, froth-webbed heaps of greenish ocean that Winslow Homer studied from the cliffs of Maine (page 67). In Heade's *Approaching Storm, Beach near Newport* (c. 1867), the breaking waves have a crêpe-papery, white-edged thinness to them, though the overlapping loops of shallow spilling water on the beach are excellently

HEADE *Approaching Storm, Beach near Newport*, c. 1867 Oil on canvas, 28 × 54⅜″ Museum of Fine Arts, Boston. Gift of Maxim Karolik for the M. and M. Karolik Collection of American Paintings, 1815–18, 45.889

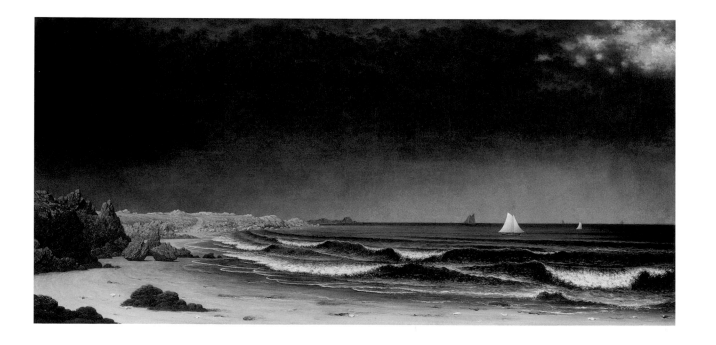

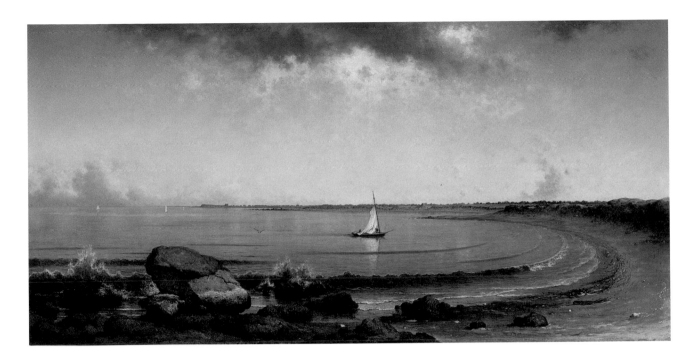

observed. Farther out, he has caught—as he did not catch in the 1859 *Storm Clouds on the Coast*—the long shadows of the waves steadily surging in behind the breakers, connecting the motionless horizon with the foreground tumult. The sunlit rocky point on the left has a lunar starkness that goes with a green-black ocean not quite of our planet.

The most pleasing and memorable Heade canvases are those, I came to feel, with a touch of naïveté. He studied as a young man with Edward Hicks and Hicks's cousin Thomas, who are considered "naïve" or folk artists. Heade's first works were portraits in the naïve style—that is, hard-edged, expressionless, and anatomically insecure. Though, after an extended youthful sojourn in Europe, he acquired more representational sophistication, there remains in even his late work a formalizing impulse and a fudging of some illusionistic challenges that Church would have brought off with an imperious ease. Heade was fond, for example, of long, looping lines, from the beach wavelets mentioned above to the black bays of *Approaching Thunder Storm;* a photograph of the spot in Rhode Island from which he painted this view reveals how he lifted the perspective to clarify the shoreline curves, while eliminating a rectangular jetty on the left. *Shore Scene, Point Judith* (1863) depicts one long loop of

HEADE
Shore Scene, Point Judith, 1863
Oil on canvas, 30⅛ × 60¼"
Museum of Fine Arts, Boston.
Gift of Mary Harris Clark,
1991.967

water coming into a curved beach, and the blunt end of the curve subtly offends correct perspective, though the pictorial logic is impeccable. A nighttime version of the same scene—*Point Judith, Rhode Island* (c. 1863)—eliminates this awkward end of the bay, and the painting is the more conventional for it. It is slightly disconcerting, in this pair of large marine views, to see how closely Heade repeated not just the rocks but the pattern of splashing waves and, somewhat, that of the clouds; for all his visionary qualities, he recycled his sketches thriftily. One oil sketch of magnolia blossoms served him in six still lifes.

HEADE *Magnolia Grandiflora,* c. 1885–95 Oil on canvas, 15⅛ × 24⅛″ Museum of Fine Arts, Boston. Gift of Maxim Karolik for the M. and M. Karolik Collection of American Paintings, 1815–1865, 47.1169

His many studies of orchids, roses, and magnolias, some of them recumbent like petaled odalisques, form his original contribution to the American art of the still life. They contain a social, if not a political, statement: these enlarged flowers, with their accompanying pairs of hummingbirds, were Heade's way of painting sex. Orchids are notoriously an erotic flower; their name derives from *orchis*, the Latin for "testicle" (based on the shape of their roots), and their petals, leading into a deep cavity, are strikingly vaginal. Heade did leave on record a statement about sex, transcribed by his first biographer, Robert G. McIntyre, from a "notebook," Stebbins tells us, "of now unknown location." With an honesty remarkable in a pre-Freudian man, Heade wrote:

> Every man who possesses a soul has loved once, if not a dozen times, for passion was created with man, and is a part of his nature. . . . As soon as the affectionate and sensitive part of my nature leaves me, I shall consider the poetry of my existence gone, and shall look upon life as a utilitarian, bargain-and-trade affair; for that poetry is the only source of real happiness we have, and I care not whether it is laughed at or acknowledged.

It must be admitted that the eroticism comes through the flower paintings rather stiffly and obliquely, and that Heade was not the most accomplished of painters in his time. Walking upstairs in the Metropolitan to the Thomas Eakins exhibit on view, one finds in abundance an element quite missing in Heade: people, in their psychology and physiognomy. Eakins's own marsh view, *Pushing for Rail* (1874), pursues human per-

sonality right into individualized faces smaller than a fingernail. Moving on to the general American galleries, the viewer confronts a dynamic magnificence in Church and Homer that was not within Heade's powers; nor was his calm the pearly calm of John Frederick Kensett or the celestially glassy calm of Fitz Hugh Lane. Heade's calm is unsteady, storm-stirred; we respond in our era to its hint of the nervous and the fearful. His weather is interior weather, in a sense, and he perhaps was, if far from the first to attempt portraits of human moods in aspects of nature, the first to portray a modern mood, an ambivalent mood tinged with dread and yet imbued with a certain lightness. The mood could even be said to be religious: not an aggressive preachment of God's grandeur but a kind of Zen poise and acceptance, represented by the small sedentary or plodding foreground figures that appear uncannily at peace as the clouds blacken and the lightning flashes.

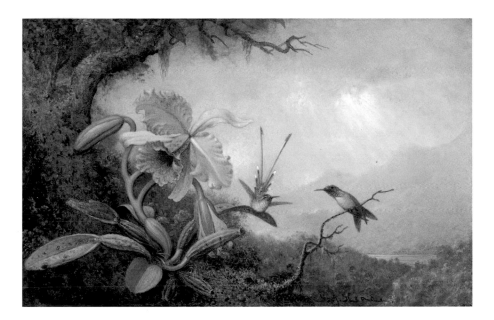

HEADE *Hummingbirds and Orchids,* c. 1880s
Oil on canvas
The Detroit Institute of Arts.
Founders Society Purchase,
Dexter M. Ferry, Jr., Fund

Epic Homer

—————

THE WINSLOW HOMER EXHIBITION that occupies thirteen rooms of the East Building of the National Gallery, this winter of 1995–96, is one to make an American proud. Its two hundred thirty-five paintings and drawings form the pictorial record of a progress from humble, scratchy artistic beginnings to a triumphant, thunderous close, by a man whose formal art training was slight and who determinedly focused on the plain life and unadorned scenery of the democracy. Homer was painting's Melville, emerging from a kind of journalism into increasingly grand ambitions, but without the bitter truncation of Melville's career. Not just their shared fascination with the sea suggests the parallel, but a boyish readiness in their talents, a quickness of assimilation, a creative eagerness which gives a morning sense of the world grasped afresh. After the sequestered, shadowy intensities of Hawthorne and Poe, we enter, in *Typee* and *Moby-Dick,* far-flung outdoor space. Those museum-goers coming, as I did, to the Homer show from the Copley exhibit over in the West Wing must be struck by the sunny uncrowdedness of Homer's oils and canvases—the scattered croquet players of 1865, for instance, in dresses as stately as lonely pyramids, compared with Copley's interlocked family scenes, overflowing with flesh like bowls of carefully arranged fruit, or the stark muddy stretches of Homer's Civil War paintings compared with the crammed contortions of the expatriate painter's exquisite and epicene *Death of Major Peirson* (pages 22–23). Two artists from Boston: the one a colonial gradually mastering the soft-edged, heavily coded visual proprieties of monarchial England, and the other, born a century later, bestowing a statuesque dignity upon country lasses in empty meadows. It is Homer's spareness, his leanness, his blunt clarity that make him so refreshing and made him, to his early critics, so disconcerting.

One early critic was Henry James, reviewing a New York Academy of

Design exhibition of 1875. James, with Homer one of the few American artists to have had a career that feels complete, was struck by Homer's three entries in the show, and devoted words to him so wryly appreciative, so entertainingly troubled, that one is tempted to quote at length:

> Before Mr. Homer's barefoot urchins and little girls in calico sun-bonnets, straddling beneath a cloudless sky upon the national rail fence, the whole effort of the critic is instinctively to contract himself, to double himself up, as it were, so that he can creep into the problem and examine it humbly and patiently, if a trifle wonderingly. . . . Mr. Homer goes in, as the phrase is, for perfect realism, and cares not a jot for such fantastic hair-splitting as the distinction between beauty and ugliness. He is a genuine painter; that is, to see, and to reproduce what he sees, is his only care; to think, to imagine, to select, to refine, to compose, to drop into any of the intellectual tricks with which other people sometimes try to eke out the dull pictorial vision—all this Mr. Homer triumphantly avoids. He not only has no imagination, but he contrives to elevate this rather blighting negative into a blooming and honourable positive. . . . We frankly confess that we detest his subjects—his barren plank fences, his glaring, bald, blue skies, his big, dreary, vacant lots of meadows, his freckled, straight-haired Yankee urchins, his flat-breasted maidens, suggestive of a dish of rural doughnuts and pie, his calico sun-bonnets, his flannel shirts, his cowhide boots. He has chosen the least pictorial features of the least pictorial range of scenery and civilization; he has resolutely treated them as if they *were* pictorial, as if they were every inch as good as Capri or Tangier; and, to reward his audacity, he has incontestably succeeded.

This tangle of praise and blame arises from preconceptions long obsolete: the paintings that spelled beauty and imagination to James now loom to us as ugly—forced, formal concoctions redolent of stuffy patronage and devoid of simple truth. James's eye was too good not to see Homer's "great merit" of atmospheric fidelity: "He naturally sees everything at one with its envelope of light and air." That to achieve this merit the painter must brave the bleak outdoors and forsake the cluttered studio and the manipulated props of "imagination" James was too European to admit. He found, in fiction, his friend William Dean Howells mundane and formless, and Mark Twain far beyond the pale. He could never quell his sensation that there was something intrinsically unworthy in American subject matter. Only the pure, dry American soul, caught in the toils of Old World corruption, pleased him; that soul's plain and

provincial furniture he gratefully eased from his mind. Homer stayed with the furniture, and his year in France (1866–67) left so little trace of influence upon him as to baffle art historians. Some say it lightened his palette.

Boston of the 1850s, Nicolai Cikovsky, Jr., points out in his extensive catalogue commentary, had no art schools and so little artistic life that young Winslow Homer's genesis as a painter amounted to an immaculate conception. He liked, he could only explain, "the smell of paint . . . in a picture gallery." His amiable, affluent family indulged him, but the best his father could supply for training was to apprentice Winslow to a friend of his, the commercial lithographer John H. Bufford. By the age of twenty-one, Homer was contributing illustrations to periodicals, and by 1859 had moved to New York, to be closer to *Harper's Weekly* and his other sources of income. While there, he took some painting lessons. The Civil War (in which he did not otherwise serve) gave him a major commercial and artistic opportunity. He preferred, from the start, the medium of painting, and *The Sharpshooter on Picket Duty,* the first painting in this show and described by a friend of Homer's as "his very first picture in oils," preceded its appearance as an engraving in *Harper's Weekly* in November 1862. As late as 1871, Homer was producing oils based on his memories and sketches of the war. They attracted good critical notice, and serve as well as photographs to record the look of the war, but as paintings they are not very pleasing. They have a thin, scrubby surface and a certain paint-by-the-number stiffness. The much-admired *Prisoners from the Front* (1866) is essentially an illustrated edi-

(Left)
HOMER *The Army of the Potomac—A Sharpshooter on Picket Duty*
Engraving from a painting, in *Harper's Weekly,* November 15, 1862
Collection of The New-York Historical Society, negative no. 34893

(Right)
HOMER *A Rainy Day in Camp,* 1871
Oil on canvas, 20 × 36″
The Metropolitan Museum of Art. Gift of Mrs. William F. Milton, 1923, 23.77.1

torial, an elaborate cartoon in two colors, brown and pale blue. But Homer had the perspicuity—the American open-mindedness—to see that stretches of hoof-pocked mud and efforts to keep dry around a campfire on a rainy day were as much a part of war as battle. *The Veteran in a New Field* (1865) is his first symbolically potent distillation, the yellow wheat-stalks slashed in with a daring freedom.

Thanks to Homer's habit of working in series—a distinctly modern method, Mr. Cikovsky claims, pregnant with implications of ultimate unknowability and irresolution—nearly each room presents a theme, whether of rural children, or tropical watercolors, or marine paintings. Familiar iconic triumphs greet us in many of the chambers, as well as the subtle variations that lead up and away from them. Homer's profession of illustrator, which he quit in 1875 upon deciding that he could make a living from his watercolors, taught him a contriver's economies—he would use the same sketch in an engraving, and then in a painting, and then in another. Two paintings of croquet deploy two identical female figures, adding, or deleting, a pair of less impressive figures. The same standing milkmaid serves three different environments; a girl blowing a dinner horn had four incarnations. The most conspicuous, and most scandalously corporeal, wet-dressed bather in the ambitious *Eagle Head, Manchester, Massachusetts* (1870) appears, smaller and reversed, in that year's *By the Shore;* this latter painting stands out as showing more venturesome color, and a freer signature, than Homer had displayed hitherto. The Eagle Head painting has the scale and finish and awkwardness of a studio work; the three monumental figures do not quite go together, and they are wringing out their attire in alarming proximity to a breaking wave. The smaller shore painting, and the two similarly sketchy scenes from 1869 (evidently once parts of a single long canvas), possess the unity of atmosphere James remarked upon and, at the edge of a dark, tumbling sea, a lovely brightness of activity, reflected and inverted in the saturated sand. We see people actually playing in the water and getting wet, rather than merely promenading as in the stately Eugène Boudin beach scenes of the same period.

HOMER *Beach Scene*, 1869
Oil on canvas, 11 × 9"
Carmen Thyssen-Bornemisza
Collection on loan at the Museo
Thyssen-Bornemisza, Madrid

Homer usually delivers a sense of genuine activity; if the maidens of his watercolors pose, they pose amid the tangible trappings of egg-gathering and apple-picking and haying, in barnyards and meadows unmistakably actual. *The Sick Chicken* (1874) is distinguished not only by its homely title but by the sun-and-shadow texture of the cluttered porch of a white-washed farmhouse. In *Milking Time* (1875) the composition is startlingly dominated by the broad planks of a fence; in *Crossing the Pasture* (1872) (page 59) the two boys are painted no more attentively than the silver pail and the branching switch that they carry as the tools of their chores. By the time of this masterly work, Homer had come into his full stabbing, flicking vocabulary of home-grown Impressionism. The alleged roughness of his technique appears to our post-Impressionist, post-Fauve eyes as precise enough and appropriately sensitive to the surprises of light and the complements of local color. His way of spattering his grassy foregrounds with dabs of wildflower, as in *Crossing the Pasture* and *The Two Guides* (1875), is exhilarating and probably more exact, botanically, than we know. The water-growth in *An Adirondack Lake* (1870) and the anatomy of its great fallen tree trunk are rendered with intensity but without, say, Church's virtuoso flourish. The acutely seen details do not disturb the tranquillity of the wide, mild vista and the modest figure of the guide: in this vast space he has his space, and no more.

Many of the mature Homer's faces are wooden or nonexistent; an animated individuality would have unbalanced the big picture. Not boys so much as boyishness forms the subject of the beautifully subdued *Seven Boys in a Dory* (1873) and the twice-painted *Snap the Whip*. Both ver-

HOMER
The Sick Chicken, 1874
Watercolor, gouache, and graphite on wove paper,
9¾ × 7¾"
National Gallery of Art, Washington, D.C. Collection of Mr. and Mrs. Paul Mellon

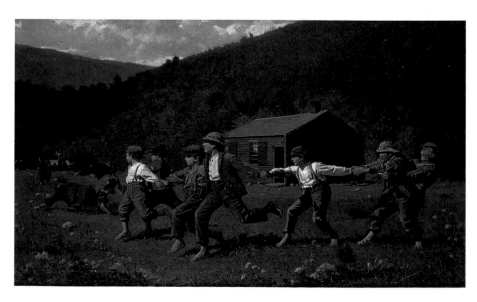

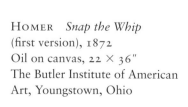

HOMER *Snap the Whip* (first version), 1872
Oil on canvas, 22 × 36"
The Butler Institute of American Art, Youngstown, Ohio

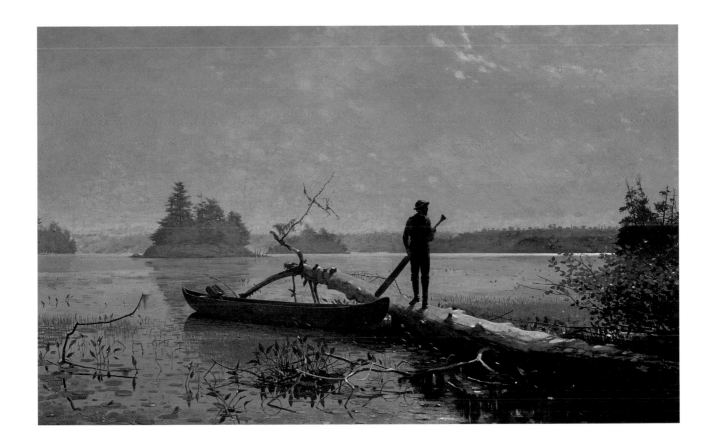

HOMER
An Adirondack Lake, 1870
Oil on canvas, 24¼ × 38¼"
Henry Art Gallery, University
Art Gallery, University of
Washington. Horace C. Henry
Collection

sions of *Snap the Whip* date from 1872; in the smaller and later, the mountainous setting has been painted over with a lower horizon and a rather generalized, fluffy-clouded sky. The barefoot boys in their frieze of frozen violence are unchanged, and, with the little red schoolhouse behind, this image flirts with a Currier-and-Ives sentimentalization of the nation's rural youth, in the ever more urbanized and industrialized post–Civil War United States. The viewer feels here, and before some of Homer's watercolors of pensive young shepherdesses, confronted with something remembered rather than observed. Considering the powerfully nostalgic effect that these country scenes painted in the 1870s make upon us now, relatively few feel calculated toward that effect; the resplendent, grave *Boys in a Pasture* (1874) and the slightly earlier *The Nooning* (with the lovable dog of the engraved version in *Harper's Weekly* eliminated) seem primarily studies in outdoor atmosphere, the sun golden on the curved straw hats that leave the little boys' faces in shadow. The shadows in Homer are as important as the highlights; an instinctive dry detach ment saved him from a theatrical doting. The much-reproduced *The New Novel* and *Blackboard* (both 1877) are tender, but from a tolerable dis tance. The watercolors (some with gouache) later in the decade, of bon-

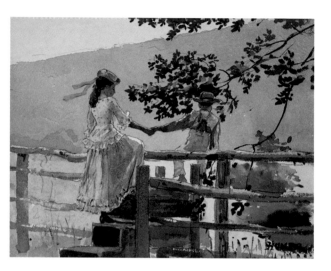

HOMER *On the Stile,* 1878. Watercolor, gouache, and graphite on wove paper, 8¹¹⁄₁₆ × 11⅛" National Gallery of Art, Washington, D.C. Collection of Mr. and Mrs. Paul Mellon

HOMER *Mending the Nets,* 1882. Watercolor and gouache over graphite, 27⅜ × 19¼" National Gallery of Art, Washington, D.C. Bequest of Julia B. Engel

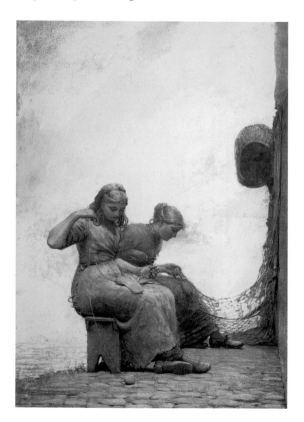

neted girls and a young couple maneuvering over a stile, manage to be primarily examples of charmingly proficient painting and only secondarily representations of a fabulous national innocence.

AND YET he did, by 1881, need new fields and a new tone. He moved to England for a year, settling in the fishing village of Cullercoats on the North Sea, and embarked upon ambitious watercolors and charcoal sketches of women on the beach, or mending nets, or watching from windswept quays. These heroic female figures, of a studied Milletesque monumentality, represent a step back into the traditional European art that he had so elegantly ignored; remote from the spiritual politics of America's wistful relation with its own landscape, they bring a neo-Grecian hauteur, a formidable coldness, into Homer's work. The sea, from now on, will exercise a pull that rarely lets go, whether manifested in the greenish waters of the Caribbean or in the storm-roiled waves of the North Atlantic.

In 1883 he moved his permanent residence to Prouts Neck, in Maine, and built a studio near a cliff, and turned his back on the civilized world, painting little but the sea and its human dependents and the watery wilderness of the Adirondacks. Of two spectacular large sea-scenes from the mid-1880s, *The Life Line* (1884) seems a bit melodramatic, monochromatic, and, in its death-defying coupling, ill-defined, but *Undertow* (1886), displayed in Washington with many preliminary sketches, is a masterpiece arising whole from all its labor of contrivance. It was based, evidently, on a successful rescue Homer witnessed in Atlantic City in 1883; if the two young women are not dead but unconscious it removes something of tragedy from the scene, but heightens the eroticism. Have any painted figures ever been more thoroughly wet than these? Homer hired two models, it was alleged by his biographer William Howe Downes, and on the roof of the building holding his

New York studio kept throwing water over the hapless females, "so that the effect of the sun on the wet clothing and the bare arms as well as the faces and hair should be entirely in accordance with the natural appearance of the group emerging from the surf." Even knowing this, we do not feel any absurdity, as we so often do when the conscientious research behind an anecdotal painting is revealed. Though *The Herring Net* (1885) and *Eight Bells* (1886), with their slickered male figures and salty, lightstruck atmospherics, make an easier entrance into our appreciation, *Undertow* has a willed magnificence and integrated brilliance that rank this artist—so modern in much of his work—alongside the most resolute of nineteenth-century academic masters. As a sensitive reviewer for the *Boston Evening Transcript* put it, "In it as many obstacles have been over come as usually are resisted by most painters in a lifetime." The *Transcript* reviewer found the subject unworthy of the labor, but the tableau of the two half-drowned, intertwined beauties with their pair of half-naked rescuers speaks in epic, mythic resonances. It is a Pre-Raphaelite vision, with muscles. The two rescuers avert their faces as if from a blinding mystery, the great Romantic mystery of life-in-death, as the two swooned (and hence sexually defenseless) females lock in a Sapphic embrace.

Homer's lifelong aesthetic drive toward a freighted simplicity and potent symbolism produced a rather ungainly series of watercolors of

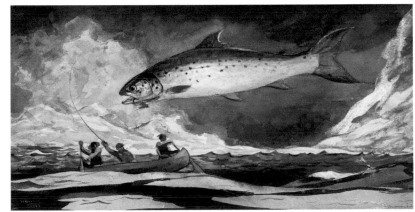

HOMER *A Good Pool, Saguenay River,* 1895 Watercolor on paper, 9¼ × 18⅞" Sterling and Francine Clark Art Institute, Williamstown, Massachusetts, 1955,1942

leaping trout from 1889 and the 1890s. The fish are unimpeachably painted, but unreal in their stilled motion and, taken with their backgrounds, optically disturbing. Human visual experience, achieved through constant unconscious focal readjustments, allows a painting a generous depth of field—that is, the background and foreground, within limits, can both appear sharp. But the literalism of an Audubon, with a fish suspended in midair inches back from the picture plane, uneasily consorts with Homer's "envelope of light and air." *A Good Pool, Saguenay River* (1895) copes with the problem by rendering the fisherman, at the distance of an unreeling line, in the watercolor equivalent of soft focus. The effect remains tricky and even kitschy amid the

more conventionally perspectived paintings of the Adirondacks hunting-and-fishing milieu, not to mention the dashing, crystalline watercolors done in the full sunlight of Florida, the Bahamas, and Bermuda.

Yet the impulse to *come closer,* to look the mystery square in the eye, is a brave one, and it finds fulfillment in the depopulated oil studies of rock and wave that Homer, working from sketches made on the weather-lashed rocks, was to execute in his Prouts Neck studio. The canvases are so celebrated as to be notorious, yet they crash upon us, in the exhibit's last rooms, with an undulled impact. *Northeaster* (1895) and *Maine Coast* (1896), both flinging up spume on the left of their rectangles and both permanently displayed at New York's Metropolitan Museum of Art, are the best-known. In the latter, the painter's attempt to render the creamy foam sliding and boiling through the dark rocks produces a veritable delirium of raw white, slathered on with a palette knife. The green foam-webbed slope of *Northeaster* classically captures the ocean's terrible weight and oblivious, tumultuous sliding; an early version depicted two men in foul-weather gear on the rocks, but, though this version won a gold medal in Philadelphia, five years later the men were painted out.

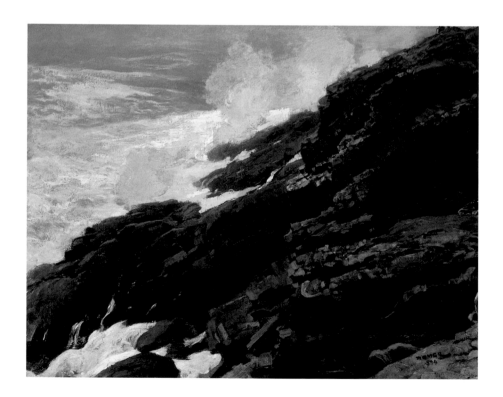

HOMER *High Cliff, Coast of Maine,* 1894
Oil on canvas, 30¼ × 38¼"
Smithsonian American Art Museum, Washington, D.C.

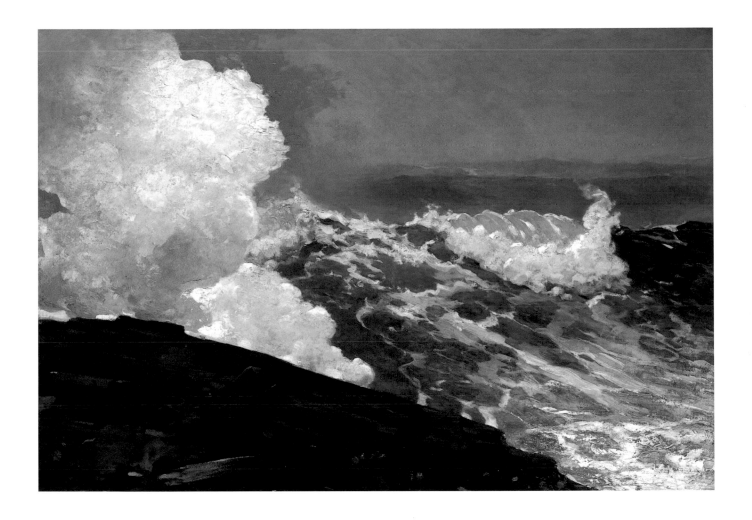

Nature without men was Homer's ultimate topic—the mindless roar at the heart of all, the "NO! in thunder" that Melville urged upon Hawthorne, the "All collapsed" which comes at the end of *Moby-Dick*. Homer's *Midnight, Wood Island Light* (1894) portrays a calmer oceanic mood, but the foreground of breaking wave and gleaming rock is rendered in surpassingly violent brushwork, as are the slant stone surfaces of that same year's *High Cliff, Coast of Maine*, broken into fragments of color as if by the weariless pummelling of the waves. So precociously liberated in technique, *High Cliff* went unsold, and Homer, as if defiantly, signed it twice.

His sense, as he aged toward death, of a primal conflict, a central heartlessness, led him into allegory. *The Gulf Stream* (1899) is famous but on the edge of the absurd, with its overkill of sharks and waterspout. *Kissing the Moon* (1904) shows a trompe-l'oeil playfulness, and a style of painting heavy seas that has become a bit automatic. Sunsets along the sea's

HOMER *Northeaster*, 1895
Oil on canvas, 34½ × 50″
The Metropolitan Museum of Art. Gift of George A. Hearn, 1910, 10.64.5

horizon became a theme. *A Summer Night* (1890), with its great flakes of moonlight, has the nocturnal mysticism of a Ryder. The falling ducks of *Right and Left* (1909) and the fox and crows of *Fox Hunt* (1893) are surreal apparitions in which this taciturn and outward-facing painter seems to ask, at last, for psychological interpretation. Expressive in more purely pictorial terms of his last mood are the hulking, bulbous cliffs of *Cape Trinity, Saguenay River* (1904–9) and the precise, brooding cannon and portal and turret of *Searchlight on Harbor Entrance, Santiago de Cuba* (1901), silhouetted against a sea both moonlit and searchlit and, for once, flat calm.

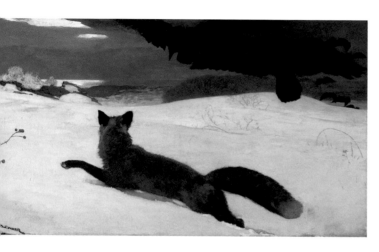

HOMER *Fox Hunt*, 1893
Oil on canvas, 38 × 68½"
Pennsylvania Academy of the
Fine Arts, Philadelphia. Joseph
E. Temple Fund, 1894.4

Whatever his mood and materials, Homer worked them toward a consummate expression. The leading popular illustrator of his time, the best American watercolorist of all time, and a virile and experimental oil-painter whose work travelled from the pedestrian to the expressionistic and near-abstract, he was supremely pragmatic. There is in him a stunning, almost mad absence of two major presences in modern art: theory, and cities. In this show one watercolor, *The Houses of Parliament* (1881), indicates an urban presence, a misty Thames view that makes us think of Whistler.

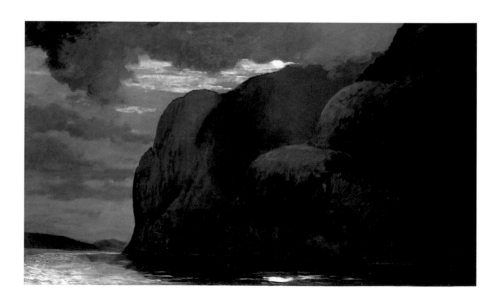

HOMER *Cape Trinity,
Saguenay River*, 1904–9
Oil on canvas, 28½ × 48"
Curtis Galleries, Minneapolis,
Minnesota

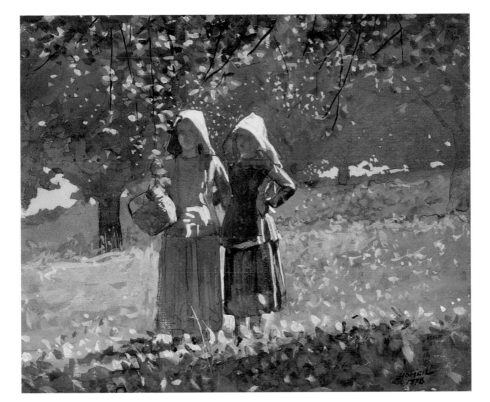

HOMER *Apple Picking*, 1878
Watercolor and gouache on
paper laid down on board,
7 × 8⅜″
Terra Foundation for American
Art, Chicago. Daniel J. Terra
Collection

Whistler, the expatriate who wasted much of his talent on theorizing and
posturing, was the anti-type of his reclusive contemporary. With Homer,
we feel no waste, just a succession of smaller or greater acts of possession,
from the dazzlingly deft and dappled glimpse of two bonneted apple-
pickers in *Apple Picking* (1878) to the oceanic appropriations of his later
oils. (Among his feats might be listed the best, least caricatural portraits
of postbellum African Americans.) He beautifully exploited his talent and
his days; a sense of strain and extravagance attends only the massive
exclusion, from his art and, increasingly, from his life, of what might be
called European civilization. To a degree no longer possible, he lived as
the New World's new man—self-ruled, resourceful, and beginning always
afresh.

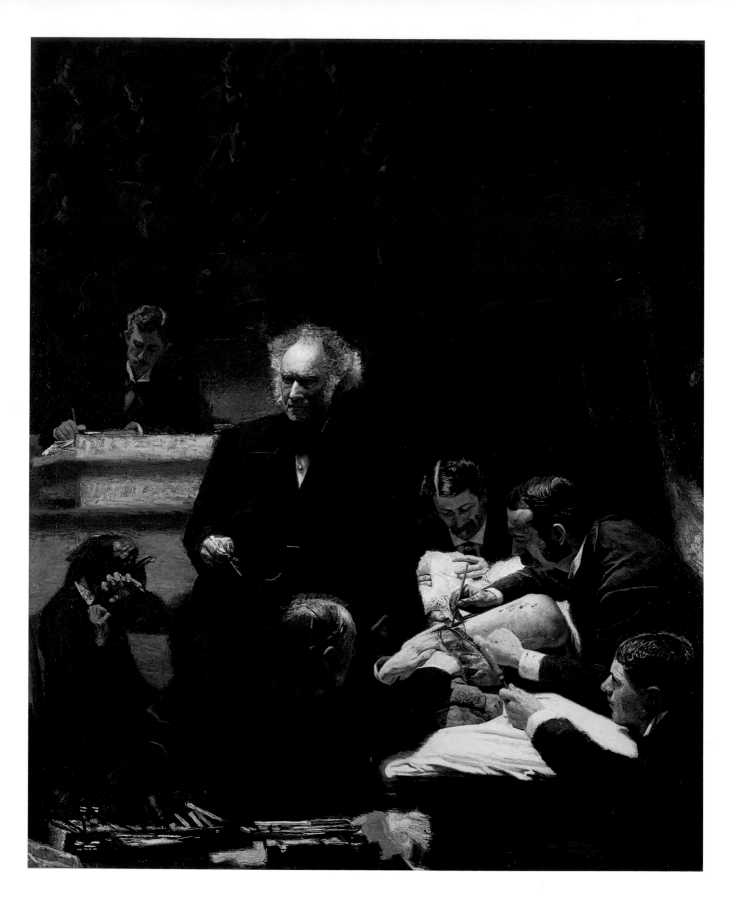

The Ache in Eakins

AT TIMES in his letters Thomas Eakins sounds as cranky and as ingenuously folksy as Ezra Pound. Writing to his father from Paris in 1868, the twenty-three-year-old art student proclaimed, "The big artist does not sit down monkey like & copy a coal scuttle or an ugly old woman like some Dutch painters have done nor a dungpile, but he keeps a sharp eye on Nature & steals her tools. He learns what she does with light the big tool & then color then form and appropriates them to his own use." Perhaps "light the big tool & then color then form" is more like Hemingway. Eakins has the reformist impatience, in any case, of an American determined to make things new, to clear out the antique clutter. If he went to Greece to live, he goes on to his father, "I could not paint a Greek subject for my head would be full of classics the nasty besmeared wooden hard gloomy tragic figures of the great French school of the last few centuries & Ingres & the Greek letters I learned at the High School with old Heaverstick & my mud marks of the antique statues." Yet he was in Paris, paradoxically, studying at the École des Beaux-Arts under Jean-Léon Gérôme, an aesthetically conservative painter of exotic tableaux in a painstaking literalist style. In Eakins's letters to his father there is never an inkling that in these years (1866–70) of his Parisian apprenticeship Impressionism is coming to birth, as Courbet and Manet challenge the marmoreal conventions of French academic painting. The young American's account of the Exposition Universelle of 1867 does not mention the rejection of these two painters from the exposition, or the display of their works in a nearby building. He in fact mentions no art at the exposition, but waxes enthusiastic about the machinery, especially the American machinery—the locomotive ("I can't tell you how mean the best English French and Belgian ones are alongside of it"), the soda-water fountains, and the sewing machines ("No people will think of competing with the Americans for sewing machines").

(Opposite)
THOMAS EAKINS
Portrait of Dr. Gross
(The Gross Clinic), 1875
Oil on canvas, 96 × 78″
Jefferson Medical College of
Thomas Jefferson University,
Philadelphia

Eakins was enthusiastic about machinery and physical science to a degree that few artists since Leonardo could match. In the Central High School of Philadelphia—a venerable institution with a curriculum and faculty comparable to that of many colleges—he scored better in science and mathematics than in history and English. The art course, which he pursued for four years, invariably receiving the grade of 100, included mechanical drawing and the study of perspective. A number of his mechanical drawings have been preserved; the 1993 Eakins retrospective exhibit at the Smithsonian Institution included, as its oldest item, his meticulous student *Perspective of a Lathe* (1860). The aesthetic theo-

EAKINS
Perspective of a Lathe, 1860
Pen, ink, and watercolor on paper, 16⅝ × 22″
Hirshhorn Museum and Sculpture Garden, Smithsonian Institution. Gift of Joseph H. Hirshhorn, 1966

ries he confided to his father are phrased in terms of manufacture, the "big" painter conceived as a manufacturer rivalling Nature, whose tools are stolen and methods imitated: "When they [the big artists] made an unnatural thing they made it as Nature would have made it had she made it and thus they are really closer to Nature than the coal scuttle men painters ever suspect." If this has the pugnacious child's-primer rhythms of Gertrude Stein, the next sentence is pure Hemingway: "In a big picture you can see what o'clock it is afternoon or morning if it's hot or cold winter or summer and what kind of people are there and what they are doing and why they are doing it." Eakins worked hard at the École for Gérôme and his other masters, disapproving of the friv-

olous French students; after three years he felt, he wrote his father, "I am as strong as any of Gérôme's pupils and I have nothing now to gain by remaining. . . . I am certain now of one thing that is to paint what I can see before me better than the namby pamby fashion painters." He travelled to Spain, and at the Prado discovered Velázquez and Ribera. It was a revelation: "Now I have seen what I always thought ought to have been done & what did not seem to me impossible. . . . Spanish work [is] so good so strong so reasonable so free from every affectation. It stands out like nature itself. . . . It has given me more courage than anything else ever could."

It is surprising, then, that, upon returning to the bustling post-war

United States in 1870, his head brimming with imperial intentions to be "big" and "strong," Eakins should have turned to a subject as lightweight, so to speak, as sculling, hitherto confined to magazine art and Currier-and-Ives lithographs. Rowing—"scull" originally meant "oar" and came to signify "a racing shell propelled by one or two persons using sculls"—had become a professional sport in the English-speaking countries as well as a socially fashionable activity for young gentlemen. The Schuylkill River in Philadelphia was lined with the boathouses of rowing clubs, and Eakins, always a keen outdoorsman, belonged to a club, probably the same one, the Pennsylvania Barge Club, to which his boyhood friend Max Schmitt belonged. Schmitt in 1867 had won the first single-scull championship of the Schuylkill, and Eakins's painting of him in his racing shell was hung at the Union League of Philadelphia for three days in 1871. Eakins followed this masterly canvas with three oils of the Biglin brothers, professional racers from New York; an oil and two watercolors of John Biglin alone; a painting of the Shreiber brothers rowing; and an oil of four rowers called *Oarsmen on the Schuylkill* (c. 1874). All nine of these finished works, with a number of preliminary oil sketches and pencil studies of perspectives and details, are present in a show on view in the East Wing of the National Gallery through the summer of 1996, accompanied by an attractively slim yet informative catalogue by Helen A. Cooper, containing essays on not only the painter and the sport of rowing but on perspective (by Amy B. Werbel), microscopic analysis of the paint layers (by Christina Currie), and concepts of Victorian manhood (by Martin A. Berger). With a scientific thoroughness that Eakins would have admired, every extant scrap of his production relating to this rowing series has been assembled, from as far away as the Portland Art Museum in Oregon and as close at hand as Upperville, Virginia. Rowing—which offered the painter a curious opportunity to combine landscape, portraiture, and studies of the nearly nude body—preoccupied Eakins for over three years, and occasioned his first concerted effort to perform as a "big artist."

The first effort was perhaps the best; it is one of Eakins's most reproduced paintings. Max Schmitt glides at a gentle diagonal across the watery foreground, the two trailing oars held lightly in his left hand. In the middle background Eakins himself, in a boat lettered with his name and the date 1871, pulls vigorously away from the viewer, toward the far bank of the Schuylkill, which is crossed by several finely detailed bridges.

The painting is startlingly fresh, cool, and bleak, from a young painter immersed for over three years in European influences. As Lloyd Goodrich says in his two-volume *Thomas Eakins,* "The light and atmosphere were those of America: clear air, strong sunlight, high remote sky, brown trees and grass—things Eakins had never seen in Gérôme's class or in the Prado. There was no trace of a derived style. An original mind was dealing directly with actualities. The vision was photographically exact, crystal-clear." Too clear, perhaps, or too indiscriminately clear; the linear precision of the iron bridges, the skimpily leafed trees on the left, and the shell and oars appear etched rather than emergent through an atmosphere, even on this dry, sunny day of high cirrus. Passages of freer painting, especially the loosely daubed cattails and the stone house on the left but also the very nice line of trees on the right, moderate the presiding mood of mechanical drawing, of a rather relentless literalism that jibes with Schmitt's glowering, intent facial expression. The river, tonally, does not recede, presenting the same lifeless gray near and far, a depthless plane upon which Schmitt's dragging oars inscribe parallel lines and Eakins's oars, rising and falling, leave methodically spaced patches of disturbed water. The canvas is haunting—an evocation of the democracy's idyllic, isolating spaciousness, present even in the midst of a great Eastern city.

EAKINS *The Champion Single Sculls (Max Schmitt in a Single Scull),* 1871
Oil on canvas, 32¼ × 46¼"
The Metropolitan Museum of Art, New York. Purchase, The Alfred N. Punnett Endowment Fund and George D. Pratt Gift, 1934, 34.92

Eakins's next rowing picture, *The Pair-Oared Shell* (1872), takes a more sculptural approach; the shell with its two occupants glides through the dark reflection of a massive pier whose shadow-side divides the canvas vertically in half. The low sunlight is such that it strikes the slender golden top of the cedar shell and the sparkling far side of the pier, while adding bright edges to the male figures. Two large perspective drawings are also displayed; they locate the craft on a precise receding grid and detail the pier stone by stone—though in the painting the foremost seams of the masonry end all but swallowed in shade. The white sky and a dull green mass of trees are quite roughly painted, while the rippled water is worked out by means of an analysis of each ripple into three reflecting planes. In sum, the water looks much like brown corduroy. Brown—as in Andrew Wyeth's landscapes from this same southeastern Pennsylvania—dominates everything; in the overall fuscousness the most vivid details are the red outrigger rods that support the oars. The painting was heavily premeditated; Eakins confided how he "made a little boat out of a cigar box and rag figures, with red and white shirts . . . blue ribbons around the head, and I put them out into the sunlight on the roof and painted them, and tried to get the true tones." But he was no slave to observation alone. He would tell his students, the wall captions reveal, "Strain your brain more than your eye," and "You can copy a thing to a certain limit. Then you must use the intellect." Eakins is never unthinking; this is his strength and his weakness. Our sense of an intelligence exerted is not always balanced by the sense of a moment captured. *The Pair-Oared Shell* is muf-

(Left)
EAKINS
Perspective drawing for *The Pair-Oared Shell*, c. 1872
Pencil, ink, and wash on paper, 31 1/16 × 47 1/8"
Philadelphia Museum of Art. Purchased with the Thomas Skelton Harrison Fund, 1944

(Right)
EAKINS
The Pair-Oared Shell, 1872
Oil on canvas, 24 × 36"
Philadelphia Museum of Art. Gift of Mrs. Thomas Eakins and Miss Mary Adeline Williams, 1929

fled and murky, for all its studied grandeur; a rapid oil sketch that mirrors the composition, *The Oarsmen* (c. 1873), is much more persuasive and energetic in its juxtaposition of sun and shadow, monumental bulk and skimming lightness.

The Biglin Brothers Racing (1872) and *The Biglin Brothers Turning the Stake* (1873) depict an actual event, a race, watched by an estimated thirty thousand people on shore, in which the Biglins defeated a pair of challengers from Pittsburgh. As in *The Pair-Oared Shell*, some painstaking technical studies (detailing the outriggers down to the nuts and bolts) seem wasted within the somber dullness of the painting. In *The Biglin Brothers Racing*, though the puffy sky declares fair weather, sunlight seems to be falling only on the Biglin brothers and the open blade of a single poised oar. Close examination shows a treatment of distant figures and carriage on the shore that would do credit to a miniaturist, and an unpleasant, scrabbly rendering of the two subjects, including the use of the pointed end of the brush for some highlights. The details are not very telling, within a flatly horizontal composition established by the shoreline and the long shell, which extends beyond both sides of the canvas. Placing the loser's pointed prow along the lower edge of the canvas is a witty touch, but overlookable.

The next year's painting is much superior as a visual drama. Silhouetted against a sheet of colorless, glaring water, the brothers tensely negotiate the maneuver of turning the race stake; their opponents, in white shirts and red headkerchiefs (though in fact these men, named Coulter and Cavitt, racily rowed bare-chested and with bare, aerodynamically close-shaven heads, in a drenching rain), tardily approach their stake, while a tiny figure in a third scull, whom the catalogue identifies as Eakins himself, raises an arm in excitement. The inevitably horizontal composition is varied by the oblique angles of the maneuver, and the contrasting bands of light and shadow work to set off the action and establish depth. It is a masterly genre painting, aloof but empathetic, aristocratic and taut in its oblique intersections of slender boats, oars, and a flagpole. The critic Mariana Griswold Van Rensselaer, seeing the painting in 1880, said that no one could match Eakins for "adopting the matter-of-fact elements of our surroundings to artistic use." The matter-of-fact eye, as Eakins turned thirty, preferred to dwell on things above all; in 1874 he painted, in his portrait *Professor Benjamin Howard Rand*, a brass microscope astounding in its vividness, outshining the nearby

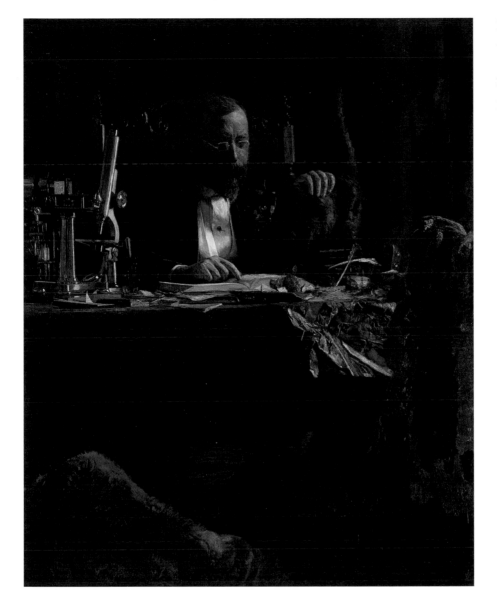

EAKINS *Professor Benjamin Howard Rand*, 1874
Oil on canvas, 60 × 48″
Jefferson Medical College of Thomas Jefferson University, Philadelphia

human face as it sinks back into shadow. Eakins here, and in his bridge supports and scull rigging, his knife-sharp lines and pinprick transfers, aspires, it seems, to duplicate the object in painted perspective rather than provide a visual sensation. The art of painting in the later nineteenth century, with photography thriving and empirical science philosophically dominant, was groping for its assignment. Gérôme deployed his meticulous studio methods, by and large, in the reconstruction of an exotic past

or a remote geography; the same analytical approach to the immediate environment threatens to embalm the living. Even the medium of watercolor, so fluid and notational for Winslow Homer, in Eakins becomes dry, pointillist, and static.

John Biglin in a Single Scull is displayed in four versions: a pencil, ink, and wash study on a receding grid, with notations in Eakins's Beaux-Arts French (c. 1873); two nearly identical watercolors, also from 1873; and an oil close-up of Biglin, in the same pose but with the boat cropped and the sky cleared of clouds, dated 1874, although an entry in Eakins's journal suggests that this oil was a study preceding the watercolors. Another watercolor, dating from 1872 and now lost, was sent to Gérôme in Paris; he complimented Eakins on "the construction and the building up combined with the honesty which has presided over this work," but thought the rower's pose lacked movement. Biglin does seem quietly brooding, though his oar is poised for a mighty pull; the most interesting passage of the watercolors occurs in the foreground, the skin of the river stippled and striped with brown reflections of the shell. The figure itself seems suitable to decorate a cigar box—the heroic rower as if in oval inset, with touches of gilt. Eakins himself declined to exhibit "those Biglin ones" at the National Academy Annual in 1875, because, he wrote Earl Shinn, a fellow–Gérôme student and now an art critic, "They are clumsy & although pretty well drawn are wanting in distance & some other qualities." Instead, he submitted a "little picture . . . better than those," which was *The Schreiber Brothers* (1874).

The Shreibers were amateur recreational rowers, and their awkwardness with the oars is faithfully rendered, along with the linear anatomy of a racing shell. The composition is familiar—the slightly diagonal glide, the shadow of the looming stone pier—but the painting represents an atmospheric advance. Except for the red outrigger supports, which glow like neon tubes, sunlight is allowed to shape the prospect, which opens on the right into a gleaming liquid plane and a space promising to release the rowers from the oppressive shadow of the pier, in which a party of fishermen are barely visible. "The picture don't please me altogether," Eakins wrote to Shinn. "I had it too long about I guess. . . . Anyhow I am tired of it. I hope it will sell and I'll never see it again."

His last rowing picture, *Oarsmen on the Schuylkill* (c. 1874), does not quite dispel an aura of boredom with the subject of sculling, though Eakins returns, with four individualized men, to the same sunlit, still

river which supported Max Schmitt in his single scull. Schmitt is among the four, still frowning, and not making much speed, because for the first time in this series the scullers cast distinct reflections. Though two pencil perspective studies show Eakins to be as diligent as ever, the boat doesn't fit the river, whose featureless wooded bank appears about to bump the prow. None of the man-made landmarks present in *The Champion Single Sculls* are visible here; the undershirted men seem rather comically abandoned in a wilderness, with their burnsides and tight dark trousers. An oil sketch shows a solitary Schmitt to have been Eakins's first thought; turning him into a foursome produced diminished psychological returns. Yet the manner of painting is freer, less scratchy, with a lighter palette, reminiscent tonally of the young Degas, while the whole feels, like some Manets, pasted together. The cumulus cloud is not convincing. The river

EAKINS *John Biglin in a Single Scull,* 1873
Watercolor on paper, 16⅞ × 23″
Yale University Art Gallery. Gift of Paul Mellon, B.A. 1929, in honor of Jules D. Prown, the first Director of the Yale Center for British Art

landscape is minimally indicated, and the blue-gray water looks like paper. His three-year exercise in sculling concluded, Eakins will turn increasingly to indoor portraits.

An odd melancholy in these moody, scrupulous canvases asks for comment. There is not a trace of a smile, though the milieu is recreational. All is earnest effort. The sunlight falls like moonlight. It is as if the painter, approaching thirty, foresaw his disappointing future of mixed reviews and grudging popular recognition. Conservative in technique, he was confrontational in his subject matter; the bloody tableau of his *Portrait of Dr. Gross* (1875) (page 70) and the flaunting nudity of *William Rush Carving His Allegorical Figure of the Schuylkill River* (1876–77) and *The Swimming Hole* (c. 1883–85) were sensational but humorless. To an age ever more at home with bright Impressionistic canvases, Eakins was an uncomfortable painter. Discomfort and a grieving inwardness distinguish the best of his many portraits— *Amelia Van Buren* (c. 1891), *Edith Mahon* (1904), and his *Self-Portrait* of 1902, which tames down a more truculent and even satanic earlier version. Ironically, this loyal pupil of French academism alienated the academies of his native land. A charismatic and enthusiastic teacher at the Pennsylvania Academy, he offended Philadelphia propriety by removing the loincloth from a male model in a class that included female students, and was dismissed in 1886. For a similar gesture he lost his position at the Drexel Institute in 1895, after a number of female sitters complained of what would now be called sexual harassment—"uncomfortable sexual advances or posing demands," as John Wilmerding puts it in his catalogue for the Smithsonian retrospective. Eakins's canvases do tease the limits of decency in his time: his portrait of Dr. Gross has the viewer looking directly up the rectum of the naked patient; his other great surgical tableau, *The Agnew Clinic* (1899), depicts a mastectomy upon a sleeping beauty; and *William Rush and His Model* (1907–8) presents, in full frontal nudity, that traditionally evaded reality, the female pubic bush. Were these calculated affronts committed in a spirit of sexual aggression or of scientific truthfulness? He defended himself by appealing to the latter, and to the need for artists to know their anatomy. Nudity and verity were linked with an unusual closeness in his mind. His many

EAKINS *Amelia Van Buren,* c. 1891
Oil on canvas, 45 × 32″
The Phillips Collection, Washington, D.C.

photographs of himself and students of both sexes naked have the dreamy ripeness of forbidden fruit. By no accident did he strike up a cherished friendship with another maligned proclaimer of the full human truth, Walt Whitman.

Yet Whitman had a great subject: New York City, melting pot of an immigrant democracy. Eakins had, instead, the troubled faces of the Philadelphia gentry. He himself, one can say, was troubled, and his brushwork—unlike that of his contemporary John Singer Sargent or his idol Velázquez—has little joyful exuberance to it. Painting itself never became, but for the briefest passages, his subject. In his last years, he saw his reputation rise from its near-ruin, and by now the sexual tension in his work seems merely factual and alert; it makes him modern, conservative though his technique remained. Like Henry Adams, he feels like a man born out of his time, with all the gifts except a confident pre-modern humanism. Whatever the reasons, there was more conflict in his career and his psyche than there should have been, given his initial talent and dedication; the cloud over his dispassionate realism can be felt even in this inaugural series, of young men launched upon the Schuylkill.

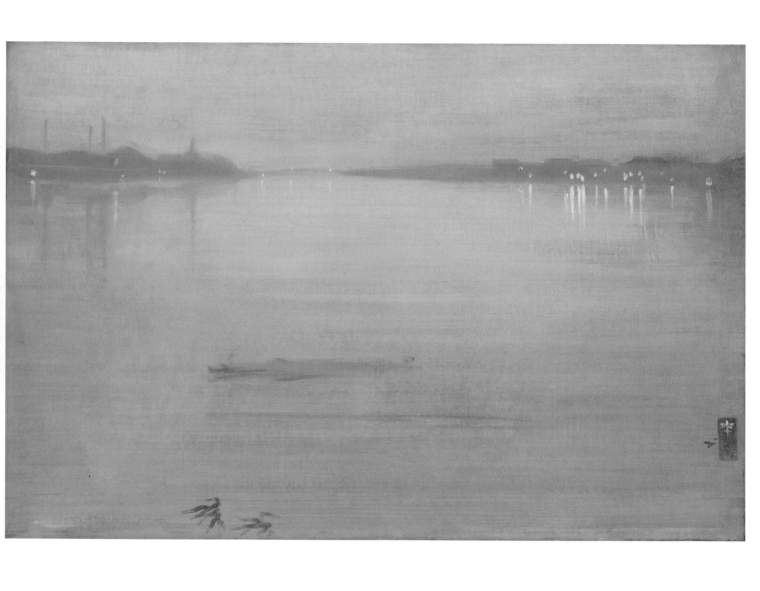

Whistler in the Dark

AS AN EXPATRIATE, James McNeill Whistler was the pure thing: born in Lowell, Massachusetts, in 1834, and educated (somewhat) at West Point, he left America at the age of twenty-one and never returned. Not once: talk of a lecture tour like Oscar Wilde's came to nothing. Not for Whistler Henry James's bemused resurveyings of the American scene, or John Singer Sargent's enthusiastic discovery, late in life, of the American West. If Whistler's ghost, therefore, is able to squint down through its monocle into the sunny cauldron of summertime Washington, D.C., with its monumental glare and mobs of bare-kneed, T-shirted tourists, it must snort in astonishment to see the butterfly-man at the center of the revels—the artistic toast of the capital, this season of 1995.

He was here before, actually, in the flesh: in November of 1854, after his discharge from West Point for deficiency in chemistry, he was appointed to a post in the drawing division of the U.S. Coast and Geodetic Survey, etching maps and plans. He lasted only a few months, and by the fall of 1855 had embarked for the Old World. And Whistler's work is always at the Freer Gallery of Art, mixed in with the Orientalia collected by his patron Charles Freer, who, after making the artist's acquaintance in 1890, acquired a number of his better paintings as well as bought and reassembled the sumptuous, claustrophobic Peacock Room, a dining room extensively and extravagantly decorated by Whistler for another patron, Frederick R. Leyland. Leyland enlisted himself in the ample ranks of Whistler's enemies by balking at the price (two thousand guineas) that the artist asked for his proliferating decorations; he had stretched into nearly a year's labor what Leyland had expected, a letter from him states, to be "the work of comparatively few days," and Whistler may have been dabbling as well at Leyland's wife, Frances, who later confided to a friend that she wished she had married him. For this

JAMES McNEILL WHISTLER
Whistler's Butterfly (detail)
Pencil on cardboard,
4⁹⁄₁₆ × 4⁷⁄₁₆″
Freer Gallery of Art,
Smithsonian Institution,
Washington, D.C. Gift of
Charles Lang Freer, FI905.326

(Opposite)
WHISTLER
*Nocturne: Blue and Silver—
Cremorne Lights*, 1872
Oil on canvas, 19¾ × 29¼″
Tate Gallery, London

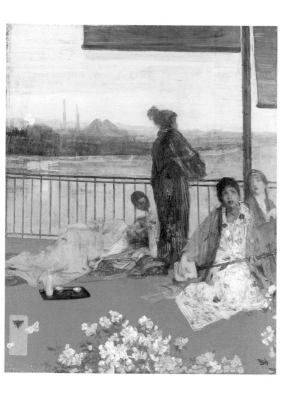

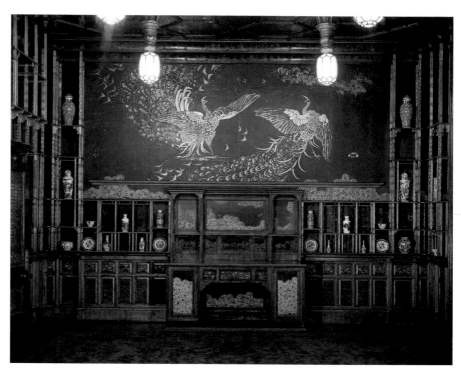

(Left)
WHISTLER
Variations in Flesh Colour and Green: The Balcony, 1864–70 (additions 1870–79)
Oil on wood panel, 24¼ × 19⅛"
Freer Gallery of Art, Smithsonian Institution, Washington, D.C. Gift of Charles Lang Freer, F1892.23ab

Right)
WHISTLER
Harmony in Blue and Gold: The Peacock Room (detail showing south wall) 1876–77
Oil and gold leaf on canvas, leather, and wood.
Freer Gallery of Art, Smithsonian Institution, Washington, D.C. Gift of Charles Lang Freer, F1904.61

Whistler summer, the Freer has set up a pleasing small special exhibition, *Whistler and Japan,* displaying Japanese prints and objects which the artist, a collector since 1863, had owned. Some of the prints were incorporated in his painting *Caprice in Purple and Gold: The Golden Screen* (1864–65), showing an Occidental model posed and costumed as a Japanese courtesan. *Variations in Flesh Colour and Green: The Balcony* (1864–70) contains the same uneasy, theatrical blend of model and kimono; in echo of Hiroshige's scenes of the Edo pleasure district, four models are disposed, with a splash of pale blossoms and a Whistler butterfly in a cartouche, upon a flat gray balcony floor innocent of perspective, while the Thames and the smoky industrial profile of South London recede into the incongruous background. These paintings, like Monet's *La Japonaise* in the next decade, push *japonisme* at us, but without Monet's overt humor.

A less aggressive *japonisme* shows up in Whistler's nocturnal landscapes of the 1870s, which, whether located in Valparaiso or Bognor or Chelsea—"nocturnes" all at the Freer—slip away, under cover of night, from perspective altogether, all parts of the canvas in the general obscurity seeming equally close to the eye. Japanese prints and calligraphy and

decorative objects reinforced, one feels, a predisposition of Whistler's toward the gestural and the delicate, toward blank spaces and a quiet, restricted palette. Placed among the Western painter's various, frequently sketchy work at the Freer, the woodblock prints of Hiroshige and Utamaro and Hokosai make little islands of settled convention and mannerly confidence, at a far pole from Whistler's shifting and—in the friezelike *Symphony* series—perilously flimsy experimentation.

Some blocks to the north, at the National Portrait Gallery, can be found an entertaining array of depictions *of* Whistler, who was, we are told, "the single most portrayed artist prior to the twentieth century." The artist as self-dramatizer dates back at least to the sonnets of Michelangelo, but dainty, peppery Whistler was an early modern master of projecting the artist's own image. The butterfly signature first appeared in the late 1860s. The monocle, the sublabial facial tuft, the upstanding little lock of prematurely white hair, and the languidly held cigarette were all in place by the mid-1870s; these dashing features made him prey to caricaturists, easily identifiable as a round-headed maulstick by Alfred Bryan in 1884, and as a faun by Aubrey Beardsley in the early 1890s. One wonders if so readily purveyed an image, and such publicity-getting incidents as the dispute with Leyland, the onstage caricature of Whistler as Pygmalion Flippit in *The Grasshopper,* and his 1878 lawsuit for libel against John Ruskin, did not distract the public from Whistler's serious work and get the critics' backs up.

Ruskin's provocation is commonly supposed to be his having described Whistler as, in *Nocturne in Black and Gold: The Falling Rocket,* "flinging a pot of paint in the public's face." But the more offensive language came earlier in the sentence: "I have seen, and heard, much of cockney impudence before now; but never expected to hear a coxcomb ask two hundred guineas for flinging a pot of paint in the public's face." The language is snobbish and overwrought—Whistler was three thousand miles away from being a London-born cockney—and Ruskin at this point in his life was too mentally unstable to appear in court for his own defense. It was an unfortunate twist that the champion of Turner, the one English precedent for Whistler's daring renderings of

(Left)
ALFRED BRYAN *Whistler at the Top of a Maulstick,* 1884. Wood engraving, from the journal *The Christmas Number of the World,* London, November 27, 1884

(Right)
AUBREY BEARDSLEY *Whistler as Pan,* 1893. Lithograph, 7 × 2¹⁄₁₆″
Private collection

pure light and appearance, should have been so blind to the merits of the younger artist's elegant canvas, and so savage in denunciation, asserting that the gallery "ought not to have admitted works . . . in which the ill-educated conceit of the artist so nearly approached the aspect of wilful imposture." Was Ruskin reviewing the paintings or Whistler's insistent, impudent image?

Among the hundred or so representations at the National Gallery, beginning with photographs and watercolors done when Whistler was around ten years old, few break through the image to give us a sense of the man. Henri Fantin-Latour's oil portrait in 1865 caught the thoughtful, pale face before the arrogant mask was quite locked on; Charles Abel Corwin in 1880 rendered in a rapid monotype a grizzled, weary profile; and Mortimer Menpes, Whistler's assistant and pupil throughout the 1880s, shows us in a series of skillful drypoint etchings a somewhat bulkier Whistler than we are used to, a man not only witty but merry. The rather primitive portraits by Whistler's pupil Walter Greaves are pure icon, over a hundred of them, many turned out long after Greaves and Whistler had parted company; four of them depict Whistler painting "Whistler's Mother" on the historically fabulous level of Washington crossing the Delaware standing in the longboat's prow. William Merritt Chase's well-known heroic portrait of 1885 (in the show's catalogue but not the show), executed with an imitation of Whistler's style more vigorous than the original, is also fundamentally iconic: Whistler as dandy, in the thin but potent line of somewhat wacky American artist-dandies that runs through Whistler from Poe to Pound. Like Wilde before his disgrace, Whistler came to symbolize the Aesthete, reassuringly eccentric and laughably vain. Only the photographs give us Whistler aging: a plucky small man whose income never matched his notoriety, whose work was dogged by harsh dismissals, and whose health ever since childhood attacks of rheumatic fever had been less than robust.

THE CENTER RING of the Whistler circus is to be found between the Freer and the Portrait Gallery, in the National Gallery, whose West Wing will house until mid-August over two hundred works previously exhibited at the Tate in London and the Musée d'Orsay in Paris. The clattering herds, many of them adolescents crazed by hours spent cooped up in sightseeing buses, pour through, pausing only to stand for a tittering moment of recognition before *Arrangement in Grey and Black: Portrait*

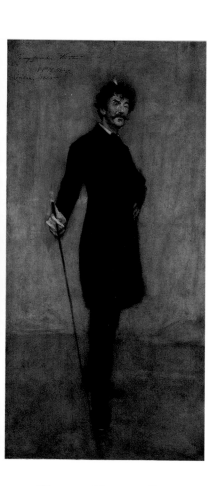

WILLIAM MERRITT CHASE
James Abbott McNeill Whistler,
1885
Oil on canvas, 74⅛ × 36¼"
The Metropolitan Museum of
Art, New York. Bequest of
William H. Walker, 1918,
18.22.2

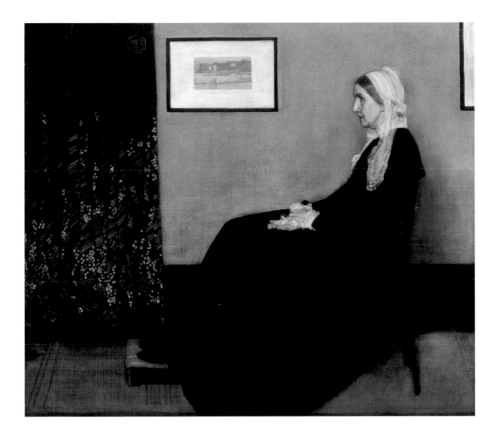

WHISTLER *Arrangement in Grey and Black: Portrait of the Artist's Mother,* 1871
Oil on canvas, 56¾ × 64″
Musée d'Orsay, Paris

of the Painter's Mother (1871), the most famous American painting in the world and one of the select company of works of art—others are the *Mona Lisa,* the Venus de Milo, and Munch's *The Scream*—whose celebrity can be said to be blinding. If we could see it, "Whistler's Mother" would reveal itself as in truth one of his better paintings, a product of the period when Whistler's aversion to color and pigment still left him some room for maneuver. Though not as unified in mood as its thoroughly subdued companion, *Arrangement in Grey and Black, No. 2: Portrait of Thomas Carlyle* (1872–73), the portrait of his mother strikes a smart balance of blacks and whites, presents in profile a real face, both stony and ruddy, and has some passages of brushwork, such as the flurry of lace and linen in the sitter's lap, around her hands, not unworthy of Whistler's idol Velázquez. The comedy in the stern pose—the cameo of a mother primly refusing to look at her son—may be what has caught the popular imagination, but the formal refinement of the large canvas is no doubt what led the Musée de Luxembourg to purchase it, for a modest

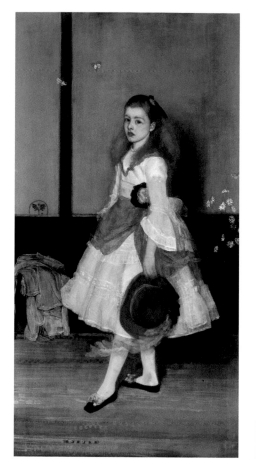
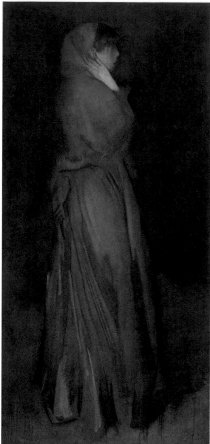
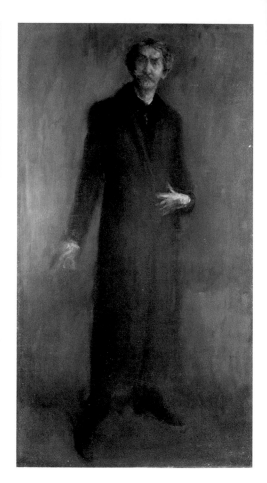

(Left)
WHISTLER *Harmony in Grey
and Green: Miss Cicely
Alexander,* 1872–74
Oil on canvas, 74⅞ × 38½″
Tate Gallery, London

(Middle)
WHISTLER
*Arrangement in Yellow and
Grey: Effie Deans,* 1876–78
Oil on canvas, 76¾ × 36⅝″
Rijksmuseum, Amsterdam

(Right)
WHISTLER
Brown and Gold, 1895–1900
Oil on canvas, 37¾ × 20¼″
Hunterian Art Gallery,
University of Glasgow. Birnie
Philip Bequest

four thousand francs, in 1891. Earlier that year the portrait of Carlyle
had been sold to the Corporation of Glasgow, Whistler's first sale to
a public collection. Compared with the tense, vigilant mother, Carlyle
seems sunken, in mien and in overall tone; Whistler's fondness for low-
keyed lighting and shadowy monotone met no spark of resistance in the
melancholy old philosopher.

The portrait of a patron's young daughter, *Harmony in Grey and
Green: Miss Cicely Alexander* (1872–74), foundered on a subject's sup-
pressed liveliness: over seventy sessions of several hours each often
reduced the child to tears and produced an expression, on the over-
worked yet not quite integrated face, of plain sulkiness. The fabrics in the
picture, however, are masterly, from the semi-transparency of the dotted
muslin dress to the texture of the felt hat she holds, with its diaphanous
feather, and the dashingly scrubbed-in coat tossed on a bench in the back-
ground. In a later large portrait, *Arrangement in Yellow and Grey: Effie
Deans* (1876–78), Whistler's attention has quite wandered away from the

face of the model (his mistress, the long-suffering Maud Franklin, costumed as Sir Walter Scott's Effie Deans) and searched out the dramatic folds of her long skirt. Absorbed in the nuances of color to be uncovered in the dull gray-green cloth, he approaches the blocky, cool tonal juxtapositions of Cézanne. Whistler resembled Cézanne in little except their indifference to humanity, whether found in individual physiognomy or in the nude body. To think of Whistler's nudes in relation to Degas's, or his faces in relation to Sargent's, is to confront an almost frightening lack of interest, of that excitement which generates specificity. In his *Arrangement in Black, No. 2: Portrait of Mrs. Louis Huth* (1872–73), the head is a tiny capstone to a slag flow of black on black; the portrait of the actor Henry Irving (1876) and of himself full-length (1895–1900) both struggle to emerge from the overall yellow sickliness of the canvas. All marks of individuation have been achieved, one feels, in spite of the painter's quest for an impersonal perfection. Whistler taxed his sitters with many long sittings and frequently wiped away large sections of the canvas to make a fresh start.

As to his few nudes, the late pencil-and-watercolor *Dancing Girl* (1885–90) makes a hefty, brown, ambiguously veiled impression of honest flesh, and the early etching *Venus* (1859) is well observed; but in the Freer Gallery's *Venus* (c. 1868) almost everything that makes a woman's body female has been eliminated. Also at the Freer, *Venus Rising from the Sea* (1869–70) is vague as well, but more suggestively, with the lambency of calendar art, and *Harmony in Blue and Gold: The Little Blue Girl* (1894–1903) shows a wingless fairy, her body as slender as a dragonfly's, with tapering, wispy legs never designed to bear weight. Though Whistler's busy love life testifies to a healthy interest in women, his concept of beauty did not alight on their flesh.

Well, what *did* interest Whistler? The first room of the National Gallery exhibit contains one ambitious and complex canvas, *Wapping* (1860–64), which aims at greatness. Three foreground figures sit at a table before a complex harbor scene of boats big and small, sails furled and unfurled, seaside houses, and, strikingly, dark lines of rigging. Ships and bridges and unsettled water (water, whose rendition in paint gave rise, a decade later, to the vibrant brushstrokes of Impressionism) inter-

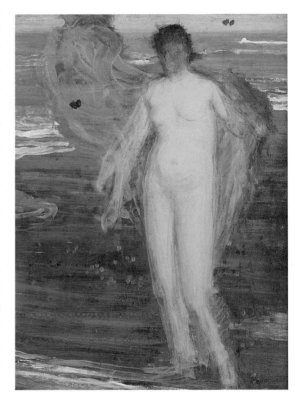

WHISTLER *Venus*, c. 1868
(reworked c. 1879–1903)
Oil on millboard mounted on
wood panel, 24⅜ × 17¹⁵⁄₁₆″
Freer Gallery of Art,
Smithsonian Institution,
Washington, D.C. Gift of
Charles Lang Freer,
FI903.175ab

(Opposite)
WHISTLER
Wapping, 1860–64
Oil on canvas, 28 × 40″
National Gallery of Art,
Washington, D.C. John Hay
Whitney Collection

ested Whistler. Spiky, upreaching rows of gaff-rigged sails, as in *Battersea Reach* (c. 1863), served him as a motif both realistic and decorative. In *Wapping,* the activity of the London docks has a packed quality, an energetic tightness, present over at the Freer in *The Thames in Ice* (1860) and the domestic *Harmony in Green and Rose: The Music Room* (1860–61). This last, with its big irregular black silhouette stark as a cutout, and its curious reflected figure in the mirror on the left, is a weird work, but its weirdness feels like the honest outcome of a wrestle. Following Courbet and Manet, Whistler was searching out a new realism and trying to catch up painting with the newly propagated photographic version of what we see—the crowded, unselected details, the spontaneous overlappings and eclipses. What painting once delivered with a good conscience—a sense of arranged tableau, of theatrically presented drama—Whistler is unable to deliver. The three figures of *The Music Room* are as oblivious of one another as three pieces of a non-fitting puzzle, and the three foreground figures of *Wapping,* over whose disposition and expression he struggled with much overpainting, are equally disassociated. He had in mind a lusty dockside parley and posed his mistress of the time, Joanna Hiffernan, as a "jolly gal," a letter of his states, with "a superlatively whorish air." But in the final version she is so worked over and blurred as to be inscrutable, and the two men with her are far off in their own mental space. What rings out are the dark interwoven lines of mast and spar and rigging; thanks in part to his map-making days, Whistler was a consummate etcher, and ink—its sharpness, its blackness—haunts these two paintings.

When, in *The Coast of Brittany* (1861), he attempts a sun-soaked plein-air scene, the effect is very clumsy: the rocks look outlined and the colors as stiff and friable as van Gogh's. He needed, as a painter, to stay out of the sun. It was happy inspiration, at the very time in the early 1870s when his gift for gray portraiture was at its peak, to go rowing on the darkling Thames and, in the style of a Japanese master, reduce his impressions, back in his studio, to marvellously simple, middle-sized oils, executed with the speed and transparency of watercolors. These "nocturnes" are the one mode in which no one equalled, let alone surpassed, him. The mists and ambiguity of night were his pictorial element, in which his etcher's skills and aesthete's minimalism combined to bring something truly new onto canvas. He did them, at first, from a window— his hotel window overlooking the pier in Valparaiso yielded both the fine

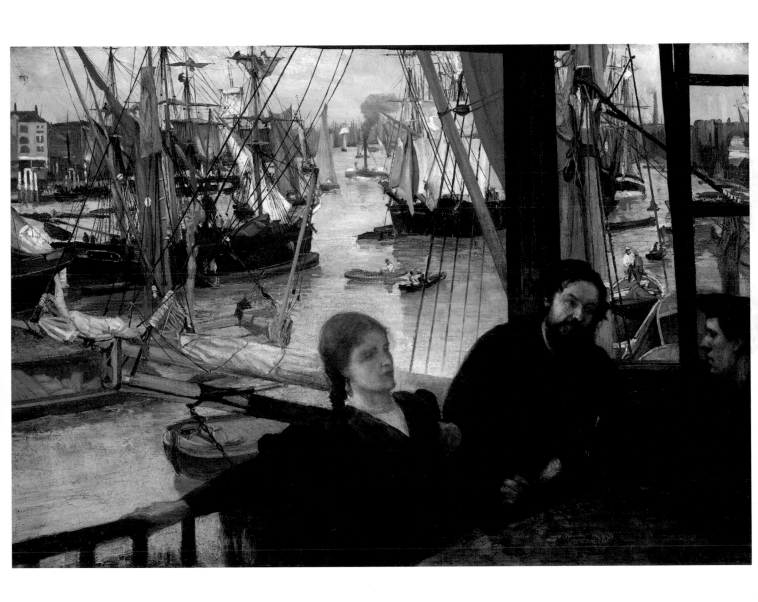

Nocturne in the Freer and a daytime view on display at the National Gallery, and his studio window in Chelsea gave him some high river views. But a greater intimacy and abstraction emerged when he began, with the faithful Greaves brothers at the oars, to glide about the Thames, making pencil sketches and leaving the execution up to retrospect and his consummate sense of design. The lights of the raffish Cremorne Gardens, London's last public pleasure park, dot the milky green-blue of river breadth in *Nocturne: Blue and Silver—Cremorne Lights* (1872). The painting that occasioned the Ruskin trial was of Cremorne's nightly fireworks—*Nocturne in Black and Gold: The Falling Rocket* (1875). In that trial Whistler testified, "By using the word 'nocturne' I wished to indicate an artistic interest alone, divesting the picture of any outside anecdotal interest which might have been otherwise attached to it. A nocturne is an arrangement of line, form, and colour first."

WHISTLER
Nocturne in Black and Gold: The Falling Rocket, 1875
Oil on wood, 23¾ × 18⅜"
The Detroit Institute of Arts.
Gift of Dexter M. Ferry, Jr.

Nevertheless, we react to one a bit differently than we do to Rothko's hovering panels or Barnett Newman's stripes, though Whistler does approach their extremity of abstraction; part of our pleasure lies in recognizing bridges and buildings in the mist, and in sensing the damp riverine silence, the glimmering metropolitan presence. One of the most exquisite in the Washington show is loaned from the White House: *Nocturne* (1870–77). The two golden ovals so dramatically extended in the reflecting water belong not, as we may think, to Big Ben but to "Morgan's Folly," a gigantic illuminated clock tower beside a crucible works in Battersea; these faces return in the fuzziest and most featureless of all the nocturnes here, *Nocturne: Grey and Silver* (1873–75). The painting—a single blurred stripe of urban shore—is additionally daring in that the sky and sea are no shade of blue but, instead, an improbable, persuasive cobalt green. Human vision is here taken to its limits, and modern painting, as a set of sensations realized in paint, is achieved.

Yet Whistler had thirty more years to go, and the remaining galleries are relatively barren. As a theorist he posed the right questions but gave weak answers. He correctly saw that Western painting had exhausted pictorial narrative, whether the anecdote was mythological, historical, folksy/domestic, or, as with the Pre-Raphaelites, neo-medieval, and he was the first to seize upon Japanese art as a clue to the future, when the

abyss of three-dimensional perspective opened by the Renaissance would be sealed shut by the frankly two-dimensional canvas. But by instinct and doctrine he declined to walk through the door to the future, which was color. He knew it was, as his tediously long titles, specifying the colors like musical keys, demonstrate; but nature is rarely as mono- or duo-chromatic as Whistler would have had it. White, black, gray, and gray's dun brothers were his pets, while across the Channel the rainbow beat on the sunhats of Monet and Cézanne. They are the heroes who brought painting gloriously into the twentieth century, not Whistler, who remains a piquant loner, a crepuscular dead end. In painting, ease is not the least of virtues, and Whistler was too often uneasy, tentative, and muddy. His chalk-and-pastel representations of Venice, from 1879–80, are finely drawn but rely for color upon mere spot indications, as if the eye, like a computer, could supply light and atmosphere from these hints, or, like a hardened concertgoer, could hum the melody once given the first four

WHISTLER *Nocturne: Grey and Silver*, 1873–75
Oil on canvas, 12¼ × 20¼″
Philadelphia Museum of Art.
The John G. Johnson
Collection, 1917

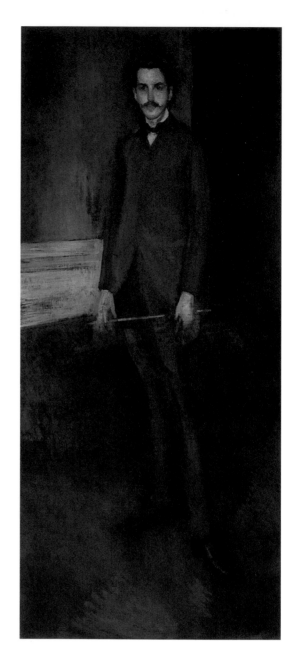

(Left)
WHISTLER *Canal, San
Cassiano*, 1879–80
Chalk and pastel on brown
paper, 11½ × 6¾"
Westmoreland Museum of Art.
William A. Coulter Fund

(Right)
WHISTLER *Portrait of George
W. Vanderbilt*, 1897–1903
Oil on canvas, 82⅛ × 35⅞"
National Gallery of Art,
Washington, D.C. Gift of Edith
Stuyvesant Gerry

notes. His figure drawings on dark-brown paper are similarly attenuated. Only in his tiny seascapes did he carry the color to the corners. He could always draw, and there are a number of fine etchings and lithographs from his latter decades, and some striking full-length portraits, done in black and gray—*Mother of Pearl and Silver: The Andalusian* (1888–1900) and *Portrait of George W. Vanderbilt* (1897–1903). The number of years enclosed by parentheses, and the unfinished or scrubbed-in portions of the portraits, show how hard a time Whistler had satisfying

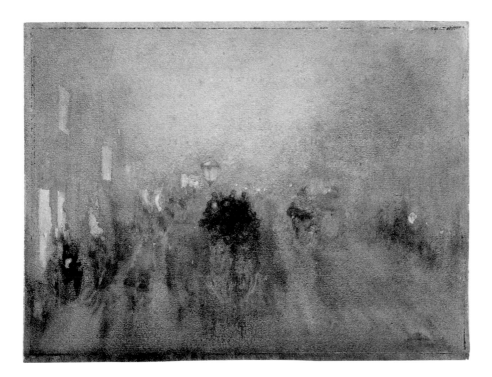

WHISTLER *Nocturne in Grey and Gold—Piccadilly*, 1881–83
Watercolor on white wove paper, 8¾ × 11½"
The National Gallery of Ireland, Dublin

himself. Not even Vanderbilt's princely offer of a thousand guineas down and a thousand more on delivery could induce Whistler to complete the painting before his death in 1903. The exact tone, the precise pitch of restraint and omission, had become more and more difficult for him to strike, as he labored with pigments so thin as to be merely tinted turpentine.

Even so, the watercolor *Nocturne in Grey and Gold—Piccadilly* (1881–83) is a triumph of restricted means—an apparently inchoate snarl of sooty brushstrokes in the middle of some gray patches perfectly resolves into a horse and carriage on a hazily window-lined city street. He did the ineffable: he painted fog. In the girl who sat for *The Little Rose of Lyme Regis* (1895), Whistler found a face he could steadily look into, though the child's hands are grotesquely small. Children and fog, empty sea and the dark, sitters with their faces averted—Whistler, though his image was cocky and brazen, as a painter was *shy*. His butterfly seems fragile, pinned this summer to the center of the Washington glare.

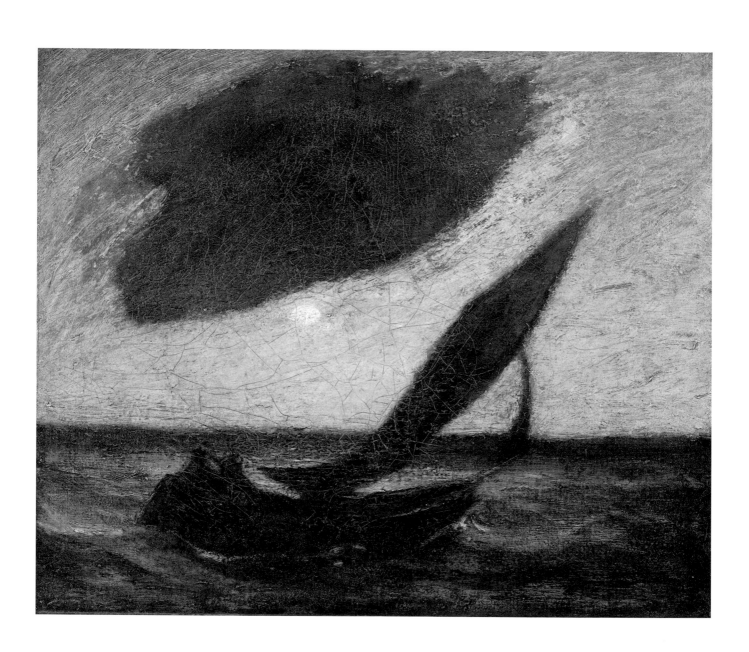

"Better than Nature"

The Art of Albert Pinkham Ryder, an exhibition at the Brooklyn Museum for the rest of 1990, is an arresting study in the problematics of painting, and should be attended by all who take an interest, morbid or not, in American art. This show will not come around again, if only because Ryder's paintings are so fragile and festering that they are disintegrating before our collective eyes. We are all aware that some paintings hold up better than others, and that few canvases executed before 1850 look quite the same now as they did to the artist the day he finished them, but the Ryder show brings home with a vengeance the mortality of the oil medium. A section of the show is devoted to the chemistry of deterioration, with grisly enlargements of Ryder's cracking, shrinking, wrinkling, bubbling, sagging, darkening, alligatoring agglutinations of pigment. His paintings are subject to "traction crackle," "varnish slide," and "perennial plastic flow"; they suffer from an ongoing chemical activity that insurance companies term "inherent vice."

It is all Ryder's fault. Though the basics of stable, enduring oil painting were established by Jan van Eyck early in the fifteenth century, and though abundant technical wisdom existed in the art schools and ateliers of the late nineteenth, Ryder, in his reckless, betranced quest for poetically lustrous surfaces, committed every chemical sin in the book, mixing his oils with alcohol, bitumen, and candlewax, painting "wet-on-wet," applying rapid-drying paints (flake white, umbers, and Prussian blue) on top of "slow driers" like lampblack and Van Dyck brown, pouring on varnish straight from the bottle and painting on top of the still-tacky surface. In his later, increasingly reclusive years he became pathologically reluctant to part with his work and trash alike; his tacky paintings were piled in the dusty jumble of his apartments and sometimes damaged underfoot. To display canvases to a visitor, he would wipe them "with a

(Opposite)
ALBERT PINKHAM RYDER
Under a Cloud, c. 1900
Oil on canvas, 20 × 24"
The Metropolitan Museum of Art, New York. Gift of Alice Van Orden, in memory of her husband, Dr. T. Durland Van Orden, 1988, 1988.353

wet cloth to bring out their depth and transparency"; the evaporating water blanched the paint and glazes. He also wiped with kerosene and was fond of melting colors together with a hot poker. Alarmed patrons found him reclaiming his paintings and ruining them; on one occasion in 1905, when the collector John Gellatly irritated Ryder by pressing him for delivery of a commissioned work, the painter, in the presence of a visitor to his studio, Sadakichi Hartmann, ragefully heated up an old hair-clipper in the coals of his fire and ran it "cross-cross through the picture surface, leaving deep gashes as if made by the prongs of a rake." X-rays of *Pegasus Departing* (1901–5?)* do indeed show parallel scorings.

RYDER *Pegasus Departing,*
1901–5(?)
Oil on canvas mounted on fiberboard, 14¼ × 17¼"
Smithsonian Museum of American Art, Washington, D.C. Gift of John Gellatly. X-ray by Conservation Analytical Laboratory, Smithsonian Institution

The fullest account of the vandalism Ryder wreaked on his own works can be found in the chapter "Albert P. Ryder: His Technical Procedures," which conservator Sheldon Keck contributed to the volume by Homer and Goodrich. But the room in the Brooklyn Museum devoted to this problem is vivid enough, displaying the pustular black ruin of the painting *Desdemona* and the lavalike crust of *The Curfew Hour,* scarcely still recognizable as a human artifact. In other rooms of the exhibit a number of well-known, much-reproduced works are failing fast: the bigger version of *Macbeth and the Witches* an inscrutable murk, *The Sentimental Journey* and *The Lone Horseman* not much better, *The Lorelei* and *The Forest of Arden* and the panel *Woman with a Deer* unignorably disfigured by great fissures, even *The Race Track*—its pale horse and pale rider made additionally memorable by the title of a Katherine Anne Porter novella and a homonymic connection with Ryder's name—so sunk in its whites as to seem less a painting than a spectral sketch of one. A number of the paintings present in the Ryder retrospective at the Metropolitan Museum of Art, a year after his death in 1917, now exist primarily in the form of black-and-white photographs taken in 1918; the originals have all but dissolved.

* Ryder did not often date his works, and his habits of prolonged revision make the dating of his works exceptionally uncertain. The catalogue for the Brooklyn show, by Elizabeth Broun, did not attempt dates; *Albert P. Ryder: Painter of Dreams,* by William Innes Homer and Lloyd Goodrich (New York: Abrams, 1989), does, on the basis of "surviving visual and documentary evidence," attempt estimates, often very rough ones. To avoid the awkwardness of parenthetical attributions as wordy as "middle 1880s–middle 1890s" and "1890s, and later," only illustrated works are dated, in their captions.

The Ryder messiness extends to an odd overlapping between restorers and forgers. Ryder is the most forged painter of his time, and also the most restored; in this exhibit we are warned that much of what we see—for instance, the outlines incised around *Dancing Dryads,* details of *Pegasus Departing,* swaths of *The Lorelei*—is the work of other hands, busy even while he was alive. After Ryder's death, his disorderly estate began miraculously to sprout new Ryders. His caretaker, Louise Fitzpatrick; his artistic executor, Charles Melville Dewey; and the Canadian artist Horatio Walker all happened to paint in the moonlit Ryderesque style, and in the shuffle between restorers and collectors and authenticators a wealth of indubitable forgeries apppeared. In 1915 he himself wrote a collector of his paintings, Alexander Morten, "I am sorry to say, a great many spurious Ryders have lately come into the market." Though Ryder generally didn't sign his paintings, "having always felt that they spoke for themselves," he consented to authenticate Morten's, and allowed himself to be taken over to the Brooklyn Museum to sign a group of six paintings purchased in 1914. The last room of the exhibition hangs thirteen alleged Ryders now thought to be forgeries, many still proudly wearing their gilt frames and museum labels. With the help of the wall commentaries, we can see how these paintings—most often, boats on a sublunar sea—lack the patient searchingness that distinguishes the mature Ryder's opaque, expressionistic skies and rigorously smoothed compositions. But, given the uncertainty and crudity of many authentic Ryders, our discernment is

(Left)
RYDER
The Curfew Hour, early 1880s
(early photograph, 1909)
Oil on wood panel, 7½ × 10"
The Metropolitan Museum of
Art. Rogers Fund, 09.58.1

(Right)
RYDER
The Curfew Hour, early 1880s
(recent photograph, before
1990)
Oil on wood panel, 7½ × 10"
The Metropolitan Museum of
Art. Rogers Fund, 09.58.1

RYDER
The Race Track (Death on a
Pale Horse; the Reverse),
late 1880s–early 1890s
Oil on canvas, 28¼ × 35¼"
The Cleveland Museum of Art.
Purchase from the J. H. Wade
Fund, 1928.8

perhaps a piece of curatorially aided hindsight. The working parts, as it were, of a Ryder are so few that even a crude imitation can click. Elizabeth Broun's catalogue (*Albert Pinkham Ryder,* published by the Smithsonian Institution Press) quotes Clement Greenberg, who wrote of one Ryder forgery that it

> manages to be a rather good picture precisely because it takes nothing from Ryder except his manner, leaving out the difficult intensity and originality of emotion he could not realize often enough in his own work. While Ryder could not always meet the high terms he set himself, the forger, even though he was only a hack, could meet them when reduced.

Mention of Greenberg brings us to the problematical matter of Ryder's high modern reputation. Jackson Pollock said in 1944, "The only American painter who interests me is Ryder." In the Armory Show of 1913, which brought modernist painting to America, Ryder was given, with such Europeans as Gauguin and Redon, patriarchal status—an old master of the avant-garde. Nor have the post-Pop fluctuations of artistic mood noticeably lowered the esteem in which Ryder is held. Paradoxi-

cally (if the post-modern sensibility can be seen as consistent enough to contain paradoxes), we *like* it that his paintings are self-destructing; each disintegrating Ryder is a slow-motion happening. We *like* it that he was so sublimely careless in his intensity—that he sacrificed product to procedure. Ms. Broun is quite eloquent in linking Ryder to Pollock:

> They were united in their faith in the very process of painting as a means of embodying the content of the work. . . . Pollock's layered skeins of paint create a tension between plane and depth that is close to that in Ryder's heavily built-up, wet-on-wet paint films. One looks through Pollock's threaded webs into a mystical, invented space much like that seen under magnification in Ryder's layered glazes and marbled paint films. . . . Ryder's peculiar approach served as an American analogue to surrealist automatism in that it was an art rooted in the process of painting rather than in a preconceived image.

"Mystical" is the key word above; indeed, Broun rather mystically credits Ryder with foreseeing the aesthetic effect of magnified crackling and chemical mismarriage. That may be what Ryder meant when he said, of his layers of paint, "I have so much enjoyment underneath." The painter's enjoyment, perhaps for the first time, is worked into aesthetic theory. A witness to his painting said of it, "It was an emotional process that often disregarded sound technique." Ryder was not much troubled by the signs of deterioration that emerged in his work: "When a thing has elements of beauty from the beginning," he asserted, "it cannot be destroyed." He wrote the dealer William Macbeth, who wanted to clean *In the Stable* of its darkening varnish, "I hope you will not have the picture cleaned; I am confident that the color is as perfect as when painted; if there are any cracks they count for little in this enlightened age." When Macbeth persisted, Ryder stormed, "It is appalling, this craze for clean looking pictures. Nature isn't clean." He would have approved when, some forty years later, Pollock left a bumblebee embedded in one of his giant drip-paintings. Art imitates Nature not in its appearances but in its processes, its uncleanness, its uncomplaining susceptibility to accident.

Ryder did not issue many statements on method and theory, but he said enough to establish him as a precursor of much that is joyously violent in modern art. One paragraph in particular, from an interview with Adelaide Louise Samson (who may have contributed the stately, balanced cadences), has the force of a revelation:

Nature is a teacher who never deceives. When I grew weary with the futile struggle to imitate the canvases of the past, I went out into the fields, determined to serve nature as faithfully as I had served art. In my desire to be accurate I became lost in a maze of detail. Try as I would, my colors were not those of nature. My leaves were infinitely below the standard of a leaf, my finest strokes were coarse and crude. The old scene presented itself to me framed in an opening between two trees. It stood out like a painted canvas—the deep blue of a midday sky—a solitary tree, brilliant with the green of early summer, a foundation of brown earth and gnarled roots. There was no detail to vex the eye. Three solid masses of form and color—sky, foliage and earth—the whole bathed in an atmosphere of golden luminosity. I threw my brushes aside; they were too small for the work in hand. I squeezed out big chunks of pure, moist color and taking my palette knife, I laid on blue, green, white and brown in great sweeping strokes. As I worked I saw that it was good and clean and strong. I saw nature springing into life upon my dead canvas. It was better than nature, for it was vibrating with the thrill of a new creation. Exultantly I painted until the sun sank below the horizon, then I raced around the fields like a colt let loose, and literally bellowed for joy.

The bellow—a "barbaric yawp"—and the "great sweeping strokes" of pure color presage Abstract Expressionism and its gargantuan color-field successors; but Ryder's canvases and panels were almost always small. He liked to paint on cigar-box lids, for the glow of the red cedar underneath. It was his enamelled tones that pleased his contemporaries, and won him admirers from the start, though early criticism had to work around the inadequacies of his draftsmanship: "Mr. Ryder . . . often raises an involuntary smile by the oddity and apparent naïveté of his pictures." One does not need to compare Ryder's skills with those of his contemporaries Winslow Homer and Thomas Eakins; compared with a middling student at a middling art school, he drew poorly. His faces have no expression; his bodies have no muscles and movement. He was introduced to brush and paints as a child in New Bedford, and, he told Adelaide Samson, "I at once proceeded to study the works of the great to discover how best to achieve immortality with a square of canvas and a box of colors." But he had troublesome eyes—they became inflamed with use, and prevented him from continuing his schooling past grammar school—and the first time he applied to the National Academy of Design in New York he failed the entrance exam. Yet quite soon he acquired a

mentor and a sponsor, the portrait painter William Marshall, and when he was at last admitted to the academy, according to his fellow-student J. Alden Weir, his "gentle & timid nature made him a favorite with everyone."

Ryder's modest successes—he had patrons from early on, and toward the end he was pursued by commissions—are entangled with the something guileless, rare, and captivating about his personality; in an art world of debonair cosmopolitans like John La Farge and Abbott Thayer, his dedication to art, despite so little apparent talent for it, savored of heroism and sanctity. His heedless techniques, his trite and wispy poems (collected in the Homer-Goodrich volume and quoted by Broun), the dim melodrama of his fairy-tale tableaux, and his decay, after 1900, into grubby eccentricity and counterproductive obsessiveness all conspire to suggest that Ryder was a bit of a simpleton. Americans, with their basically millennial expectations, admire holy fools, especially in the arts, and the full-blown Ryder, combining Whitman's beard with Emily Dickinson's reclusiveness, is our holy fool of painting. Puritanism continues to shape our collective aesthetic sensibility if not our personal behavior; it values sincerity and prefers to a suspect facility like John Singer Sargent's a definite awkwardness, an evident wrestle with difficulty, like Ryder's. In its world-hating heart, Puritanism admires, as ultimate proof of sincerity, self-destruction, whether it comes as the plastic slide of Ryder's gumbo or Pollock's drunken car crash. On such disdainful negations are lofty reputations built.

RYDER *Near Litchfield, Connecticut,* 1876
Oil on composition board, 9⅝ × 9⅛"
Collection of Robin B. Martin, Washington, D.C.

Viewed as visual entertainments rather than as demonstrations of spiritual effort, the Ryder paintings on display in Brooklyn offer limited satisfactions. The early daubs, small brownish glimpses of rural America influenced by the impersonal rustic intimacy of the Barbizon School in France, have at their best a golden glow and an astonishing minimalism. *Near Litchfield, Connecticut* and *Landscape* could hardly be less and be

paintings at all, yet they convey reality, a cloudy-day, nameless-tree atmospherics that is curiously American. Nothing to say becomes something to say; the center of *Autumn Landscape* contains only crackle and warm haze, and the upside-down ghost of a painted-over horse. Horses, usually depicted in a frontal foreshortening that makes them look wistfully like people, interested Ryder, whose family had owned a white horse in New Bedford. Even though the white horse in *Mending the Harness* is exceptionally well anatomized, it and the one in *The Grazing Horse* have a poetic glimmer; they do not seem quite real horses but dream-images, symbols. Ryder has begun to make, instead of receive, pictures.

Ryder's anecdotal paintings, whether the anecdote is rustic-genre *(In*

RYDER *Mending the Harness,*
middle to late 1870s
Oil on canvas, 19 × 22½″
National Gallery of Art,
Washington, D.C. Gift of
Samuel A. Lewisohn

the Stable, The Sentimental Journey), piratical *(Smuggler's Cove)*, Shakespearean *(Macbeth and the Witches)*, Wagnerian *(The Lorelei)*, or allegorical-mythological *(The Temple of the Mind, The Poet on Pegasus Entering the Realm of the Muses)*, speak in a hoarse whisper, even to those who can make out, in the alligatored chiaroscuro, what is happening. Though Ryder was removed by an ocean and a great breadth of sophistication from Whistler, the two strikingly shared a reductive tendency toward nocturnal illumination and drastically simple forms. Ryder's human figures are so dimly grasped, so pastel and undefined, as to be not even comic. When a little definition creeps in, comedy does too, as in *Perrette (The Milkmaid)*, with her jauntily swinging stride, or *A Country Girl*, with her big cartoon eyes. *The Shepherdess*, delicately brushed on a gilded wood panel that glimmers through in scratched highlights, is one of his more successful decorative works, using the same glowing tawny hues as his famous *The Dead Bird*, thinly and enduringly painted on a cigar-box lid and given as a playful present to the wife of his dealer, James S. Inglis. Mrs. Inglis had a habit of saying, when tired, "I feel like a dead canary."

The three overtly Christian paintings on view are not as lame as you might think. *The Story of the Cross*, especially, with its stiff parallel figures and unusually fresh and sunny colors, reinvents the faded Biblical imagery, like a more tender Rouault; the woman with child and donkey, as if the infant Christ were being held up, in a white nightie, to witness His own crucifixion, is like nothing else in Christian iconography. Of Ryder's theatrical constructs, *The Tempest* (partly painted, as we know, by those busy posthumous hands) takes a certain life from its jaggedly

RYDER
A Country Girl, c. 1903
Oil on canvas, 9½ × 5¾"
Collection of the Maier
Museum of Art, Randolph-
Macon Women's College,
Lynchburg, Virginia

RYDER *The Dead Bird*, 1890s
Oil on wood panel, 4¾ × 10"
Acquired 1928, The Phillips
Collection, Washington, D.C.

gesturing heavens, and *The Flying Dutchman* from its troughed mass of ragged waves and the contrast with the golden sky, of which the phantom ship, sails full, seems to be part. Here Ryder has managed a double plane of reality, a hallucination within his hallucinatory world, and it is a measure of our nervous relation with his erratic talent that we are relieved he has brought off what, after all, any competent illustrator could have.

His moonlit marines—*Moonlight, Under a Cloud, Moonlight Marine, With Sloping Mast and Dipping Prow, Moonlit Cove*—are his signature pieces. His primitivized draftsmanship gives the various boats a spiritual vagueness and spares us, often, crew and rigging; the simplicity of the constituents—sea below, sky above, a moon, a sail—enables him to construct a scene that tightly fills the canvas with flat shapes. His opalescent skies with their cut-out clouds are marvellous inventions that echo down through Robert Motherwell and Clyfford Still. Ryder's seas, with their

RYDER *The Story of the Cross,* middle to late 1880s
Oil on canvas, 14 × 11¼″
Princeton University Art Museum. Gift of Alastair B. Martin, Class of 1938

RYDER
Moonlight Marine, 1870–90
Oil and possibly wax on wood panel, 11½ × 12″
The Metropolitan Museum of Art, New York. Samuel D. Lee Fund, 1934. 34.55

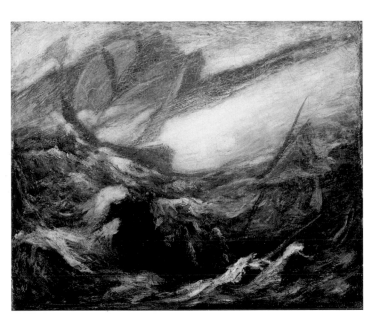 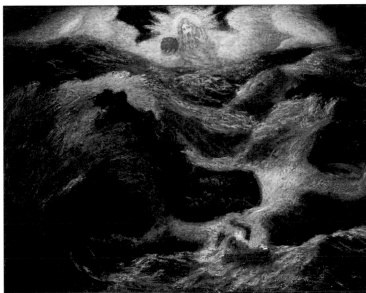

more ragged scrabbled brushwork, are almost as visionary; the heaving brown hillocks of *Jonah* and the flung pillow-shapes of *Lord Ullin's Daughter (The Sea)* are as abstracted as his clouds, and indeed one of the foaming crests in the latter seems to be trying to qualify as a cloud, leaping oblong into the sky. Of course, it is not a sufficient compliment to say of an artist that he anticipated artistic developments of the future: this would reduce his function to a kind of soothsaying. His duty is to the contemporary *Zeitgeist,* to push at its envelope where it can be pushed, and to communicate with the living. By flattening his skies and enamelling his waves, Ryder was able to re-express the old Romantic sense of Nature as a *presence,* not necessarily a benign one. The Blakean God smiling between His wings in *Jonah* strikes us as eccentric and fantastic; not so the blank intensity of Ryder's furiously glazed moons. In his marine images, as native and universal as the eternity-minded prose of *Moby-Dick,* this problematical painter does lay claim, against all odds, to the immortality he sought.

(Left)
RYDER *The Flying Dutchman,* middle to late 1880s and later Oil on canvas, 14¼ × 17¼" Smithsonian American Art Museum, Washington, D.C.

(Right)
RYDER *Jonah,* c. 1885 Oil on canvas, 27¼ × 34⅜" Smithsonian American Art Museum, Washington, D.C.

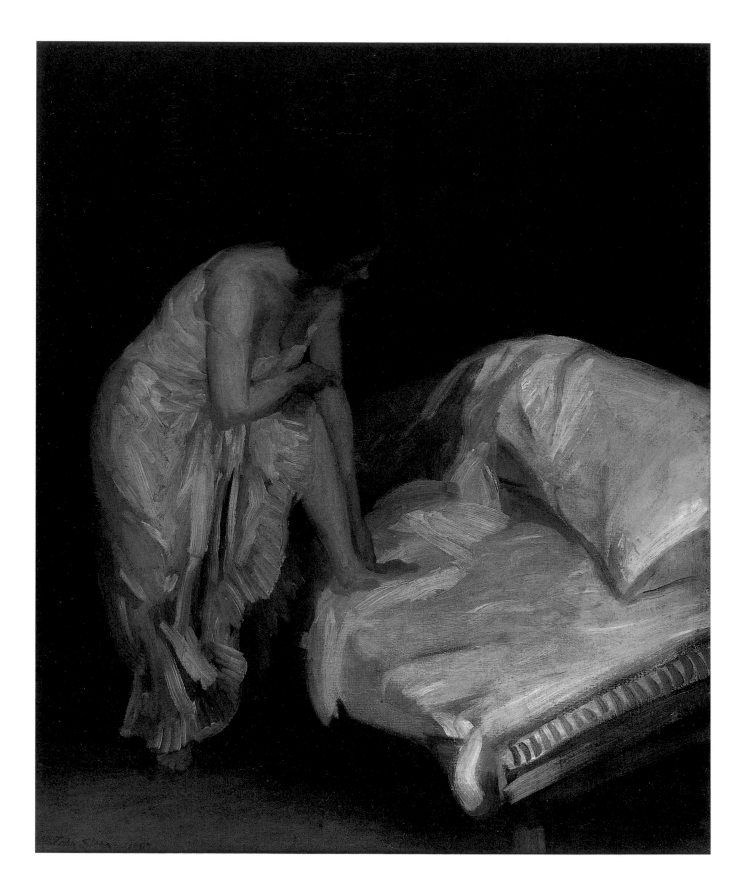

Walls That Talk Too Much

———

THE MEGASHOW gives way to the talk show—an art exhibit where more time is spent in absorbing the pedagogic text on the walls than in looking at the pictures. As insurance costs rise and government support dwindles, and the number of artists for whom the public will form long queues approaches its limit, the kind of global round-up that Matisse and Renoir and Picasso and Degas and Sargent and Caravaggio have received in recent years may be joining the junk-bond boom in the annals of heydays; in these drabber times museums are turning scholarly, delving into their and their fellow institutions' copious reserves of less than supremely fashionable works of art to assemble purposeful lectures through which we walk as if galleries were paragraphs and paintings were slides of themselves. *American Impressionism and Realism: The Painting of Modern Life, 1885–1915*, at the Metropolitan Museum of Art from May to July of 1994, uses eighty-five canvases by twenty-six artists to illustrate its deconstruction of a verbal distinction that, in the minds of all but art curators and professionals, was rather hazy anyway.

According to received cultural history, the American Impressionists, following their French masters in rebelling against the studio-bound academic tradition of the nineteenth century, had become by the beginning of the twentieth century the contemporary art establishment and were in turn rebelled against by the Realists, who signalled their rebellion with an independent exhibition, at the Macbeth Gallery in 1908, of The Eight—so named to distinguish itself from The Ten, a group of Impressionists that had seceded from the Society of American Artists in 1897. The Impressionists were exemplified by William Merritt Chase, Childe Hassam, and J. Alden Weir, and the Realists were led by Robert Henri, William Glackens, George Luks, and John Sloan.

But according to the abundant wall-inscriptions, and the more than

(Opposite)
JOHN SLOAN *The Cot*, 1907
Oil on canvas, 36¼ × 30¼"
Bowdoin College Museum of Art, Brunswick, Maine. Bequest of George Otis Hamlin

usually ample exhibition brochure sponsored by Alamo Rent A Car ("If, after you've seen these scenes of American life in the exhibition, you're inspired to take your own show on the road, call us," the brochure urges), and the heavy, opulently informative catalogue by H. Barbara Weinberg, Doreen Bolger, and David Park Curry, the Impressionists and the Realists weren't as different as they had imagined. "Both studied in Europe, taught in the same schools, sought patronage in the same circles," the first wall tells us. And both, the dominant message of the mural commentary repeatedly insists, were guilty of "genteel euphemism" in soft-pedalling the grim facts of an America in the throes of urbanization, industrialization, and mass immigration.

True, the Realists employed a more somber palette and sometimes depicted the poor and the slums, but even when they did so they sheltered the viewer from the true hardness of the case. John Sloan's painting *A Woman's Work* (1912) shows a healthy-looking—nay, attractive—young woman hanging out wash from a tenement fire-escape landing; the wall caption points out that this clean, sunny moment leaves out of sight the dirt purged by "soapy water heated on a stove," and that the woman has "not yet struggled with the heavy iron." The fuller text of the catalogue finds even more to raise an eyebrow at: it quotes Sloan's words, in which he confesses "an urge to record my strong emotional response to the city women, any woman running up the colors of a fresh, clean wash. Sun, wind, scant clothing, blowing hair, unconscious grace give me great joy." The catalogue's gloss follows with the swiftness of divine vengeance: "Sloan's evocation of outdoor elements and the 'fresh, clean wash' sounds as if he were describing a sporty racing sloop, effectively masking his desire to observe these women in intimate moments." Sloan is taken to task for voyeurism, his decision to "depict the most pleasant moment in the washing process," and his failure to show us how his "faithful wife, Dolly," felt about the laundry, which, before the advent of electric washers and dryers, "occupied as much as a third of a housewife's working time."

The captious wall-captions, more integral to the show than the fuller sociological indictments of the catalogue, are obsessed by what Sloan does *not* depict. Of the laughing figures in *The Picnic-Grounds* (1906–7) we are told that he has "recorded the pleasures of their holiday outing rather than the hardships of the work in shops or in factories," and, apropos of the snowman-making children of *Backyards, Greenwich Village*

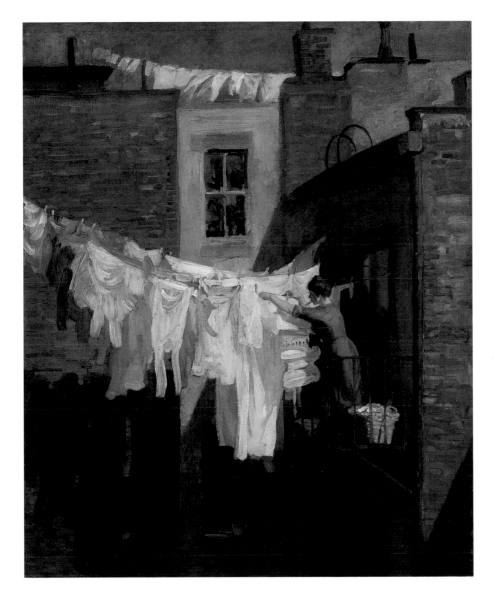

SLOAN
A Woman's Work, 1912
Oil on canvas, 31⅝ × 25¾"
The Cleveland Museum of Art.
Gift of Amerlia Elizabeth
White, 1964.160

(1914), that the "lives of these youngsters [appear] much sunnier than those of the slum children recorded in photographs by more candid observers of the period, such as Jacob Riis." The Realists, with their pretensions to honest democratic and urban perspectives, disappoint the wall-inscribers repeatedly. George Bellows, in his crowded city canvas *Cliff Dwellers* (1913), "was at least as concerned with recording curious types as he was with offering a polemical account of conditions on East Broadway," and of the sometimes polemical Robert Henri's *Street Scene with Snow* (1902) it is complained that Fifty-seventh Street "was a com-

J. ALDEN WEIR
The Factory Village, 1897
Oil on canvas, 29 × 38″
The Metropolitan Museum
of Art. Gift of Cora Weir
Burlingham, 1979, and
Purchase, Maguerite and Frank
Cosgrove Jr. Fund, 1998,
1979.487

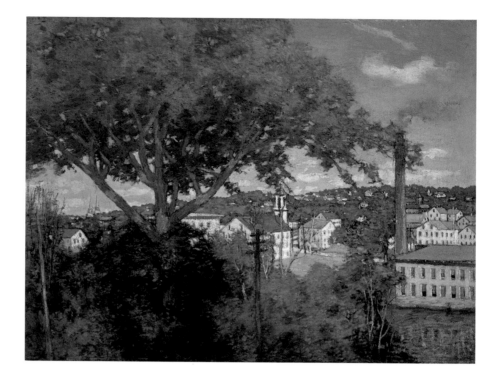

(Opposite, top)
WILLIAM GLACKENS
Central Park in Winter, c. 1905
Oil on canvas, 25 × 30″
The Metropolitan Museum of
Art, New York. George A.
Hearn Fund, 1921, 21.164

(Opposite, bottom)
CHILDE HASSAM *Charles
River and Beacon Hill,* c. 1892
Oil on canvas, 16⅛ × 18″
Museum of Fine Arts, Boston.
Tompkins Collection, 1978.178

fortable cultural and residential neighborhood far from the slums where
the poor suffered in midwinter."

The Impressionists, too, were capable, in their landscapes, of
deplorable evasions. Childe Hassam, in his festive paintings of American
flags, "even near the end of the second decade of the twentieth cen-
tury . . . maintained American Imperialism's rosy spirit," and his elevated
view of *Union Square in Spring* (1896) "ignored the Square's association
with political gatherings and protests, its role as a hub for the labor
movement, and its decline as a theatrical and entertainment center." But
it is J. Alden Weir, in his *The Factory Village* (1897), who works the most
perfidious concealment of all:

> The large tree spreads its protective canopy over the smokestack of the
> Willimantic Linen Company's factory, its spool shop's tower, and the tele-
> graph pole. There is no hint of the immigrant labor problems that the
> company had experienced in the 1880s or of the financial problems it
> faced in the late 1890s.

The assemblers and labellers of this show have gone out on a provocative
limb, and it would insult their sensitivity and expertise to harp on the

obvious limits of what a painting can include. The medium's silence and its lack of an olfactory or tactile dimension make it inadequate to render the noisome reality of a slum or squalid dwelling. Further, such documentary capabilities as painting possessed had by 1885 been pre-empted by the medium of photography; a Bellows painting could not bear the same inarguable testimony as a Jacob Riis photograph. Impressionism arose partly in response to the crisis imposed upon the pictorial arts by the arrival of photography; painting was driven to seek out those things that only it could do. The overt art of painting slowly replaced the covert skills of depiction. As one moves through the rooms of this show, giving one's eyes a rest from the incessant wall-notes with an occasional peek at the paintings, the essential distinction emerges as not that between Impressionism and Realism but that between painting and depiction.

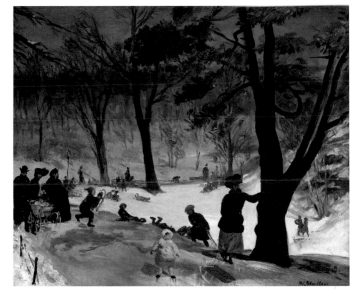

The Realists as a group tended to have been illustrators, and their purpose remained illustrative even when it was not polemical. George Bellows's *The Studio* (1919) and William Glackens's *Central Park in Winter* (c. 1905), for instance, are depictions; once the facts of the setting have been indicated, the figures solidified and disposed, and the colors filled in, the artist's task is complete, even if some details are left hasty and coarse. Childe Hassam's *The Room of Flowers* (1894), by contrast, is unintelligible and chaotic in impression; the background is painted with the same intensity as the foreground, and a process of meditation, or enjoyment, seems still in progress and could have been extended beyond the final state of the canvas. Hassam's *Charles River and Beacon Hill* (c. 1892) records a moment when Back Bay was still muddy and life preservers hung on its fenced edge, but such historically interesting depiction feels incidental to its flat-

tened flurry of paint, to a turbulent and visibly venturesome process. One of the secrets of Hassam's continuing vitality is his willingness to throw himself and his paints at nearly anything. If his American flags are imperialistic, then so are Jasper Johns's.

Several of the Realists, we learn from the catalogue, had wealthy wives, and thus could afford descending into the world of the common man for subject matter. Almost all, Realists and Impressionists both, made good livings at what William Merritt Chase called "the most magnificent profession that the world knows." Sloan's fond gaze upon the city women he could see from the window of his studio on East Twenty-second Street, considered politically, belongs to centuries of inequitable power relations between the artist and his models, generally recruited from an inferior class. But an artist must capture beauty where he sees it, and there is a progressive if not revolutionary content in the artist's announcement that beauty and joyfulness arise among the humble and lowly as well as among the fortunate. The democracy of the eye implies a democracy of law; lust stirs the melting pot more effectively than pity, and crediting the working classes with moments of jubilation and triumph—even the minor triumph of clean wash—acknowledges them as kindred souls. To reproach the American Realists with optimism and euphemism is to denigrate the affirmative message that art brings us all. No Realist was more immersed in the actual lives of the poor than George Luks, yet his painting of two ragged children dancing together, *The Spielers* (1905), is a celebration out of Frans Hals and Pieter Brueghel the Elder. A critic wrote of it in 1915, "It is a joyous canvas, a picture to live with. For all their ragged attire, the two little maidens, locking their hands together, are as happy as princesses."

In 1915 an ancient decorum still ruled whereby beauty, harmony, and energy were thought to be the natural subjects of art, and the ugly and pitiful were relegated to the inferior genre of the grotesque. The painters had to think of their buyers, and the domestic settings their paintings were meant to adorn. The modes of photography and black-and-white etching had a different, journalistic market, and indeed the unsoftened views of labor and squalor that the wall commentary seems to demand are easily found in the companion exhibit of prints and watercolors assembled entirely from the Metropolitan's own collec-

GEORGE LUKS
The Spielers, 1905
Oil on canvas, 36¹⁄₁₆ × 26¼″
Addison Gallery of American
Art, Phillips Academy, Andover,
Massachusetts. Gift of
anonymous donor, 1931.9.

tion. Black-and-white images can be news, with the shock value of news. Bellows's lithograph *Why Don't They Go to the Country for a Vacation?*, published as a frontispiece in a 1913 issue of the socialist journal *The Masses*, gives a much stronger impression of the hellish crowding of the Lower East Side than the painting closely derived from it, *Cliff Dwellers* (1913). In the painting, the foreground figures in white suggest the heavenly thronging of a Tiepolo, and the chiaroscuro of the receding crowd and the sunless tenement front holds these elements to a plane of their own, so that they no longer press mercilessly forward as in the lithograph. Several bearded, distinctly Jewish faces have disappeared, and a certain generalizing pervades the broad, fluid brushstrokes. The figures of the child-carrying woman on the right, and the seated women beneath her, have become monumental and heroic. A balanced calm, as in a crammed but carefully arranged Renaissance tableau, has overtaken and subverted the unmistakable editorial message of Bellows's scratchily drawn, outrageously crowded black-and-white transfer lithograph.

(Left)
BELLOWS *Why Don't They Go to the Country for a Vacation?*, 1913
Transfer lithograph reworked with pen, 25 × 22½"
Los Angeles County Museum of Art, Los Angeles, 60.43.1

(Right)
GEORGE BELLOWS
Cliff Dwellers, 1913
Oil on canvas, 40³⁄₁₆ × 42¹⁄₁₆"
Los Angeles County Museum of Art. Los Angeles Count Fund, 16.4

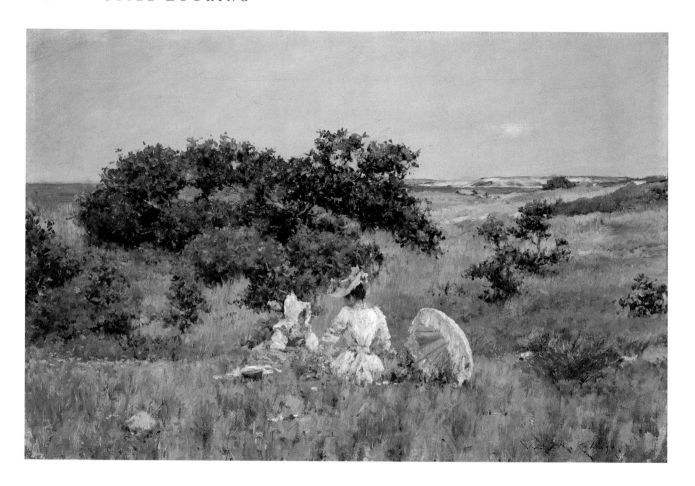

WILLIAM MERRITT CHASE
The Fairy Tale, 1892
Oil on canvas, 16½ × 24½"
Collection of Mr. and Mrs.
Raymond J. Horowitz

VIEWED without reference to the hectoring comments on the walls, or to the catalogue with its Braudelian accounts of the evolution of bathing attire and laundry appliances and of American attitudes toward boxing and beaches, the eighty-five paintings less describe social conditions between 1885 and 1915 than provide a luminous and benignly noncommittal view of the human condition in general, as it perennially manifests itself beneath blue skies, on crowded streets, and in furnished rooms. The painters most represented, with nine canvases each, are Hassam, Sloan, and Chase. Chase emerges as the exhibit's star. His somewhat cursory and gaudy *At the Seaside* (c. 1892), with its big Chinese-red beach umbrella, is used as the catalogue's cover and was made into a poster as one of the exhibit's signature pieces. A striking work, in its sunstruck brilliance and long low shape, and a good example of Chase's stabbing, crumbling brushwork, it seems less finished and consummate than his

two other displayed landscapes of Southampton, both of them grassy, scrubby seaside expanses decorated with a few white-clad summer folk. The wall commentary, besides irritably noting that the summering women and children of the 1890s were "isolated from male company, from the working world, and from nature's discomforts and dangers," appears also to feel cheated by the "artful" way in which Chase makes the "unprepossessing topography of Southampton's Shinnecock area" look "delightful." As their titles—*The Fairy Tale* (1892) and *Idle Hours* (c. 1894)—suggest, these are not Realist works, though surely the halcyon moment of American summer was real enough. "Paint the commonplace in such a way as to make it distinguished," Chase advised his students. He also declared, "When I have found the spot I like, I set up my easel, and paint the picture on the spot."

The issue of "the picturesque" is raised by a pair of placards surprisingly placed in two of the museum windows looking into Central Park, treating it as a work of art eight hundred and forty acres in dimension, of "natural materials rearranged," credited to Frederick Law Olmsted and

CHASE *The Park,* c. 1888
Oil on canvas, 13⅝ × 19⅝"
The Art Institute of Chicago.
Bequest of Dr. John J. Ireland

Calvert Vaux. A contemporary commentator is quoted on the challenge their raw materials posed: "Long and narrow and flat . . . without a natural stream or any sheet of water, and with one of the most uninteresting varieties of rock-formation on which forming Nature ever tried her hand, the picturesque seemed impossible." Impressionism, like the Barbizon School, which preceded it, and Realism, which, in America, followed it, extended the meaning of "picturesque"—indeed, much of Western painting can be seen as an expansion, since the holy scenes on altarpieces, of what was considered worthy of being painted. Impressionism appropriated photography's apparent randomness of inclusion. Chase's handling of shape and color, whether found outdoors or in the gilded-age decor of his studio, is bright and crisp and sturdy, but he often contrives in his compositions to include an amount of empty foreground space that throws us off balance. *Prospect Park, Brooklyn* (c. 1886), *The Park* (c. 1888), *The Lake for Miniature Yachts* (c. 1890), and *Ring Toss* (1896)—all are jaunty in this Japanese, Whist-

lerish way. The classic full-length portrait of Whistler is by Chase, whose paintings overshadow those of Sargent in the show, save for Sargent's spectacular double portrait *Mr. and Mrs. I. N. Phelps Stokes* (1897). When Sargent attempts to be bucolic, as in *The Sketchers* (1914) and *Paul Helleu Sketching with His Wife* (1889), the effect can be sickly; he was rarely at ease with the color green.

In the so-called Realist camp, it is John Sloan who most fervently depicts the electric light and dark of city life, its shadowy, cooped-up flares of human incident. His painting, in a canvas like *Sunday, Women Drying Their Hair* (1912), remains rather loose, but the anecdotal element co-exists with a strict and inventive pictorial sense in *Easter Eve* (1907), the maligned *A Woman's Work*, and a charming gem, *Chinese Restaurant* (1909). *The Cot* (1907) (page 108) is the only painting in the show that directly invites us to contemplate the sexual life that teemed within the tenements, and is powerfully fleshy in its sullen reserve, as the light from an unseen window breaks in a few slashes of white on the edge of an unmade bed, while the bare-armed, bare-legged woman and her ruffled undergarment keep to the urban shadows. The olfactory barrier is almost broken; the smell of warmed bedclothes seems to waft out. The tints of city life were so thoroughly imbued in Sloan's blood that even the jumbled rooftops and blue waters of his *Gloucester Harbor* (1916) have a somber indoor cast to them.

George Bellows's paintings of ivory-pale, baroquely bent boxers remain the most memorable Realist works, but only one is hung here—*Club Night* (1907). His *Kids* (1906)—showing slum children in a state of staring, smoking, squalling idleness—is the most forthrightly proletarian of the exhibit's numerous vivid paintings of children, which include Mary Cassatt's chalky, elegant *Mother About to Wash Her Sleepy Child* (1880) and her masterly and much-reproduced *The Bath* (1891–92).

Cassatt and Sargent were, of course, expatriates; yet the training of all the artists in the show except Bellows and Sloan involved some European intervals, so that the artistic milieu of the period could be called transatlantic. In the transatlantic exchange, Americans were receivers rather than givers, as critics of the time were not too patriotic to avoid pointing out. "A good Monet is worth money; an imitation is worth nothing," Alfred Trumble wrote in *Art Collector* 2. Americans were buyers rather than sellers, also; not one of these eighty-five canvases was borrowed from a European museum. Our native performers had their spirited

twists of individual style, and their own continent to paint, but the attitude they as a group project is of dutiful students rather than of defiant truants. Only a single canvas, *Central Park* (c. 1914–15), by Maurice Prendergast, a Newfoundland-born display-card designer who had fallen under the influence of Cézanne and the Fauves, dared to look primitive and to provide an indication of what post-Impressionism might become. With its faceless figures, friezelike arrangement, and stained-glass colors applied in fat lateral brushstrokes as discrete as flagstones, the picture resembles none other in the show and takes Central Park only as a point of departure. The departure was already wildly under way in Europe (Picasso's *Les Demoiselles d'Avignon* was painted in 1907) and would lend the peace of a backwater to our Impressionism and Realism both— a peace that not all the sniping from the wall can quite shatter.

MAURICE PRENDERGAST
Central Park, c. 1914–15
Oil on canvas, 20¾ × 27"
The Metropolitan Museum of Art, New York. George A. Hearn Fund, 1950, 50.25

Street Arab

―――――

CHILDE HASSAM is a curious name, suggesting exotic antecedents; in fact, "Hassam" is a corruption of the English surname "Horsham," and the future painter was named Frederick after his father and Childe (meaning a youth of noble birth, as in Byron's Childe Harold) after an uncle. Frederick, born in 1859, early disposed of his given name—his earliest watercolors are signed "F. Childe Hassam"—and accepted from friends the nickname "Muley," after Muley Abul Hassan, one of the potentates of Granada described in Washington Irving's popular *The Alhambra*. The painter, who had a swarthy complexion, further teased the Middle East by attaching a crescent to his signature. But, no, he was born in Dorchester, Massachusetts, attended the Mather School atop Meeting House Hill, and basked in his Anglo-Saxon pedigree; he became, as his talent hardened, a Wasp reactionary, spurning much of modernism and in his work glorifying the American flag, white-painted Protestant churches, and what William Dean Howells called "the smiling aspects of life," as these aspects were found in well-preserved Yankee villages like Cos Cob, Old Lyme, and East Hampton. Like Howells, he was considered a regressive dinosaur in his old age, and his death brought on a collapse in reputation which neither the Library of America (in Howells's case) nor the Metropolitan Museum, in its generous 2004 retrospective *Childe Hassam: American Impressionist,* can easily repair.

 The show takes up eight rooms and intelligently concentrates on the early decades of Hassam's lengthy and prolific career. The later decades, the catalogue essay by Kimberly Orcutt explains, were taken up with a quixotic but brave neo-academism, involving stiff nudes in more or less real gardens—*Spring on Long Island (Venus Genetrix)* (1926), for example, shows a lanky naked lady strolling along a South Fork pathway in plain sight of a suspended farmer sowing his seeds. Much of Hassam's

(Opposite)
CHILDE HASSAM
Sunset at Sea, 1911
Oil on canvas, 34 × 34″
The Rose Art Museum,
Brandeis University, Waltham,
Massachusetts. Gift of Mr. and
Mrs. Monroe Geller, New York

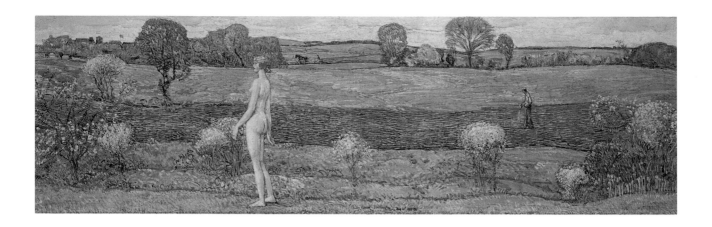

HASSAM *Spring on Long Island (Venus Genetrix),* 1926 Oil on wood panel, 24 × 49″ Collection of the American Academy of Arts and Letters, New York City

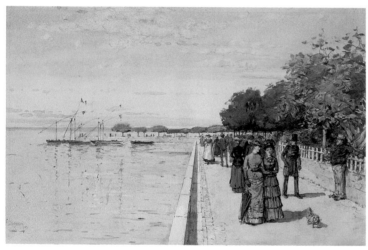

HASSAM
*Esplanade, Dunkerque
(The Beach at Dunkirk),* 1883
Watercolor, gouache, and
graphite on off-white wove
paper, 16¹⁵⁄₁₆ × 25¹³⁄₁₆″
The Metropolitan Museum of
Art, New York. Gift of Mr. and
Mrs. Arthur G. Altschul, 1971
(1971.246.2)

later production, unbought, was left to the American Academy of Arts and Letters, where its sales continue to fund the purchase and donation to museums of contemporary canvases that might spin the donor in his grave.

Hassam began, like Winslow Homer and Edward Hopper, as an illustrator. The loss of his father's hardware business to fire in 1872 helped to propel him out of high school and into the offices of a wood engraver, George Johnson, where he designed letterheads and commercial logos before moving on to illustrations in a children's magazine, *Wide Awake,* and the adult journals *Harper's Weekly, Scribner's Monthly,* and *Century.* By the age of twenty-three he had an office on Boston's School Street and listed himself as "artist"; he started to sell paintings in the early 1880s. His art education was improvised and spotty—he never learned anatomy, it was said when he began to paint nudes. The early watercolors *Country Road* (1882), *Old House, Nantucket* (1882), *Esplanade, Dunkerque* (1883), and *On the Deck* (1883) show a proficiency and composure not matched by a work in oils like *The Old Fairbanks House, Dedham, Massachusetts* (c. 1884), which all but loses the house itself in a slathering of dark-brown pigment and smothers the foreground grass under a ponderous wealth of strokes. *Village Scene* (1883–85), deploying what would become a characteristic mix of architecture and flowers, is painted conscientiously, with an anxious thickness. However, a large oil sketch, *French Peasant Girl* (c. 1883), executed either during Hassam's first trip to Europe or shortly thereafter, shows a

light, translucent touch, adventurously broad and flickering. Hassam's vigorous, even reckless, brush and his illustrator's eye for an arresting image sustained his career and did much to ease this viewer's suspicions that a full-fledged, 150-work (120 paintings, watercolors, and pastels, and some thirty prints) retrospective was a bit of a stretch.

His youthful, undertutored eye saw things that a more experienced painter might have skimmed past. *A Back Road* (1884), with its watery ruts, grassy mane, and battered irregularity, makes most such byways in Impressionist paintings look like the Yellow Brick Road. In 1884 Hassam married Kathleen Maude Doane and moved to Boston's newly expanded but already fading South End; he began to paint his neighborhood, remembering years later, "The street was all paved in asphalt, and I used to think it very pretty when it was wet and shining, and caught the reflections of passing people and vehicles. I was always interested in the movements of humanity in the street." *Rainy Day, Columbus Avenue, Boston* (1885) is a shimmering atmospheric study, gray and a muted brick-red, of a wide city space in the rain, which compares favorably, for a plausibility of tone and perspective, with Gustave Caillebotte's iconic *Paris Street; Rainy Day,* from the previous decade.

HASSAM
Rainy Day, Columbus Avenue, Boston, 1885
Oil on canvas, 26⅛ × 48″
Toledo Museum of Art. Purchased with funds from the Florence Scott Libbey bequest in memory of her father, Maurice A. Scott, 1956.53

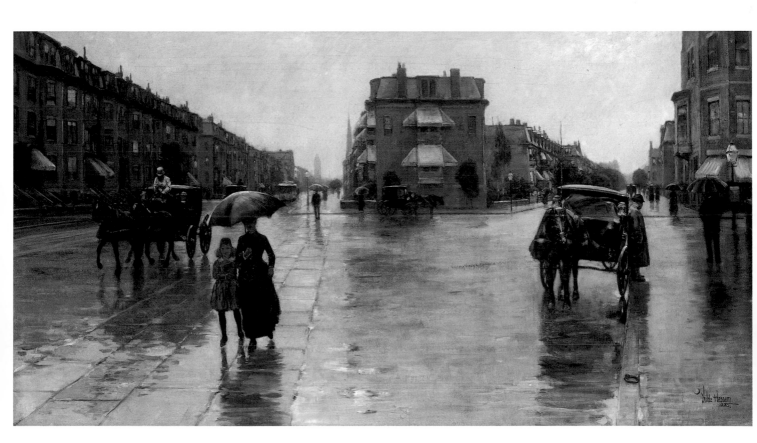

Hassam's *Boston Common at Twilight* (1885–86) is perhaps his masterpiece, and certainly one of the most-loved paintings in the collection of the Boston Museum of Fine Art. Divided exactly in half, like an open book, it crowds onto its lefthand page the tall buildings and the seething traffic of Tremont Street and the pedestrians treading a path worn in the snow at the Common's edge; the right half holds only a few small birds, a tapering row of benches and another of elms, and a snow-covered expanse. In the west, an orange glow through the trees signals the passing of sunset; city gloaming, the suspenseful moment as darkness descends and life moves toward the lamps of home, becomes elegiac. The tender foreground trio, a mother and her two children feeding the park sparrows, is rendered with the slightly awkward formality that Hassam brought to the human figure, and they are saved by it from sentimentality and overanimation. The viewer has no doubt that the subject of the painting is the dying orange light that tinges this frozen but inhabited urban extent. Some of the best of Hassam's copious painted tributes to New York City, such as *Winter, Midnight* (1894) and *Late Afternoon, New York: Winter* (1900), take fire, as it were, from a similar snow-shrouded moment, in which we feel Nature infiltrating and overshadowing a metropolis, whose lights nevertheless continue to burn.

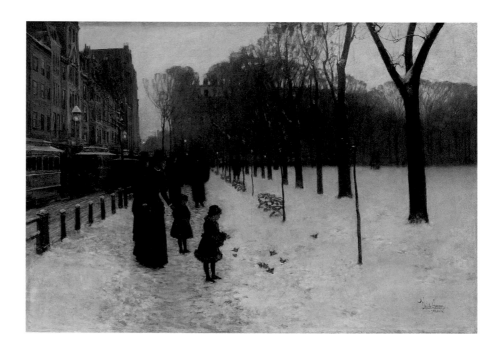

HASSAM *Boston Common at Twilight,* 1885–86
Oil on canvas, 42 × 60″
The Museum of Fine Arts, Boston. Gift of Mrs. Maude E. Appleton, 31.952

HASSAM
The Rose Girl, c. 1888
Center panel, oil on canvas
with gold leaf, 21¾ × 30⅛";
side panels, oil on wood with
gold leaf, each 15¼ × 6¼"
Senator and Mrs. John D.
Rockefeller IV

H. Barbara Weinberg, the chief curator of this exhibition as well as of the rather tendentious *Realism and Impressionism* show at the Met ten years ago, in her remarks at the press preview described Hassam as the American painter who went to Paris and brought back Impressionism; yet the room devoted to his three years studying and living in Paris, from 1886 to 1889, does not seem especially Impressionistic. Hassam had already absorbed, by transatlantic osmosis, the stabbing brushwork and plein-air approach of Monet and Pissarro, and by the late 1880s the movement had already sprouted the programmatic pointillism of Seurat. Hassam's attention, to judge by his results, was as much focused on the relatively conservative school of painters known as the "juste-milieu," the happy medium who, in Ms. Weinberg's phrase, "used conservative styles to render Impressionist subjects." Hassam's artistic temperament was too bold and impulsive to be thoroughly conservative, however. The decorous maiden of *In the Garden* (c. 1888–89), for instance, daydreams amid the violence with which the painter has scrubbed in lavender lilacs above her head. The orderly geraniums of *Geraniums* (1888–89) and their intent gardener are upstaged by the metal sprinkling cans in the foreground, rendered in a searching variety of grays. *The Rose Girl* (c. 1888), in its unusual triple frame (Hassam took an active hand in his frames, following Whistler's innovations, which favored unadorned bands of gilding), seems all too Pre-Raphaelite; the girl's uplifted, Joan of Arc face refuses to jell with either the tumbled flowers in front of her or the weirdly collagist street scene behind.

(Left)
HASSAM
La Fruitière, c. 1888–89
Oil on composition board,
14¼ × 10¼″
Curtis Galleries, Minneapolis

(Right)
HASSAM
Along the Seine, Winter, 1887
Oil on wood, 8 × 11″
Dallas Museum of Art. Bequest
of Joel T. Howard

Une Averse—rue Bonaparte (1887), Hassam's first Salon piece, is imposing but ungainly. The hard-pressed working couple, presumably man and daughter, in the forefront make it look like a piece of protest art; as such, it wins Ms. Weinberg's praise for signalling "the coexistence of hardship and prosperity in the modern city and the demise of rural traditions that accompanied urban growth." Sociologically correct it may be, but its jaundiced colors look willfully dull, and the gleam of wet streets doesn't have the magic it did back in the freshly paved South End of Boston. The line of hackney coaches with their horses draws forth his best painting. Hassam's Paris sojourn is distinguished by some dazzling, dashingly painted horses and carriages, above all the one moving through the snow in *Along the Seine, Winter* (1887). *Grand Prix Day* (1887) brings a conclave of carriages into sunlight, and the union of brightness and solidity suggests Degas, as do the cut-off forms of *Carriage Parade* (1888). Hassam, who turned thirty on his return voyage, was somewhat older than his fellow–art students, and, already married, staider. He worked hard, up to a point, at the Académie Julian, but his less academic moments are the ones to be treasured: the slashing, broad-brushed skirts and reflections in *Promenade at Sunset, Paris* (1888–89); the brittle white

petticoats of *Mrs. Hassam and Her Sister* (1889); the memorably mis-shapen tree of *Peach Blossoms—Villiers-le-Bel* (c. 1887–89); and the astonishing action painting of the turquoise half-walls and gumbo pump-kins in *La Fruitière* (c. 1888–89).

Hassam returned to live not in Boston but in New York, of which he said, "To me New York is the most wonderful and most beautiful city in the world. All life is in it." As such it was the ideal place in which to prac-tice his credo of 1892:

> I believe the man who will go down to posterity is the man who paints his own time and the scenes of every-day life around him. . . . A true histori-cal painter, it seems to me, is one who paints the life he sees about him, and so makes a record of his own epoch.

Here, as skyscrapers replaced mansions and brick tenements, and elec-tric- and gasoline-powered conveyances replaced horse-drawn carriages, he set up, in a succession of apartments and studios, his easel. He did not teach or accept many commissions; he manufactured product for galleries to sell. Small wonder that an assembly-line quality dulls the voluminous work with which he supported himself and Maude in the style of a Northeastern grandee. A certain haste and scratchi-ness appear, and bits of blank canvas peep through. As the century turns, his franchise as—as one critic said in 1892—New York's "street painter par excellence" lapses in favor of brooding apartment-bound women in kimonos and negligees, of halcyon New England scenes, of endless flowers and rocks in New Hamp-shire's isolated Isles of Shoals.

Still, the remaining rooms of this "chromothemati-cally" arranged retrospective display some stirring intervals of observation and technical adventure. *Con-versation on the Avenue* (1892), for instance, does not work at all as a representation in three dimensions; it is as dynamically flat, and perhaps as gynophobic, as a de Kooning *Woman*. Some of the urban views (*Lower Fifth Avenue*, 1890; *Union Square in Spring*, 1896) do more, as dramatic compositions, than merely record—a matter of interest, as he predicted—the vanished cos-

HASSAM
Lower Fifth Avenue, 1890
Oil on canvas, 25¼ × 21"
Private collection

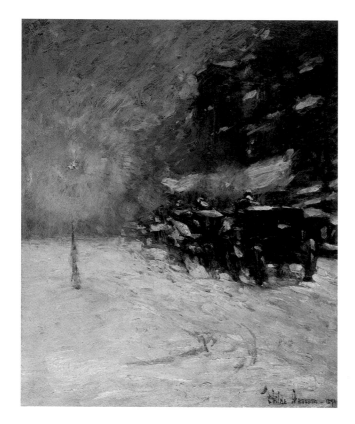

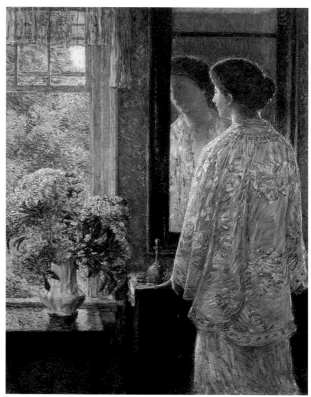

(Left)
HASSAM
Winter, Midnight, 1894
Oil on canvas, 21½ × 17½"
Columbus Museum of Art

(Right)
HASSAM
Twenty-sixth of June, 1912
Oil on canvas, 31¾ × 24½"
Collection of Mr. and Mrs.
Theodore N. Lerner

tumes and architecture of his Manhattan. Some of the night scenes (*Winter, Midnight; Cab Stand at Night, Madison Square*, 1891) are brilliantly theatrical and convey a sense of the urban underside, the struggle for survival, not unworthy of George Luks or George Bellows. The well-known *The Room of Flowers* (1894), depicting the poet Celia Thaxter's parlor, is one of the few American paintings that could be called riotous, in the way that Bonnard is riotous, cramming in color with no fear of dissonance; each detail speaks a language of time and place and class.

The Realist in Hassam was as strong as the Impressionist. Approaching him as an Impressionist, we are disappointed at the lack of an ongoing theoretical pursuit, such as the one that took Monet through all the shades of haystacks and poplars to the giant color-tangle of his water lilies, or Cézanne's enterprise of reconstructing, one weighed stroke at a time, the basis of visual form, or even Hassam's friend John Twachtman's patient seasonal exploration of his own property in Greenwich. The most theoretical painters to have an admitted influence on Hassam were

Turner, whose watercolors struck him on his first trip abroad, in 1883, and Whistler, whose kimonos and nocturnes receive the homage of imitation in *Twenty-sixth of June, Old Lyme* (1912), *Nocturne, Railway Crossing, Chicago* (1893), and *The Evening Star* (1891). This last, relatively early work, a pastel, is Hassam's most nearly abstract work.

The sea is a great simplifier. Cruising through the numerous—all too numerous: a tenth of his total output—paintings of the Isles of Shoals, one comes upon two near-pointillist, high-horizoned paintings of stark ocean, *The West Wind, Isles of Shoals* (1904), and the deliciously colored *Sunset at Sea* (1911). His watercolors in this stony marine environment can be freer and more intense than his oils; the blue-greens of *The Cove* (1912) and *The Gorge, Appledore* (1912) sink the eye in ink-pure depths. Looking at the tumultuous brushwork, in oils, of the watery foregrounds of *Surf, Isles of Shoals* (1913) and *Duck Island from Appledore* (1911), or the stratified, tenaciously clinging strokes of *Sylph's Rock, Appledore* (1907), one sees how much of a Fauve this painter of smiling aspects was. His still life *Winter Sickle Pears* (1918) evokes a comparison with van Gogh's *Apples* (1887), but in van Gogh parallel brushstrokes become a mannerism, a signature of his increasingly inward vision, whereas in Hassam they remain the byproduct of an energetic hurry, a trace of vigor never formalized into a motif.

His case is very American in that we feel something—the haut-bourgeois art market he had to court, or a prematurely closed mind, or a too-keen enjoyment of a comfortable and honored life—prevented him from doing full justice to his talent. He turned, first, from the city subjects that he had proclaimed his to capture, and then, in the 1920s, to a stylized, muralistic Arcadia that was dim enough when Puvis de Chavannes was doing it. But the finer talent of John Singer Sargent took a similar neo-

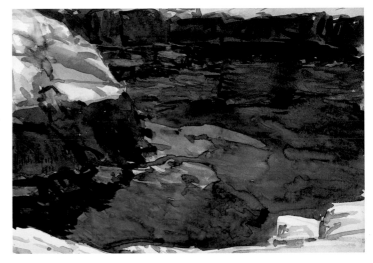

HASSAM *The Cove*, 1912
Watercolor on paper, 14 × 20″
The John W. and Mildred L. Graves Collection, Wichita Art Museum, Wichita, Kansas

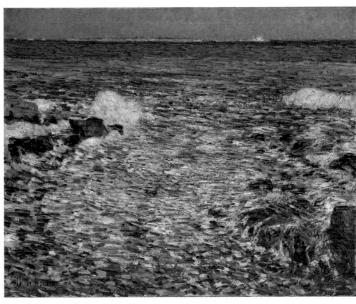

HASSAM *Surf, Isles of Shoals*, 1913. Oil on canvas, 28¼ × 35¼″. The Metropolitan Museum of Art, New York. Gift of Dr. and Mrs. Sheldon C. Sommers, 1996, 1996.382

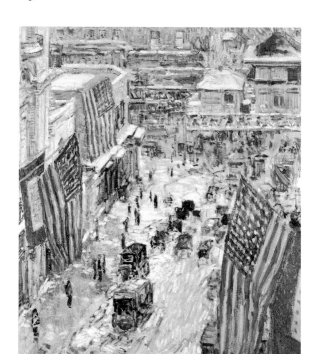

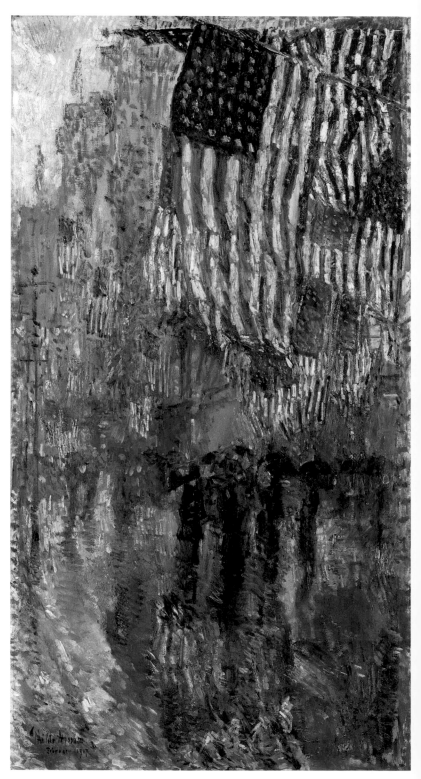

(Left)
HASSAM *Flags on Fifty-seventh Street,
the Winter of 1918,* 1918
Oil on linen, 37 × 25″
Collection of the New-York Historical Society,
1984.68

(Right)
HASSAM *The Avenue in the Rain,* 1917
Oil on canvas, 42 × 22¼″
White House Historical Association
(White House Collection)

classic turn, as if seeking, in the hustling world of privatized gallery art merchandized to the well-to-do, the kind of communal accreditation and official patronage bestowed on artists in the Renaissance. The exhibition's last room holds seven of Hassam's thirty flag paintings, a series depicting Fifth Avenue and adjacent streets as canyons hung with patriotic banners between 1916 and 1919. These paintings bring his highest prices now, though he was disappointed by his failure to sell the lot to the city of New York or an American museum.

Collectively they show him excelling as an illustrator but not as a painter. The dun-colored buildings along the avenue are perfunctory and milky-pale. The people are black daubs, most brutally reduced, along with the black boxes of motorized vehicles, in *Flags on Fifty-seventh Street, the Winter of 1918* (1918); they put me in mind of the bug-people Saul Steinberg used to draw from the vantage of his Union Square studio. A painted flag, as Jasper Johns was to make clear, is both an image and the thing itself; we are tempted to salute. Hassam's flags are raw red, white, and blue, with little attempt to give them texture or folds. In *Flags on the Waldorf* (1916), they almost merge with the spattery indications of cornice and window, and in *Victory Day, May 1919* (1919), the mist of the day envelops them. The most engaged and unified painting, to my eye, was *The Avenue in the Rain* (1917), where Hassam's old love of wet reflection stirs him to the broadest, boldest brushwork in the series. Over three feet tall, the canvas resides in the White House.

Posterity looks for hooks to hang old reputations on; the flags have become Hassam's hook, and there is a fittingness in this, even in their relative vulgarity. "The movements of humanity in the street" are epitomized on high by the outflow of flags from the stony façades; without violating the realism that was Hassam's strength, the flags, like emotions made visible, express the city's humanity, in a joyous voice.

Evangel of the Lens

————

IN 1983 the National Gallery in Washington mounted its first exhibition devoted to photography, a show of seventy-three prints by Alfred Stieglitz, curated by Sarah Greenough and Juan Hamilton. Hamilton was an assistant to Stieglitz's widow, Georgia O'Keeffe, who in 1949 and in 1980 had donated to the Gallery approximately sixteen hundred Stieglitz photographs; the photographer had died in 1946, at the age of eighty-two. O'Keeffe, who died in 1986 at the age of ninety-nine, took a loving hand in the 1983 show, providing not only its materials and her advice and expertise but funding for the elegant catalogue, utilizing tritone reproductions and designed by Eleanor Caponigro. With the financial support of the Eastman Kodak Company, whose changing standards of manufactured film and stock more than once infuriated the fastidious Stieglitz, the catalogue, its original edition long out of print, has been reproduced in a second edition by "the skilled craftsmen at Stamperia Valdoncga, Verona."* Some pages of acknowledgments thank the many who have enabled the moving spirits "to realize this dream and share this beautiful publication with a new generation," and over forty pages at the end give, in thoughtfully arranged excerpts from letters and essays, Stieglitz's thoughts on photography.

So sumptuous an artifact, measuring eleven by fourteen inches, printed on creamy "specially manufactured archival paper," would surely, for all its self-congratulatory clatter of a mobilized establishment, have pleased Stieglitz as homage to photography as an art, and as tribute to his own contribution to the art. In his evangelism for "the advancement of pho-

ALFRED STIEGLITZ
Dancing Trees, 1922
Palladium print, 9⁷⁄₁₆ × 7½"
The Metropolitan Museum of Art. Gift of David A. Schulte
(28.127.2)

* *Alfred Stieglitz: Photographs & Writings,* edited by Sarah Greenough and Juan Hamilton, with an introduction by Greenough (Boston: Bulfinch Press, Little, Brown and Company, 2nd edition, 1999).

tography along the lines of art," he sometimes neglected to practice what he so passionately preached. In 1915 he wrote to H. C. Reiner, "Strange as it may sound, my photograph experimenting had to be side-tracked for years, for the bigger work I was doing in fighting for an idea, fighting practically single handed." The word "idea," sometimes italicized, recurs in his writing like a war cry. A letter of 1917 to Williamina Parrish, rejecting some of her photographs for his gallery of the time, tells her bluntly:

> The Little Gallery is not devoted entirely to the ultra modern in painting and sculpture. It is devoted to ideas. To the development of such. And I feel that your work, good as it is, is primarily picture making. That is not adding to the idea of photography, nor to the idea of expression. And for that reason it would be out of place in the Little Gallery.

Sometimes in his letters, Stieglitz regrets that he cannot express himself better, in German; as if English *were* German he coins the curious compound expression "idea photography":

> [I am] trying to establish, once and for all, the *meaning* of the *idea* photography. I have proceeded in doing this in an absolutely scientific way. . . . And possibly the greatest work that I have done during my life is teaching the value of seeing. And teaching the meaning of seeing.

It is hard to remember that he came from Hoboken, so Old World is the humorless absolutism of his pronouncements. He was born in 1864, the son of cultured German-Jewish immigrants who had prospered in dry-goods merchandising. In 1871 they moved to Manhattan, and ten years later Alfred's father sold the business and moved the family to Europe, for the cultural benefits. Alfred was sent to study engineering at the Technische Hochschule in Berlin, but at nineteen he fell in love with photography, under the influence of Professor Hermann Wilhelm Vogel, a pioneer in the field of photochemistry. Stieglitz was ever a technical experimenter, pressing the rapidly evolving process for its new possibilities. Returning to New York in 1890, after eight years of a European education, he became the first photographer extensively to use the hand-held camera, the first to photograph in snow and in rain and at night. For him photography was an art not just of exposure but of development and print-making; an 1899 article for *Scribner's Magazine*, "Pictorial Photography," waxes poetic on the process:

The photographer has his developing solutions, his restrainers, his forcing baths, and the like, and in order to turn out a plate whose tonal values will be relatively true he must resort to local development. This, of course, requires a knowledge of and feeling for the comprehensive and beautiful tonality of nature. . . . The photographer, like the painter, has to depend upon his observation of and feeling for nature in the production of a picture. Therefore he develops one part of his negative, restrains another, forces a third, and so on. . . . The turning out of prints likewise is a plastic and not a mechanical process.

This essay, written a hundred years ago, when equipment was relatively cumbersome and tricky, recognized the problem with photography as an art: it is too easy.

Pictures, even extremely poor ones, have invariably some measure of attraction. . . . Owing, therefore, to the universal interest in pictures and the almost universal desire to produce them, the placing in the hands of the general public a means of making pictures with but little labor and requiring less knowledge has of necessity been followed by the production of millions of photographs.

Out of the morass, then, produced by the medium's "fatal facility," how to extract an art, an *idea*? The difficulty gives his theoretical pronouncements, as the years go on, an increasingly fanatical and ascetic, even a martyred ring. In the "antiphotography" of the post-Impressionist Europeans, and the moderns like Picasso and Matisse, he sees a salvation from cheap representationalism, whether practiced by the masses or by the adepts of "art-photography (I hate that word!)," with their soft-focus and (horrors!) retouched imitations of painting. His gallery at 291 Fifth Avenue, which continued to be called "291" after it moved next door to 293, took to displaying artists like Picasso, Brancusi, and Elie Nadelman, as well as such experimental American painters as John Marin, Marsden Hartley, and Arthur Dove. The organizing, the polemicizing, the magazine editing (*American Amateur Photographer* [1892–96], *Camera Notes* [1897–1902], *Camera Work* [1902–17]), the late-night discussions ("to give you an idea of the strenuousness of it all I might tell you," he wrote Ward Muir in 1913, "that during the four days last week I got only sixteen hours sleep and the other eighty hours were taken up in intellectual discussions") took a toll on his own work. He assured a correspondent in late 1911, "Daily I realize more and more, that in sacrificing my own

photography I have gained something I could have never possessed, and that is certainly a bigger thing"—the idea of modernism, presumably, which led, a letter of 1912 states, to "the true medium (abstraction)."

More and more he located the meaning of a photograph in a feeling that its record of surfaces somehow captures, "a feeling generated by, born of, intense experience." By 1922, he wrote Paul Strand, "*all* of me is in the centre of that thing digging into that centre's centre"; in 1925 he told J. Dudley Johnston, "My photographs are ever born of an inner need—an Experience of Spirit." In 1938 he complained to Edward Weston,

STIEGLITZ *A Street in Sterzing, Tyrol,* 1890
Platinum print, 5¾ × 8″
The Art Institute of Chicago, Alfred Stieglitz Collection

There seem to be millions on millions of photographers & billions of photographs made annually but how rare a really fine photograph seems to be. . . . Its a pathetic situation.—So little vision. So little true *seeing.*—So little *inness* in any print.

By 1938 he gave up the practice of the art, grown too weak to manipulate his heavy, old-fashioned apparatus. An exalted self-pity rings out as early as 1923: "I have all but killed myself for Photography." To Ansel Adams in 1933 he wrote a kind of epitaph: "I chose my road years ago—& my road has become a jealous guardian of me. That's all there is to it."

When one turns, after all this rhetoric of agonized purism, to Stieglitz's photographs, a certain sense of anticlimax is perhaps inevitable. Upon much of his work has fallen the fate he spelled out for "Steichen, Demachy, Eugene, the Viennese," who "did honest work for the development of photographic pictorial expression," but the bulk of whose prints "from the living art value point of view . . . have a greater historic value than art value." Among the seventy-three prints so lovingly reproduced in *Alfred Stieglitz,* the first, *At Biarritz,* dating from 1890, is charming, but perhaps almost any shot of beachgoers of that era, with their umbrellas and tall hats and drawing-room clothes, would charm. Of the photographs taken in Europe in the 1890s, our attention divides between the technical effects painstakingly achieved (mottled sunlight, sunlight shimmering on bent-over grain stalks, the slats of sunlight in a room with venetian blinds) and the venerable European idyll of wooden pumps, hand-harvesting, peasant girls in high button shoes, Venetian urchins in ornate rags.

Sarah Greenough's introduction suggests that "when he consciously set about to make, as he said, 'pictures,' not photographs, his images were usually quite derivative. . . . It was as if conquering the technical problems of photography freed him from the repetition of time-worn picturesque themes of painting." *A Street in Sterzing, The Tyrol* (1890) and *A Street in Bellagio* (1894) both swallow their picturesqueness in the technical feat of incorporating sunstruck plaster walls and heavily shadowed walls in the same print without loss of detail. Stieglitz was always interested, right up to his late photographs of New York City skyscrapers, in capturing the full range of tones presented by architecture in daylight. When Eastman Kodak let him down with an inferior grade of stock, the drop in quality, he wrote, "had changed the image completely—a gray superseding a rich black—a dirty white replacing a sparkling white.—It is enough to kill a sensitive human."

In the 1890s, he switched from European to Manhattan scenes, and the atmosphere sootily darkened. *Spring Showers—The Street Sweeper* (1901) is a study in grays, as dainty as a Japanese print and cropped into an elongate Whistleresque shape. (Stieglitz usually cropped, not regarding this type of "hand-work" as violating the integrity of the photograph.) From the decades of the century's turn come the smoky heroic masterpieces, seized at the outer limit of the camera's ability to capture half-light, by which Stieglitz is represented in photography anthologies: *Winter—Fifth Avenue* (1893), *The Steerage* (1907), *The Hand of Man* (1902), showing railroad yards in Long Island City, and *The Flatiron* (1902), his most famous image but absent from the National Gallery selection. There are also some smaller, sunny gems—*The City Across the River* and an untitled ferryboat, both from around 1910 and both playing on the bright ovals that sunshine makes of pilings and straw hats, respectively. He advised photographers to make their hand cameras weatherproof and to

choose your subject, regardless of figures, and carefully study the lines and lighting. After having determined upon these watch the passing figures and await the moment in which everything is in balance; that is, satisfies your eye. This often means hours of patient waiting. My picture, "Fifth Avenue, Winter," is the result of a three hours' stand during a fierce snowstorm on February 22d, 1893, awaiting the proper moment. My patience was duly rewarded.

STIEGLITZ *Spring Showers— The Street Sweeper,* 1901 Photogravure, 12⅛ × 5″ The Library of Congress, Washington, D.C.

STIEGLITZ *Winter—Fifth Avenue*, 1893
Photogravure from *Camera Work* 12, 1905, 8⅝ × 6¹⁄₁₆"
Philadelphia Museum of Art

Indeed so: the sensation of a city in a snowstorm, down to the texture of the slushy rutted snow and the American flag distantly whipping in the gray sky, has been brought eternally fresh from the era of horse-drawn carriages. Snow figures too in some of the night cityscapes Stieglitz took from the window of "291"; the dim but distinct line of drying wash in one, captured on the same plate as the incandescent windows, is a virtuoso stroke. To the Teens and Twenties of the twentieth century belong a muted series of portraits of artists and associates—Dove, Hartley, Marin, Marie Rapp, Francis Picabia, Sherwood Anderson, Hodge Kirnon. Except for an arrestingly boyish profile of Marcel Duchamp (1923), they are frontal, somber, backlit or dimly lit, fuzzy, and matte. Georgia O'Keeffe figures among them, beginning in 1917, and it is to her presence in Stieglitz's life, and to the closing-down of "291" in 1917, that we must credit the reawakening that his own photographic work underwent from 1917 to 1929. The letters to her quoted in the book have a new, innocent tone—the theoretical burden of "idea photography" has been put aside, and he simply sees and feels:

There are no stars out to-night.—Before I left 291—when all was darkness, as I stood a while at the old back window—It is more marvellous than ever—the new buildings are full of tenants—& all the windows were aglow.—It would be wonderful to spend a night there—on a simple cot—right at the window—watch the lights gradually go out one by one—until the buildings stood up as vast silhouettes—& then the dawn—the sun rises behind those giants.

Her loved person—her beautifully lean body (shown to better advantage by a print on display in Hartford* than by the angular pose in *Alfred Stieglitz*) and her plain, calm, determined face—gave him a subject, which he pursued with all his technical zeal, frequently focusing on her hands in conjunction with other textures. Stieglitz did not follow her into the Southwestern desert, but while she was a presence in his life he turned to nature: the trees around the Stieglitz summer place on Lake George

(Opposite)
STIEGLITZ *Georgia O'Keeffe: A Portrait (5)*, 1919
Palladium print, 9¹⁄₁₆ × 7⁵⁄₁₆"
Museum of Fine Arts, Boston. Gift of Alfred Stieglitz, 24.173

* *Stieglitz, O'Keeffe & American Modernism*, an exhibition at the Wadsworth Atheneum, April 16 to July 11, 1999. Catalogue by Elizabeth Mankin Kornhauser and Amy Ellis, with Maura Lyons.

(Left)
STIEGLITZ *Equivalent*, Set G,
Print 3, 1929
Gelatin silver print, 4⅝ × 3⅝″
Museum of Fine Arts. Gift of
Miss Georgia O'Keeffe, 50.852

(Right)
STIEGLITZ
*From My Window at An
American Place, North*, 1931
Gelatin silver print, 9½ × 7⅝″
The Art Institute of Chicago,
Alfred Stieglitz Collection

(e.g., the brilliant close-up *Dancing Trees* of 1922) and clouds, at first recognizably related to a horizon line, as in the eloquent *Music—A Sequence of Ten Cloud Photographs* (1922), and then severed from the earth and diagonally tipped, in the extensive *Equivalent* series of 1927–31, to effect virtually abstract photography. These prints made a stir in their time and satisfied Stieglitz's passion for an *idea*, but they don't, I confess, do much for me, especially at their snapshot size. Mostly strato-cumulus, the clouds might as well be mud puddles or dents left in the sand by retreating waves or waves themselves, conveying a sense of chaotic, sinisterly indifferent cosmic churning; one's eyes are grateful to locate, in some, a tiny white orb that we presume to be the sun.

Stieglitz never quite found, within his general conviction that photography should be an art, an artistic project as sweeping and consuming as Edward Weston's distillations of organic form or Ansel Adams's embrace of the West's vast spaces. Nor was he one of those, like Eugène Atget and

Henri Cartier-Bresson, for whom the camera was a natural and agile outgrowth of the mind, an organ of apprehension. Stieglitz's search for a photographic *"inness"* that would evoke "an Experience of Spirit" took the odd final form of deadpan window views of New York's buildings as they basked in the light and played host, even in the Depression, to new construction. These pellucid views, immaculate in their rendering of light and shadow, extend, according to Greenough's introduction, the cloud pictures' "abstract equivalent of emotional tension and spiritual conflict." She writes:

> They do not abandon the idea that photography could embody subjective expression. By contrasting the beauty of the skyscrapers with their unremitting growth, Stieglitz made the buildings symbolic not only of the continuous change of New York, but of change itself as a principle of all being.

This is reaching. To be sure, anyone not utterly inured to New York is, if not subject to the bliss Stieglitz described in his "giants" letter to O'Keeffe, moved by the grandeur and poignance of so much high-piled human housing. We cannot expect, however, the camera to suck in, with light and shade, the photographer's emotion. He must work at re-creating it; some such effort shows in the selection and arrangement of the *Equivalent* clouds. But the late midtown exposures, taken from convenient windows, are as impassive as surveyors' maps; they are rectilinear Rorschach blots in which we see what we can. They are inhumanly abstract—Pollocks without the dynamic dribble-work, color-fields without the color, photography for photography's sake. Photography is facts, seems to be Stieglitz's statement with these stark but brimming exposures, after a life spent vigorously contesting that it is an art.

Stieglitz's reputation feels in danger of dissolving. One hears his name (rhymes with "free glitz") mispronounced in ostensibly cultured circles. There is a nominal confusion between him and Edward Steichen, who in fact, after an early discipleship, offended his mentor by going commercial, at Condé Nast, and entrepreneurial, becoming, as a director at the Museum of Modern Art, the post-war photography world's powerbroker. Stieglitz's mistress and (as of 1924) wife, who came to him when she was a thirty-year-old Texas schoolteacher and he a handsome and famous master of fifty-three, eventually eclipsed him in fame and fortune; moving each summer to New Mexico, she left him behind in New York.

GEORGIA O'KEEFFE
*Pink and Green Mountains
No. 1, 1917*
Watercolor on paper, 9 × 12″
Spencer Museum of Art, The
University of Kansas, Lawrence,
Kansas. Letha Churchill Walker
Fund

O'KEEFFE
Evening Star V, 1917
Watercolor on paper, 8⅝ ×
11⅝″
Collection of the McNay Art
Museum. Bequest of Helen
Miller Jones

The German-educated native of Hoboken, once such a vital rabble-rouser in the retarded American artistic scene, is remembered through the mist of battles long won or, what comes in the heartless long view to the same thing, battles hardly worth fighting.

To refresh our collective memory, then, the National Gallery has issued its seventy-five-dollar memento ($101 in Canada), and the Wadsworth Atheneum has mounted its small but various show, containing a number of Stieglitz prints considerably sharper than their book versions (*The Steerage* is improved, and the portraits of Hartley [p. 145] and Marin), as well as photographs by a range of his contemporaries, such as Clarence H. White and Gertrude Käsebier, and paintings by modern American artists whose then-revolutionary works were displayed on the walls of "291" and its successor galleries. Georgia O'Keeffe is present seven times as a photographic subject and once as an artist, with a not-very-typical *The Lawrence Tree* (1929). A number of critics, the redoubtable Robert Hughes and Hilton Kramer, for two, have taken occasion lately to state that O'Keeffe's reputation is inflated—"a provincial talent," Kramer recently decreed in the *New York Observer,* whose magnified flowers and clamshells are "all tricked out with smarmy suggestions of a kind of freeze-dried eroticism." The Hartford show does not offer enough evidence to debate the issue, but its three examples of Arthur Dove's work remind us of how much O'Keeffe owes to Dove, who, like her, could not stop looking to the natural world even when painting abstractions. Kramer feels there is something half-baked and non-European in clinging to nature, even by a fingernail, yet for that generation of Americans it was where *inness* and Experience of Spirit lay; criticism must have more to do than complain of O'Keeffe that she was not Helen Frankenthaler, or of Dove that he was not Robert Motherwell.

The work by which O'Keeffe has become posterized and popular does have a dry, bleached quality of brushwork far from the impasto fury that is commonly taken as a sign of artistic authenticity. On the other hand, the catalogue for last year's show at the McNay Art Museum in San

Antonio, *O'Keeffe and Texas*,* shows how wet and wild and bright her work, especially in watercolors, could be, in the period when she and Stieglitz met and she was teaching at West Texas State Normal College, in the Panhandle. She had a number of strings to her bow, and if one string became a kind of Santa Fe kitsch, others sustain with indelible, determinedly personal images the spirit of Stieglitz's galleries, which were devoted, as he wrote in 1917, not to "the ultra modern in painting and sculpture" but to "ideas." However well her pictorial ideas hold up—and they have certainly achieved popular currency to a degree matched by few of her generation, male or female—her appearance in Stieglitz's life turned him back into an artist for a time, recalling him to reality, fleshing out his abstract passions.

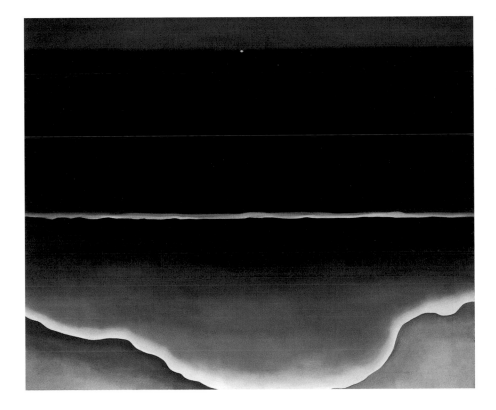

O'KEEFFE
Wave, Night, 1928
Oil on canvas, 30 × 36″
Addison Gallery of American
Art, Phillips Academy, Andover,
Massachusetts. Purchased as
the gift of Charles L. Stillman
(PA 1922), 1947.33. All rights
reserved

* Catalogue by Sharyn R. Udall, with a foreword by Ellen Bradbury and an introduction by William J. Chiego (San Antonio: Marion Koogler McNay Art Museum in association with Harry N. Abrams, Inc., 1998).

"A Lone Left Thing"

THE SOMETHING WOEBEGONE about Marsden Hartley—that long ponderous face, those haunted pale eyes, that wide-brimmed black hat—has perhaps put a damper on his reputation. Born of English emigrant parents in the dismal mill town of Lewiston, Maine, he was wounded by the death of his mother when he was eight and by a subsequent dispersal of his family that placed him in the care of an older sister; he became, he later wrote, "in psychology an orphan, in consciousness a lone left thing to make its way out for all time after that by itself." Homosexual, homely, egocentric, shy, slow to develop as an artist, pious in an Emersonian-Episcopalian way, he became a global drifter, largely in Europe but including Mexico and Nova Scotia as, perennially short of cash, he occupied a succession of rented, shared, or borrowed quarters. At the age of sixty he returned, part-time, to Maine, dying there at sixty-six, in the middle of World War II, just as his paintings were beginning to sell and he had, for the first time ever, some spare money.

However, the impression given by the extensive retrospective exhibition occupying ten stately upstairs chambers of the Wadsworth Atheneum Museum of Art, in Hartford, from January to April 2003, is one of boldness, freshness, jubilance, and élan. Hartley was first exhibited in New York in 1909, when he was already thirty-two, at Alfred Stieglitz's avant-garde "291" gallery; he is therefore considered one of the "Stieglitz circle," of which other members were John Marin, Arthur Dove, and Georgia O'Keeffe. These early American modernists have been overshadowed, much as the size of their canvases was dwarfed, by the Abstract Expressionists and the Pop artists, whose spectacular scale and international impact made their American predecessors look indecisive—parochial spirits wistfully caught between imported Cubism and native mysticism. Now that the magnificent monotones of the New York School

ALFRED STIEGLITZ
Marsden Hartley, 1915
Platinum print, 9⅝ × 7⅝"
The Art Institute of Chicago,
Alfred Stieglitz Collection

(Opposite)
MARSDEN HARTLEY
Sustained Comedy, 1939
Oil on board, 28⅛ × 22"
The Carnegie Museum of Art,
Pittsburgh. Gift of Mervin Jules
in memory of Hudson Walker

have themselves sunk into art history, we can be more patient, perhaps, with the conflicted impulses of American art between the wars. Two such impulses, amid the general pull toward abstraction, were the wish, carried over from the nineteenth century, to render American landscape in its bald beauty and inhuman force, and the desire, inherited from the Puritans, to make a personal spiritual declaration. The two tendencies, the naturalistic and the mystical, were strong in both Hartley and Georgia O'Keeffe, two Stieglitz protégés who never relaxed their sibling rivalry.

The oldest work on view in Hartford—*Walt Whitman's House, 328 Mickle Street, Camden, New Jersey* (c. 1905)—could hardly be smaller and dowdier, a greenish-black frontal view of the modest residence in which the Good Gray Poet harbored his strength and nurtured his legend. Yet curious flickering flames edge the many windowpanes. Hartley, a poet as well as a painter, saw himself in terms of flames: "bright flames of spirit laughter / around all my seething frame." His homage to Whitman carries a personal charge: Whitman's paeans to male camaraderie and pansexual rapture gave high-minded permission to Hartley's homosexuality and provided a lesson in artistic courage. Though three decades were to pass before Hartley's painted celebrations of the male body, his landscapes quickly acquired a naked force and individuality. *Storm Clouds, Maine* (1906–7) employed the overlapping "stitch" stroke of the Italian Giovanni Segantini to show a zigzag of sunlight imposed on a mountainside by a gap in the torrential clouds. *Carnival of Autumn* (1908) loosened the technique to replace spatial depth with running stripes of red and gold, under a sky whose clouds have already assumed the surreal lumpiness—clods of vapor—peculiar to Hartley. *The Ice-Hole, Maine* (1908–9) and *Deserted Farm* (1909) are yet more expressionistically rough and stark; his clouds are as solid as the earth and in close conversation with it, like those in the seascapes of Albert Pinkham Ryder. Hartley slightly knew Ryder when both, in 1909, lived on West Fifteenth Street, one as a struggling novice and the other as a notorious old eccentric residing in a nest of junk and sporting a long beard and wool skullcap. The elder painter's work was a revelation to Hartley, who later wrote that he "gave us first and last an

HARTLEY *Walt Whitman's House, 328 Mickle Street, Camden, New Jersey,* c. 1905 Oil on board, 9½ × 5½" Berta Walker Gallery, Provincetown, Massachusetts. Private collection

incomparable sense of pattern and austerity of mood" and "saw with an all too pitiless and pitiful eye the element of helplessness in things."

Stieglitz, in the course of a quarrel in 1923, wrote Hartley, "You were given your original Show in '291' because of my reading Suffering—Spiritual anguish—in your face." Though sales were few and far between, Stieglitz continued to be indispensably supportive. It was he who arranged the funds when Hartley, all of thirty-five, travelled to Europe at last to drink directly from the springs of Western art. *My Dear Stieglitz* (published by the University of South Carolina Press and edited by James Timothy Voorhies) prints the letters they exchanged, at a proportion heavily tilted toward Hartley's, between 1912, when the painter sailed for Paris, and 1915, when he returned for a second time from Germany. He was a copious letter-writer, in a run-on, dash-heavy style breathless with neediness and self-description; the letters to his niece, Norma Berger, are a treasure for Hartley scholars. These to Stieglitz trace his rapid disillusion with Paris. The artists "all talk so glibly but what do they produce":

HARTLEY
Storm Clouds, Maine, 1906–7
Oil on canvas, 30 × 25″
Collection of Walker Art Center, Minneapolis. Gift of the T. B. Walker Foundation, Hudson Walker Collection, 1954

> Apart from Renoir and the Cézannes one may see occasionally there is absolutely nothing worth looking at. I have been quite shocked of late with the mediocrity of men like Flandrin, Friesz—Manguin—it is too dreadful. Matisse becomes one of the gods after this terrible stuff.

French men, furthermore, struck him as "hideous": "I turn to the Germans as to the gods—if there was ever a more ridiculous lot of males as a clan it is these French men." A visit to Berlin in 1913 confirms his Germanophilia:

> One sees such fine types all about—a fine extravagance of physical splendour. I think nature is especially interested in her German product. The general type is so well formed and equipped with energy—there is here a fine creative tendency in the race. None of the sickliness of the French.

Moving to Berlin later that year, he arrives in a season of celebrations and revels in the ubiquitous military presence:

> The military life adds so much in the way of a sense of perpetual gaiety here in Berlin . . . those huge cuirassiers of the Kaiser's special guard, all in white—white leather breeches skin tight, high plain enamel boots—those gleaming, blinding medieval breast plates of silver and brass—making the eye go black when the sun glanced like a spear as the bodies moved. There were the inspiring helmets with the imperial eagle, and the white manes hanging down. There was six foot of youth under all this garniture— everyone on a horse, and every horse white—that is how I got it, and it went into an abstract picture of soldiers riding into the sun.

Up through 1915, with war declared and anti-German sentiment rising in the just barely neutral United States, Hartley clung to his Berlin residence, his vain hope of becoming a successful artist there, and his good opinion of the Germans. One fulsome sentence eerily anticipates the methodical

HARTLEY *The Warriors,* 1913
Oil on canvas, 47½ × 47¼″
Private collection

ruthlessness of the Holocaust: "The genius is always despised for his peculiar efficiency and Germans do not dream of war—they do it with system and with all the methods of business that any business requires."

Hartley's first major phase, dealing with German subjects and memories, is given a starring role in the Hartford exhibit, preceded by a beautiful *Still Life* of 1912, suggesting a heavier-handed Cézanne, and by several large mystical/musical canvases, thinly painted and hectically composed, influenced by the Blaue Reiter theories. Hartley had absorbed them, and Kandinsky's *On the Spiritual in Art* (1910), before venturing to Germany. His early German canvases—*Portrait of Berlin* and *The Warriors,* both from 1913—continue a sketchy, thinly painted manner, his version of Macke's and Delaunay's stained-glass colors. Arcane symbols—eight-pointed stars, the figure 8 in a triangle—further attenuate the effect; the "abstract picture of soldiers riding into the sun" mentioned above turns the cuirassed white warriors into rather feebly outlined dolls, symmetrically arranged among mock cathedral arches; all but a few in profile are presenting a rear view of their eight-starred backs and their horses' rumps. Just as one should not hasten to patronize Hartley's positive view of a more innocent Germany, one should not rush to read anal symbols* into his celebration of military manhood. But sphincterlike rings dominate *Himmel* (c. 1914–15) and the thrust of phallic penetration is alarmingly vivid in *Military* (1913). *The Aero* (c. 1914), the catalogue explains, "takes its name from the flaming red spot in the upper half of the canvas, which is meant to depict the flames at the rear of a dirigible engine." Zeppelins with their flaming anuses frequently passed over Berlin—"a fascinating thing which transports one somehow every time one sees any of them," Hartley wrote Stieglitz in June of 1914.

After the guns of August, he did not paint for several months. The fall casualty lists began to include the names of his friends, most painfully that of his close friend Karl von Freyburg. Hartley wrote Gertrude Stein that the slain von Freyburg had been "in every way a perfect being—physically—spiritually & mentally beautifully balanced—24 years

HARTLEY *Military,* 1913
Oil on canvas, 39¼ × 39¼"
Wadsworth Atheneum Museum of Art, Hartford, Connecticut. The Ella Gallup Sumner and Mary Catlin Sumner Collection Fund

* He was aware of sexual symbols. In 1921 he wrote, in a tone of disapproval, that Georgia O'Keeffe's paintings were "probably as living and shameless private documents as exist, in painting certainly." The shamelessness presumably refers to her paintings of large flowers, with their pictorial suggestion of the human vagina.

young—and of all things—necessary." He embarked upon a series of commemorative paintings in some of which military symbols—banners, stirrups, spurs, white helmet tassels, crosses (von Freyburg was awarded an Iron Cross in a campaign preceding his death near Amiens)—are grouped to form the shape of an absent body. *Portrait of a German Officer* (1914), which passed from the Stieglitz Collection to the Metropolitan Museum of Art, was the first and most impressive of these. Two numbered paintings (*Painting No. 47, Berlin,* 1914–15, and *Painting No. 49, Berlin,* 1914) more distinctly communicate the human shape, one on a black background and the other on a white. The majority of these so-called War Motif canvases were primed in black, which leaks through the rousing colors. Two abstractions (*The Iron Cross,* 1914–15, and *E. [German Officer—Abstraction],* c. 1915), full of ring shapes and the stripes and black-and-white checks of military flags, are the most densely, stridently hued, around a keynote of red. Georgia O'Keeffe said that these paintings, exhibited in New York in 1916, were "like a brass band in a small closet." They also call to mind a saying of Cézanne's that Hartley had pinned up on his wall: "When color reaches richness form attains fulness." In Hartley's most satisfying paintings, colors jam the frame, filling every inch of space as if wedged there.

He returned from Germany but did not settle down. His peripatetic life finds reflection in the restlessness of his work as it trails through the rooms at the Wadsworth Atheneum. In the very period of his War Motif paintings he was also producing large canvases on American Indian themes. In November of 1914 he wrote Stieglitz, "I find myself wanting to be an Indian—to paint my face with the symbols of that race I adore." The Germans liked Romantic images of the Native Americans, but Hartley's pastiche of tepee shapes, staring birds, and braves in feather headdress look like faded rugs, carrying much less conviction than his thickly dark still life *Indian Pottery (Jar and Idol)* from 1912, or the rugged naïve paintings of New Mexican religious statuettes from 1918–19. A rather Klee-like still life, *Handsome Drinks* (c. 1916), strikes a bright note of civilized recreation, as does *A Nice Time* (c. 1915–16), with its ruddy banana and tinkling colors, one lime-green lower corner somehow chiming with two corners of pale salmon above. Hartley could be as impudent and lyrical a colorist as Matisse.

At about this time in his necessarily thrifty career he switched from canvas to various sorts of composite board, which he said took forceful brushstrokes, was easy to transport, and cost less than a quarter of what canvas did. His cheap brushes, we are told in an illuminating catalogue essay by Stephen Kornhauser and Ulrich Birkmaier, left many a stray hair in the paint. His style of brushstroke, usually as fixed as handwriting in a mature painter, varied from the sweeping, greasy strokes of *Landscape, New Mexico* (1923) and *New Mexico Recollections—Storm* (1923) to the dry dabble of the Provincetown-Bermuda semi-abstractions *Elsa* (1917) and *Trixie* (c. 1916–17). Painting *Mont Sainte-Victoire, Aix-en-Provence* (1927), he parodies Cézanne's tight parallel strokes in electric violets and pinks, and in *Mountains in Stone, Dogtown* (1931) his strokes pursue shapes that writhe like foreshortened figures in a Thomas Hart Benton mural. From the same series, done in Gloucester, Massachusetts, *Flaming Pool, Dogtown* (1931) offers an especially happy meeting of Cézanne's patient intensity with a brusquer, more expressionist handling.

If all these shifts have a direction, it is perhaps toward a style of rich colors and slightly ragged black outlines, like that of the later Max Beckmann, whose self-portraits and enigmatic allegories were on display, with other contemporary German work, in the 1930s in New York. Certainly there is much Beckmann in Hartley's "archaic" (his word) portraits, both group and individual, of the Masons, a family of Nova Scotian fishermen with whom he lived, drank, and possibly loved for stretches in 1935 and 1936; the idyll ended when two of the brothers, Donny and Alty, were drowned, with a cousin, in a September gale. Their portraits, done from memory, begin with the tableau *Fisherman's Last Supper* (1938), in which the two drowned sons are given, in the place of halos, the eight-pointed stars with which Hartley's cuirassed German soldiers had been endowed, and end with the same group and title in a 1940–41 version. In between, there are individual portraits of (under false names) the mother, father, the forlorn sister, and Hartley's favorite, Alty, with a rose above his ear and the fanciful designation *Adelard the Drowned, Master of the "Phantom"* (1938–39). The portraits have a saintly sternness and primitive frontality, monumental but gentle, the subjects' big limp hardworking paws on display in the foreground. They look lovingly carved in paint. To this same blocky style belongs a charmingly wooden flower study, *(Flowers) Roses from Hispania* (1936) and the remarkable *Smelt*

Brook Falls (1937), a portrait of a white waterfall as firmly posed and decisively angled, in its setting of autumn brown and bare black branch,

as a still life. There is a cartoony quality to Hartley's later works, but, then, the Thirties were a heyday of comic strips and caricatures; their jaunty approach served other contemporary artists of high intent—Grant Wood, Ben Shahn, Jack Levine.

Hartley's Nova Scotian interlude with its tragic end had the effect of bringing him back to Maine. In this decade of artistic regionalism, he declared himself "the painter from Maine," emphasizing the "the," even though Marin and Andrew Wyeth and others were also in the state. From 1937 on, slowly letting go of New York City, he spent part of each year in Maine, the locales including Georgetown, Vinalhaven, Portland, Bangor, and the isolated fishing village of Corea, where he lived until his death. He came home in several senses—to the mountains and the sea that were in his blood and, in a number of Beckmannesque male figures, to his homoeroticism. A stunning self-portrait, *Sustained Comedy* (1939), shows him (with a nod to Walt Kuhn's painted clowns) as a flaming queen, martyred by an arrow piercing each blue eye, consoled by butterflies and birds on his shoulder, marked by tattoos of nudes and a crucifixion and a sailboat, a starfish and a rose;

HARTLEY *Adelard the Drowned, Master of the "Phantom,"* 1938–39 Oil on academy board, 28 × 22″ Collection of the Frederick R. Weisman Art Museum, University of Minnesota, Minneapolis. Bequest of Hudson Walker, from the Ione and Hudson D. Walker Collection

his hair is dyed blond and his unsmiling face is rouged and lipsticked, beautified like that, perhaps, of the man who twenty-seven years before, fresh in Paris, had gone to the Quatres Arts Ball and boasted to Stieglitz, "Quite the most wonderful spectacle probably in existence—2000 people in Arabian Nights costume—myself as gorgeous as any in effect."

This confrontational self-outing clears the way for *Flaming American (Swim Champ)* (1939–40) and *Madawaska—Acadian Light-Heavy* (1940), two panels commissioned to decorate a gymnasium, near-nudes of great-chested young men, the former dotted with blond hair and the

(Left)
HARTLEY *Madawaska—
Acadian Light-Heavy,* 1940
Oil on hardboard, 40 × 30"
The Art Institute of Chicago.
Bequest of A. James Speyer

(Right)
HARTLEY *Christ Held by
Half-Naked Men,* 1940–41
Oil on hardboard, 40 × 30"
Hirshhorn Museum and
Sculpture Garden, Smithsonian
Institution, Washington, D.C.

latter a black-furred gladiator, a burly *kouros,* with a blank yet lovely
mask of a face. As much as in a Malliol or Lachaise statue of feminine
grandeur, erotic focus deforms anatomy; the locals in *Down East Young
Blades* (c. 1940) have tiny heads with oval eyes like those of a Modigliani
mistress. A real woman, in a bathing suit, is admitted to *On the Beach*
(1940), but she is a stiff little cutout, no bigger than a dog, compared
with the deeply browned bodies of the two male bathers, lounging broth-
ers to the standing *Canuck Yankee Lumberjack at Old Orchard Beach,
Maine* (1940–41). Hartley was not oblivious to female charms; he experi-
enced several heterosexual involvements and even was claimed as father
by a gentleman born in 1915. But his eye, as he aged and weakened and

fattened, went to squared-off male flesh, which received its weirdest tribute in *Christ Held by Half-Naked Men* (1940–41), an all-male Pietà whose mourners wear little lobstermen's hats like miners' caps. The dead Christ has a head the size of a nugget, while his legs and arms trail into nothing. In the skimpy annals of American religious art this is among the strangest instances but not the least moving: a chorus of love objects silently cherishing "a lone left thing."

Men, and mountains: after making the strenuous trip, for a man so out of shape, to the base of Mount Katahdin (whose bleak summit had been marvellously described by Hartley's hero Thoreau), the artist sketched for six days and eventually did nearly twenty mountain paintings between 1939 and 1942, of which four are on view in Hartford. Each has its qualities but all share one we might call yearning—the lakeside trees and mountaintops reach upwards toward those opaque cloud-boulders, and the elemental gesture is not so different from the crashing upsurge of water in *The Wave* (1940) and the serenely phallic *The Lighthouse* (1940–41), where waves and clouds are indistinguishably of the same raw white. The silhouette of *Mount Katahdin, Autumn No. 2* (1939–40) is pure black, against a child's sky of clouds like islands in a stark blue sea, and the autumnal red is not far from the red of the war paintings: it's all as economical as a linoleum cut. Under his touch the world

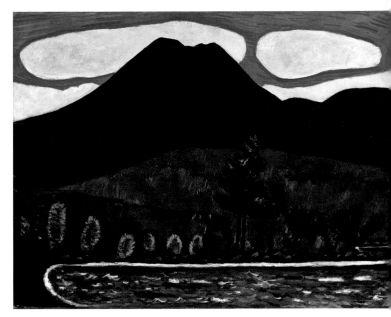

HARTLEY *Mount Katahdin, Autumn No. 2*, 1939–40 Oil on canvas, 30¼ × 40¼" The Metropolitan Museum of Art, New York, Edith and Milton Lowenthal Collection. Bequest of Edith Abrahamson Lowenthal, 1991, 1992.24.3

dissolved into its elements; the wandering painter had arrived at iconography—at a way of painting as primitive and resonant as Ryder's. He wrote a friend about his trip to Mount Katahdin, "I feel as if I had seen God for the first time. I found him nonchalantly solemn."

O Pioneer!

ARTHUR DOVE broods over New York this mild winter of 1998. In addition to the admirable retrospective show, extensive but not exhausting, running from January to April at the Whitney, there are: from February to June, a smaller, mezzanine exhibit at the Metropolitan, entitled *Land and Water* and displaying twenty works by Dove with four by his second wife, Helen Torr; shows of his small works on paper at the Terry Dintenfass and Tibor de Nagy galleries; and an array of Helen Torr's works at the Graham Gallery. Dove in his lifetime (1880–1946) enjoyed some renown and patronage but never enough for comfort's sake; his existence was an edgy, financially distressed one, lived in such marginal accommodations as an old farmhouse in Geneva, New York, without electricity or running water, a small former store and post office on stilts in Centerport Harbor on Long Island, and, for seven years, a forty-two-foot yawl that he shuffled about Long Island Sound. His privations took a toll on his health and, with his intermittent career as an illustrator and farmer, on his practice of art. His father was a rich brick-manufacturer and contractor in Geneva, New York, who disinherited Arthur after the young man not only declined to become a lawyer but gave up commercial illustration for pure painting. In his photographs the artist, even when he is clowning with a frame around his head, looks serious and a bit harried—a well-combed, white-shirted, scarcely smiling refugee from the upper middle class.

To him belongs the honor of being (after Navajo blanket-weavers and Amish quilt-makers) the first American abstract artist; he suddenly lit out, in 1910, for the non-figurative territory implicit in the paintings of Cézanne and Picasso and in the relativistic readjustments of space and time proposed by Bergson and Einstein. To the end of Dove's life he thought about the issues of abstraction, and in his last, ailing years,

embraced its larger, more colorful possibilities, having begun in the brown aura of Cubism. A lover and student of outdoor nature from his upstate boyhood, he never attained the unbridled egotism and anthropocentricity of action painting, and kept almost always in his work a kernel of representation, however well hidden—the sun, clouds, the blue horizontal of sea or pond, phallic bioforms and vaginal archways. Georgia O'Keeffe, whose fame has eclipsed his, was as early as 1914 an admirer of Dove, calling him "the only American painter who is of the earth." Both found in Alfred Stieglitz something more than artistic sponsorship; O'Keeffe found a lover and, after 1918, an open consort, and Dove a surrogate father, to replace the brickmaker who had disowned him. Dove early became a key member of the Stieglitz circle. Stieglitz provided him exhibition space at his three successive Manhattan galleries— "291" on Fifth Avenue, the Intimate Gallery on Park, An American Place on Madison—and gave Dove, in his bucolic rootlessness, a continuous connection with New York and its art world. The two men died the same year, 1946, by which time the bolder and more triumphal movement of Abstract Expressionism had put the Stieglitz set in the shade. Dove's earnest nature-mysticism and effort to (as he noted in 1942) "work at the point where abstraction and reality meet" had become quaint and tame. Who needed reality?

Visitors to the second floor of the Whitney tread cautiously in their bulky tourist sneakers, as if not wishing to startle any meanings from the underbrush of Dove's muddy-colored, semi-representational early canvases. For visitors from France, Japan, and Des Moines, there can be none of that brisk swish-through with which the vast color-field canvases stacked on MoMA's third floor can be absorbed, nor that nodding clockwork survey, punctuated by smiles of recognition, warranted by the Whitney's recent retrospectives of Edward Hopper and Edward Kienholz. American realism, with or without social commentary, wins respect. But with Dove what you see is not quite what you get. The painter is pondering, looking for underlying principles. In 1909 Dove returned from a year and a half in France and, according to Helen Torr, "when he returned he spent much time in the woods analyzing tree bark, flowers, butterflies etc." Torr, too, studied and painted nature, but, as we can see at the Graham Gallery, when she looked at a leaf or a dandelion head it became spiky, detailed, specific. The longer Dove looked at nature, the more generic and inward it became.

In 1910 Dove moved to Westport, Connecticut, to try farming, and at about the same time leaped into abstraction. From Moscow to Paris, subject matter was becoming the merest of excuses, a *point de départ.* In a 1910 issue of Stieglitz's quarterly *Camera Work,* the sculptor Elie Nadelman had written in an essay, "It is form in itself, not resemblance to nature, which gives us pleasure in a work of art." Dove's five epochal Ur-abstractions follow, on the first wall of the Whitney show, one bright but bumpily overpainted still life from 1909. The five are surprisingly small—a bit more than eight by ten inches. Two of them look like houses rendered by a distracted child with a thick brush in his fist, and two more like monochromatic (green, maroon) snippets of a Delaunay, whose Orphic variation of Cubism was the talk of artistic Paris at the time. The crisp parallel brushstrokes pay a debt to Cézanne, and the flat color-patches pay another to the Fauves. It is not clear that these two are pure abstractions; they could be rough views of a forest's tangle. The green one, *Abstraction No. 3* (1910–11), appears to have a blue waterfall in it, and patches of sky. Only *Abstraction No. 2* (1910–11), the scrubbiest and most garish of the lot, has seemingly cut all ties with the realm of representation. Even so, its central form, the shape of an axhead, strongly suggests an unhappy face—a hydrocephalic version of Munch's *Scream.* This hint of a visage will return in the last painting of the exhibit, *Flat Surfaces* (1946). Surely one of abstraction's necessary concerns, though

(Left)
DOVE
Abstraction No. 3, 1910–11
Oil on board, 9 × 10½"
Collection of The Newark
Museum, Newark, New Jersey

(Right)
DOVE
Abstraction No. 2, 1910–11
Oil on paper on board,
8½ × 10½"
Private collection

DOVE *Plant Forms*, c. 1912
Pastel on canvas, 17¼ × 23⅞"
Whitney Museum of American
Art, New York. Purchase with
funds from Mr. and Mrs. Roy
R. Neuberger

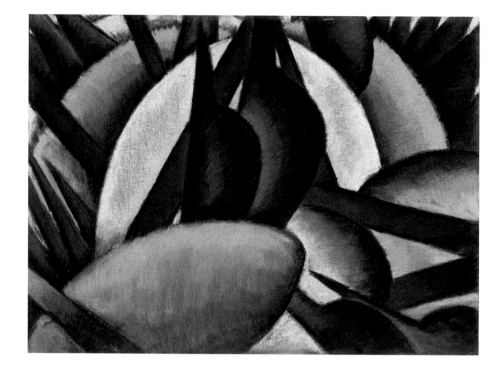

one little discussed, is to keep things from looking like faces, which our eyes are prone to see everywhere.

His leap liberated Dove to seek out the underlying forms and impulses of nature—the flow, the bubbling tumble, the thrust and concentric swelling of growth. In the next ten years he produced a series of works in pastel, charcoal, and (rarely) oils that, though cautious in color, are bold in their removal from the figurative. *Plant Forms* (c. 1912) and *Sun on Water* (1917–20) are especially pleasing, and typical in their oblique allusions to natural phenomena. *Plant Forms* applies a smoothing microscope to the minute strands and barbed thrusts and eggy ovals in the botanical seethe; *Sun on Water* perpetrates in charcoal's gray a stained-glass fragmentation of solar reflection and refraction. The sun would become his prime image and symbol, an ever-fructifying source of splendor. However, the viewer, and the artist, walk a fine line; *Team of Horses* (1911–12) sets us to looking for the horses as in some comic-book teaser; in *Sails* (1911–12) and *Nature Symbolized No 3: Steeples and Trees* (1911–12) the symbolization feels blatant. We might like these paintings if they had no titles; the black-on-manila *Drawing (Sunrise II)* (1913) and

the blue-and-black *Pagan Philosophy* (1913), with their vaguer referents and purer, jazzier Cubism, court our interest on pictorial terms that benefit from being enigmatic.

In these early attempts to represent what Dove, in an "Explanatory Note" issued with a 1916 exhibition, termed "the reality of the sensation," he is in danger of falling off the fine line into a stylish glibness, into Art Deco mannerism. The sunburst rays of *Abstraction No. 2* and the arcs of graduated ribbons of color which appear in *Sunrise* (1924) remind us of Rockefeller Center bas-reliefs. Debra Bricker Balken, in her sensitive catalogue essay on Dove's work up to 1933, aptly describes the painter's "direct distillations of nature." But a distillation, without some other ingredient added, may become a diagram or a caricature.

The forms of the charcoal drawing *#4 Creek* (c. 1919) are not easy to read; a humped mass of concentric parabolas seems to be pushing against or toward a vaulted cavity. Dove stated "that he drew it while knee-deep in flowing water, looking downstream into the woods; but that his friends

(Left)
DOVE *#4 Creek*, c. 1919
Charcoal and pencil on cream paper, 21½ × 17⅞"
Corcoran Gallery of Art, Washington, D.C. Museum purchase

(Right)
DOVE *Sunrise,* 1924
Oil on panel, 18¼ × 20⅞"
Milwaukee Art Museum. Gift of Mrs. Edward R. Wehr

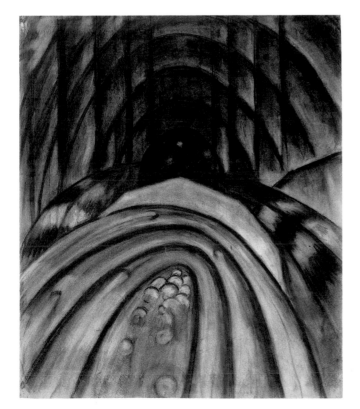

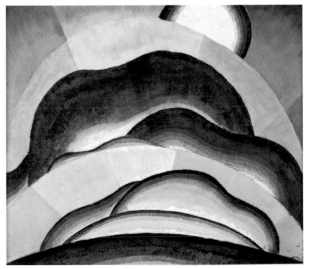

called it *Penetration*—which came nearer to his intention." The friends may have included Sherwood Anderson, who had gotten to know Dove during the years they both lived in Westport. Anderson had a lot of ideas about painting, and in 1921 wrote Dove, "There is some faint promise of rebirth in American art but the movement may well be just a stupid reaction from Romanticisim into realism—the machine. To be a real birth the flesh must come in." The 1924 painting called *Penetration* follows the outlines of the creek charcoal but mainly adds strident color: a copulative sunrise is suggested, but the overall suggestion is as of a looming cowled alien, a comic space-priest, whose broad chest bears a white vagina. What we value in Dove, what is valuably American, is less his willingness to pursue a Freudian metaphor than his willingness to stand up to his knees in flowing water.

DOVE *Ten Cent Store*, 1924 Assemblage of plain and printed paper, fibers, foliage, and paint on paper, 18 × 16¼" Sheldon Memorial Art Gallery and Sculpture Garden, University of Nebraska– Lincoln, Nebraska Art Association Collection, Nelle Cochrane Wood Memorial

How to invest abstraction with seriousness—the problem tugs at these early works, and Dove in the decades left to him rarely settled on an easy, repeatable solution. He resorted to portraiture of the dread machine—*Mowing Machine* (1921), whose toothed edge reappears as a lightning bolt in his *Thunderstorm* of the same year, and the drab *Mill Wheel, Huntington Harbor* (1930). "I'm tired of putting brush strokes on canvas," he announced to Torr in 1924, and set about assembling collages in which twigs, sand, bits of wood, and pieces of cloth serve to bring nature's materiality into the picture frame. *Ten Cent Store* (1924), mixing real grasses and artificial cloth flowers, is the most beautiful specimen of these; nevertheless, its charms feel tainted—the painter has vacated his role of middleman, letting nature and the manufacturer of cloth flowers do for him his work of creating interest. In his same mood of impatience with traditional materials, Dove resorted in these years to metallic paint and metal as a surface, with some striking effects: *Sea II* (1925) used streaks of chiffon over metal with sand in a ghostly conjuration of marine feeling, and *Something in Brown, Carmine, and Blue* (1927), an oil painting on a sheet of metal, has a shudder to it no canvas could have supported. But these, and the Klee-like filled-in continuous lines of *The Park* (1927) and *Seagull Motif* (1928), and the stabbing, colorful, Pollock-like pure abstractions he did while listening to music (*George Gershwin—"Rhapsody in Blue," Part II* [1927] and *Orange Grove in California by Irving Berlin* [1927]) all give a sensation of spirited groping rather than of

secure arrival. They come from the period when Dove and Helen Torr lived mostly on their boat *Mona*. The Whitney retrospective is oddly shy of boats, but several can be seen in the Metropolitan show: Dove's chunky landlocked *Fishboat* (1930), as both a watercolor sketch and an enlarged oil, and Torr's droll *Houses on a Barge* (1928), an ark crammed with tenement buildings, expressing perhaps her feelings about nautical housekeeping.

We come ashore, so to speak, in *Alfie's Delight* (1929), the first oil painting that has the unique Dove look. The color is still subdued and tawny but also racy; the dominant yellow-brown is applied so thinly and dashingly that dribbles mark the canvas. The space is shallow yet deep enough to keep the abstract elements apart; Dove's cherished theme of concentric emergence is stated with a breadth and unforced glow that are dramatically fresh. The same year brought forth the majestic *Silver Sun,* with its cat's pupil of black inside a huge sun lowering upon a tiny earthly reflection of itself, and the well-known *Fog Horns,* with its overlapping lavender blossoms of sound—worrisomely Disneyesque in its animated synesthesia, but in the end winning. Dove's strange blooms, or targets, lopsided like clamshells, crop up as trees as well as celestial objects, and one floats in *Ferry Boat Wreck* (1931) like a subaqueous curiosity seeker, a chamber without a nautilus. The yellow floral shapes in *Pine Tree* (1931) are a botanical puzzle and a somewhat violent pictorial interjection. Perhaps we should keep in mind Lewis Mumford's observation, in a 1934 *New Yorker,* that "Dove has a light touch, a sense of humor. . . . [He is] a witty mind whose art is play, and whose play is often art." Klee and Miró empower Dove's playfulness throughout his career—for example, *Sun and the Water* (1929), *Golden Sun* (1937), and *Flagpole, Apple Tree and Garden* (1943–44).

His five years spent in Geneva, settling up, with his brother, what appears to have been a troublesome and unprofitable estate, produced work of a generous scale and a vegetative geniality. Inland weather and space did him good. *Naples Yellow Morning* (1935) buoyantly reduced the natural world to its basic blobs, and *Sun Drawing Water* (1933) is one of the most telling of Dove's many attempts to evoke weather on the painted canvas. In the Redonesque eye on a stalk of *Moon* (1935) and the embracing Arp-shapes of *Summer* (1935) he produced images that could

DOVE
George Gershwin—"Rhapsody in Blue," Part II, 1927
Oil, metallic paint, and ink on paper, 20½ × 15½"
Michael Scharf G. I. T.

(Above)
DOVE
Sun Drawing Water, 1933
Oil on canvas, 24⅜ × 33⅝″
Acquired 1933, The Phillips
Collection, Washington, D.C.

(Right)
DOVE *Summer,* 1935
Oil on canvas, 25⅛ × 34″
Museum of Fine Arts, Boston.
Gift of the William H. Lane
Foundation, 1990.405

DOVE *Sunrise I,* 1936
Tempera on canvas, 25 × 35″
Museum of Fine Arts, Boston.
William H. Lane Collection,
L-R 1.2000

be called surreal—raids on the subconscious. He thinned his paint on the brush so that every hair shows in the stroke; he experimented with tempera and wax emulsion to achieve a more translucent effect. He made many suns, some, like *Sunrise I* and *Sunrise II* of 1936, their portent rather lumpily thickened with phallic and spermatozoid shapes. *Sunrise III* (1936) is all concentric circles, mostly dark, resting on the swaled horizon with a sag toward the oval, as if of excess weight. This sun, strikingly shaded with a three-quarters outline, seems subdued to a lunar glow, and *Me and the Moon* (1937) buries the golden orb in mountains of black. Some of his best work in this Geneva interval employs a dark palette, like *Holbrook's Bridge to Northwest* (1938). *Flour Mill II* (1938), though distinctly based upon a majestic concrete structure recently arisen in Geneva, approaches action painting, and floats its patches of color on a blank background of near-white. It is as "a leader among the so-called abstract painters" that Dove was touted by William Einstein in the catalogue of his 1937 show at An American Place, and his own reflections, in his journals and his letters to Stieglitz, turn toward "pure painting" and a quality of abstraction that he called "self-creative in its own space."

DOVE *Flour Mill II, 1938*
Oil and wax emulsion on
canvas, 26⅛ × 16⅛"
Acquired 1938, The Phillips
Collection, Washington, D.C

Though some of these exercises in self-creativity come off as messy and clangorous—for example, *Swing Music (Louis Armstrong)* of 1938—pure abstraction was the preoccupation of his last years, after moving to Centerport in 1938. He sought to pass beyond the "point where abstraction and reality meet" to a place where he would be "free from all motifs etc just put down one color after another" and could "make something that is real in itself, that does not remind anyone of any other thing, and that does not have to be explained." Yet things were not so easily transcended; suns appear in *Long Island* (1940) and *Indian Summer* (1941) and *That Red One* (1944), and, as with Richard Diebenkorn's Ocean Park series, the local landscape underlies a thoroughly geometricized surface. William Agee's enthusiastic essay on the late work finds aspects of Centerport in the severest color patches. Dove's rendering became more monumental and flat, but meteorological phenomena continued to fascinate him; e.g., *Thunder Shower* (1940), *Rain or Snow* (1943), and *Partly Cloudy* (1942). He once wrote to Stieglitz, "Weather shouldn't be so important to a modern painter—maybe we're still 'too human.'" Despite the urgings of theory, he kept being human.

It is the earthiness and weather in Dove to which we respond. Paintings like *Silver Sun* and *Rain or Snow* catch at the silvery essence of air, and a homage to seed shapes and tree rings and the elusive materiality of clouds and flowing water and the sunburst of creation that opens each day animates even his most abstract designs; nature was his way into art. The tiny watercolors with which he jotted impressions—on view in several Manhattan galleries, and on sale for twenty thousand dollars and up—have a life, a spark of connection, sometimes missing from the large paintings based on them, which he took to transferring to canvas by the mechanical means of a pantograph.

Dove is a pioneer of abstract painting but not one of its heroes; his canvases remained sub-heroic in size, and his mainspring remained received sensation rather than vatic promulgation. Now Dove seems all the more worth cherishing in his edgy, earthbound failure to enter the happy but faraway land where, in the words of Clyfford Still, the most vatic of the Abstract Expressionists, "Imagination, no longer fettered by the laws of fear, became as one with Vision. And the Act, intrinsic and absolute, was its meaning, and the bearer of its passion."

DOVE *That Red One,* 1944
Oil and wax on canvas,
27 × 36"
Museum of Fine Arts, Boston.
Gift of William H. Lane
Foundation, 1990.408

Logic Is Beautiful

———

"UP LIKE A ROCKET, down like a stick"—thus, more or less, the multinational career of the Polish-American sculptor Elie Nadelman (1882–1946), whose extensive exhibition at the Whitney, from April to July of 2003, projects, despite the jaunty flair and exquisite finish of many of its items, a certain melancholy. Nadelman was captivated by ideas, which inhibited and limited his work even as they inspired it. His art was not earthy. Born in Warsaw at a time when Poland didn't exist except as an idea, a language, and a fervent if wistful nationalism, and into an assimilated Jewish family whose one concession to their tribal heritage was to name their youngest and seventh child Eliasz (Elijah), Elie Nadelman moved to Munich and then Paris in his early twenties, and to New York when he was thirty-two. He found the émigré artistic communities in these metropolises far from immune to the anti-Semitism that accompanied Polish nationalism; in later life he identified himself as a Pole rather than as a Jew, marrying a Catholic, Viola Spiess Flannery, in 1919, and raising their one child, a son, as a Christian.

In personality he was reticent, private, and formal; in a 1911 artistic credo he maintained, "The element that brings beauty in Plastic Art is logic, *logic in the construction of form.* All that is logical is beautiful, all that is illogical is inevitably ugly." There is a hermetic quality to his statues, as if they have been sealed against infestations of illogical detail. In his later work, the layer of sealant gets thicker and thicker, and toward the end his figures, fingerless and all but faceless, seem wrapped in veils as thick as blankets.

Barbara Haskell's catalogue, in this day of catalogues composed like Dagwood sandwiches of disparate essays, has the rare virtue of being written by one person; with a brisk expertise she leads us through Nadelman's early education, and the artistic currents of fin-de-siècle Europe.

ELIE NADELMAN
Two Circus Women, c. 1930
Plaster covered with paper,
62¾ × 38 × 17″
Whitney Museum of American
Art, New York. Purchased with
funds from The Lauder
Foundation, Evelyn and
Leonard Lauder Fund, 99.90.4

Symbolism, the dreamy, semi-surreal countercurrent to naturalism, was felt to be expressive of the Polish soul as well as the individual inner life. Rodin's contorted, vigorously thumbed forms dominated sculpture. Nadelman's earliest three-dimensional works, three untitled plaster sculptures from 1903–4 (lost but photographed for a Paris magazine), were Rodinesque in the extreme. But he had already received the aesthetic ideas of the Polish Stanislaw Witkiewicz, who wrote in 1891,

> The value of a work of art does not depend on the real-life feelings contained in it or on the perfection achieved in copying the subject matter but is solely based upon the unity of a construction of pure formal elements.

In his six months spent in Munich, the young Nadelman encountered the rich trove of early classical Greek statuary in the Glyptothek, the decorative simplifications of German Jugendstil, and the theories of the Munich-based Adolf von Hildebrand, who in his 1892 book *The Problem of Form in Painting and Sculpture* proposed, much as did Witkiewicz, that, in Haskell's paraphrase, "true art did not imitate nature. . . . Rather, art must obey its own internal structural laws in order to achieve its true content and immutable aim: formal unity . . . which was attainable only by means of distinct outlines, compact form, and smooth surfaces."

In Paris, Nadelman put these principles to work, and in 1909, two years after Picasso had painted African masks into his large and discordant canvas *Les Demoiselles d'Avignon*, the Polish artist achieved a sensation with a show, at the Galerie E. Druet, of thirteen plastic nudes and heads evoking classic Greek models, plus one hundred radically formalized, rather attenuated drawings.* Two years later, at London's William B. Paterson Gallery, he exhibited ten female marble heads closely patterned after heads by Praxiteles; one viewer, the Polish cosmetics queen Helena Rubinstein, recognized in them a paean to generalized beauty, and bought the entire show, as well as commissioning the artist to execute

NADELMAN
The Bird, c. 1907–9
Ink on paper, 25¼ × 19⅜"
Whitney Museum of American Art, New York. Purchase with funds from Philip Morris Inc. 76.4

* Nadelman placed a high value on these drawings. Writing for an exhibit in 1923, he claimed, "These drawings, made sixteen years ago, have completely revolutionized the art of our time. They introduced into painting and sculpture abstract form, until then wholly lacking. Cubism was only an imitation of the abstract forms of these drawings and did not attain their plastic significance." Two years later, he asserted, "*Picasso is not the originator of Abstract Form,* he merely exaggerated the abstract forms discovered by me, and not knowing their workings, piled up pell-mell abstract forms . . . with a result which is meaningless and unsignificant from the point of view of plastic art and is merely a sensational novelty."

"a quartet of freestanding female figures engaged in the daily activities of bathing, combing their hair, and dressing." Not yet thirty, the slender, wavy-haired, romantically handsome Pole was a success, an anti-Rodin offering the public an ideal of beauty harking back to the wellsprings of Western art.

Encountering these works nearly a century later is a mixed and somewhat muted experience. The bronze *Suppliant* (c. 1908–9) greets us, arms lifted, hips invitingly tilted, as we step off the Whitney elevator. How could one not love her? True, her breasts seem a bit close together, and, though graceful from the front and back, she seems in the side view rather stiff and ungainly. Her supplicant gesture reaches for the timeless; unlike a nude by another anti-Rodin, Aristide Maillol, she does not make us think of the flesh-and-blood model who posed for this rendering. From the same 1908–9 time frame, Nadelman's smaller pearwood *Standing Female Nude*, with her tiny head and rubbery limbs, strikes the note of caricature that will flavor much of his best work; her sinuous, even agitated lines remind us that young Nadelman had opportunity to study the vivacious altarpieces of Germanic limewood sculptors like Veit Stoss (in Kraków) and Tilman Riemenschneider (in Munich). The bronze of a hefty, hunched nude alleged to be Gertrude Stein makes us smile, but her Junoesque mass is something Nadelman will circuitously recover through the coming decades of distinct outlines and smooth surfaces.

His marble heads, of which more than Helena Rubinstein's ten are displayed, confront us with a deliberate polished blankness. As in the drawings of Nadelman's fellow-Pole Bruno Schulz, the faces are downcast, the foreheads leading. When we stoop down and seek to look them in the eye, the eyes are not only pupil-less but, often, blurred as if blind. If, as I was told in a fine-arts class fifty years ago, the stone faces of medieval statues have an inner life not found in those of classical Greece, Nadelman's manage to have even less inner life than their Greek prototypes. Rather desperately we rove from one to another, hoping to penetrate their marmoreal opacity; some have noses a little broader than others, and some of the stylized, hatlike headdresses differ in detail, and the marble in which they have been carved varies in tint from bluish to brownish, but all have been sacrificed on the same high altar of impersonality, like so many heads severed in the cause of revolution. There is a soapy coldness to them, faintly interrupted by the *Ideal Head of a Woman* (c. 1910–11) owned by the Mount Holyoke College Art Museum; the big

NADELMAN *Standing Female Nude*, c. 1908–9 (carved later from plaster original) Pearwood, 15 × 3¾ × 4½" The Minneapolis Institute of Arts. Gift of Ruth and Bruce Dayton

NADELMAN
Standing Female Nude, c.
1912–13
Bronze, 21¾ × 8⅝ × 7¼"
The Museum of Modern Art,
New York. Aristide Maillot
Fund

chin and dished face hint at individuality, as if a real woman momentarily distracted Nadelman from his courtship of ideal beauty.

Beauty lives, surely, in a harmonious excitement of particulars. The spark of life comes in individual vessels. In some slightly later heads—the bronze from the Philadelphia Museum of Art (c. 1912–13), and one of wood from the Whitney's own collection (c. 1912–13)—have a Modigli10nesque edginess, a hint of incipient motion, an impudent caricatural shrinkage of lips and the width of the upper lip, which animate them. Highly animated are the five bronze nudes dated 1912–13: the male, from a private collection, carries the restless mannerist line into a fine swagger, and the female nude from the Museum of Modern Art almost explodes into dance. This is the kind of visual jazz that Nadelman's instincts called for but his formal puritanism kept repressing. The beat continues in the two draped, bare-breasted figures of the same years, one in bronze and one carved (c. 1915) from cherrywood; they are identical but in substance, and the bronze surface is the one where the highlights swim and flow.

Nadelman was a tireless experimenter in materials; his method generally began with plaster models and could branch into wood, marble, or bronze in various patinas. The nudes mentioned above were done in a dark, almost black, bronze. The Metropolitan Museum's *Standing Nude* (originally *Juggler,* c. 1912) is painted with gilt, and the *Two Standing Nudes* (c. 1912)—a reserved but charming and lively work, one of his first linked duos—are golden-tinged gilt bronze. Like Brancusi, he manipulated a finite number of motifs, varying the material and the size, though something authentically primitive in Brancusi avoided any impression of mass production or of seeking a serial approach to Platonic ideality.

Nadelman's rocket was still ascending as World War I approached. His neo-mannerist pieces sold, and Guillaume Apollinaire in 1914 praised his early attempts to blend classical forms with contemporary clothing. The venture into modern costume came about by way of the god Mercury's brimmed helmet, which looked like a bowler hat (*Mercury Petassos I* and *II,* c. 1914) and led to the top hat of *Le Boulevardier* (1914). Nadelman's initial reaction to the guns of August was to want to travel through Germany and report for duty as a reservist in the Russian army; the authorities advised against so hazardous an enlistment, and Helena Rubinstein concocted a commission for him to create a plaster relief for her newly opening salon in New York. He left on the *Lusitania,* expecting to stay in America a few months. He stayed for the rest of his life.

Though the United States struck him as "a country of bluffers and snobs and . . . still quite wild," some of his most elegant and memorable sculptures date from his first years here: *Man in the Open Air* (c. 1915), insouciantly posed by a minimal tree, clad in no more than a bowler hat and a wire bow tie; the larger black bronze *Horse* of 1914, the broad-chested, slim-legged, crop-tailed essence of equineness; and the four taut and fine-boned cervine figures of 1916–17, *Standing Buck* warily alert, *Fawn* and *Resting Stag* peacably licking their feet, and, most dramatically, *Wounded Stag,* of bronze with a golden patina, bent back in agony, compactly contorted like a Celtic clasp. Such enlivening touches verge, for Nadelman, on the vulgar, or on rivalry with the American master of Art Deco animals, Paul Manship. A startling experiment, not repeated, mingles white marble and dark bronze in *Sur la plage* (1916–17), a kitschy flirtation with the anecdotal. Nadelman still produced ideal

(Left)
NADELMAN
Female Head, c. 1910–11
Marble, height 17¾"
The Metropolitan Museum of Art, New York. Gift of Mala Rubenstein Silson, 1992, 1992.211

(Right)
NADELMAN
Le Boulevardier, 1914
Plaster, 18½ × 9 × 13½"
Los Angeles County Museum of Art. Gift of Mr. and Mrs. Nathan Smooke, M.84.267

(Left)
NADELMAN *Horse,* 1914
Bronze with dark brown patina,
height 12¾″
Collection of Barbara and Pitt
Hyde

(Right)
NADELMAN
Wounded Stag, 1916–17
Bronze with natural gold
patina, 13⅜ × 20¾ × 7¼″
Estate of Elie Nadelman

heads, more Renaissance now than classical in feeling, and misty if not somnolent in expression, with headdresses like handles, and the marble so polished as to ape porcelain.

His marriage to the wealthy Mrs. Flannery opened to him a field of society portraits and, though not among Nadelman's tickets to the annals of modernism, these portrait busts and heads gave value to their sitters: real likeness contends with Nadelman's softening style. Francis P. Garvan, Jr., and his sister Patricia (both c. 1920) emerge as eerie but actual children; the little girl originally called Marie (1916–17) is darling in her pudgy contours, curving fingers, and pert shoulder ribbons; and the several classy adult females outface the half-melted look Nadelman gives them. Yet, while still enjoying social and critical esteem, he was about to take an enduring blow: he had developed a series of painted plaster figures drawn from the life around him, and it met with a surprisingly hostile reception.

Most of these works survive only as photographs; *Femme assise*

(1917), displayed as part of a war-relief benefit on the roof garden of the Ritz-Carlton Hotel, was knocked from its pedestal and shattered. It and his two other plaster pieces in the show were ridiculed in the press. Haskell reports, "In a satirical feature article they were singled out, along with work of Brancusi and Henri Matisse, as avatars of modern art's preposterous incomprehensibility." So anti-modernism had caught up with the conservative Nadelman, and, though clothed and painted statues had a venerable artistic pedigree, he could never sell his. At a 1919 one-man show at M. Knoedler & Company, the plaster works went unbought and the option of ordering wooden or bronze duplicates went untaken. A 1925 show, at Scott & Fowles, featuring stained, gessoed, and painted wood figures sold a single piece, *High Kicker* (c. 1920–24), and that one to Stevenson Scott, a partner in the gallery. The pieces were withdrawn to the basement and attic of the Nadelsons' big Riverdale house, where they may have suffered dampness and damage.

Seeing many of these spurned works at the Whitney, one wonders how such wit and sculptural élan could have been so thoroughly missed. *Hostess,* for example, comes right at you with social momentum, her white face turned as if to spot a new guest; *Host* is all heavily seated pomp; *Tango,* used for the catalogue's cover, has an apprehensive grace made haunting by the figures' abraded faces and failure to touch hands. *Woman at the Piano* is iconic, an American maenad with her flailing hands and transfixed sideways stare, her feet up on their heels to press the invisible pedals. The bare-legged circus girls, the white-tied conductor, and a row of high-kicking dancers seem to pause and gyrate like figures on a music box. The art public, accustomed to investing in enduring materials like marble and bronze, hung back from sculptures so modest in size (rarely more than three feet high) and means, their impermanence and fragility manifest in their flitting gestures, their scabbed and rubbed surfaces. Critics, according to the catalogue, have revived Nadelman because the rough treatment in his later work anticipates Abstract Expressionism; early Pop Art better fits the case, as in the wooden sculptures of Marisol and the junky combines of Rauschenberg and Johns. The Nadelmans in their financial heyday collected folk art with an omnivorous zeal, on the theory that the formal basis of all art would emerge from a sufficient accumulation. In the meantime, Nadelman's shapely sculptures bore an uncomfortable resemblance to the battered dolls that can be found on flea-market tables.

NADELMAN
Dancer (originally titled *High Kicker*), c. 1920–24
Stained, gessoed, and painted mahogany, height 28¼"
The Wadsworth Atheneum Museum of Art, Hartford, Connecticut. The Collection of Philip L. Goodwin through James L. Goodwin and Henry Sage Goodwin

NADELMAN
Woman at the Piano, c. 1917
Wood, stained and painted,
35⅛ × 23¼ × 9″ including base
The Museum of Modern Art,
New York, The Philip L.
Goodwin Collection

His financial fortunes followed his artistic. The Nadelmans' wealth was hit so hard by the Depression they had to sell their folk art and some of their real estate. Then the war came, bringing Nadelman sympathetic pains for the fate of Poland and its Jews, though he avoided specifically Jewish causes. He joined the war effort as best he could, serving as an air warden and volunteering to teach sculpture and drawing in the occupational-therapy division of the Bronx Veterans Hospital. He tried to ignore a heart condition, calling it "my amusing pain," but failing health drove him to take his own life in the last days of 1946. After a week, Lincoln Kirstein, art critic and general director of the New York City Ballet, who had never met Nadelman, began a twenty-five years' campaign of study, preservation, and promotion of the, by then, nearly forgotten artist.

During the Depression and the war Nadelman had become reclusive, refusing the few invitations to exhibit that came his way, dropping out of his posh clubs, and trying to hang on in Riverdale. His experiments with plaster continued, however; from 1925 to 1927 he worked on what he called "galvano-plastiques"—large electroplated plaster figures, ten of which were exhibited in 1927 at M. Knoedler. They failed to sell at the bargain price of one thousand dollars each. Next, he took to laminating large hollow-core plaster shapes with brownish papier-mâché, giving them the warm, clumsy look of terra-cotta. In the early Thirties he did small ceramic figures, often pairs of women, with scanty, festive costumes painted on. Lastly, from 1938 to his death, he devoted himself to very small plaster figures, multiply cast in molds and then worked over with a file, fork, or penknife. Inches long, unable to stand on their own, reminiscent of prehistoric fertility charms, these figurines, forty or so of which are collected in the exhibit's last room, radiate the fitful unease of a man at the end of his tether amusing himself, an obsessed hobbyist gouging away at problems only he can discern.

But the larger works, the galvano-plastiques and papier-mâché giants, called "circus women" but more like lounging goddesses, have an air of arrival, of self-careless triumph. They are fat, by a sculptor whose rendition of slender, nervously dwindling legs amounted to a signature. They are the culmination of Nadelman's drive toward the undefined, the blurred, the featureless generic. They suggest George Segal's white body-casts, Botero's unembarrassed tubs, and Niki de Saint Phalle's jubilantly bulbous female forms. Not that these figures of Nadelman's are jubilant; they are eyeless, groping in a kind of dark. But they have a monumental-

ity not present in his work before, and the papier-mâché women are grander and vaguer still.* Two foot-high marble statues called *Standing Nude* (c. 1930–35) achieve the same formlessness, which seems weirder in marble than in ceramic. The impulse behind such blobbiness, such reverse refinement, like that behind the monotonous repetition of pseudo-classical heads, baffles and mocks a critic's expectations of— what?—of declaration, of *Dasein*. As the stick of his rocket descended, Nadelman's figures seem to sink back into the all-dissolving waters of being. Perhaps, having early turned against the amorphous ethos of Symbolism—Munch's swooning women, Moreau's luminous nebulae—the sculptor yearned to revert to it, an inner world devoid of formal logic.

(Left)
NADELMAN *Standing Female Figure*, c. 1925–26
Galvano-plastique,
60½ × 32 × 21"
Whitney Museum of American Art, New York. Purchased with funds from The Lauder Foundation, Evelyn and Leonard Lauder Fund

(Right)
NADELMAN *Figure*, 1938–46
Plaster, 8½ × 3¼ × 2¼"
Estate of Elie Nadelman

* *Two Circus Women* (page 168), which measures about five feet tall, was, with Kirstein's approval, posthumously cast in bronze for Nelson Rockefeller and then subjected to a threefold enlargement in marble for the New York State Theater at Lincoln Center. This rendition, though a spectacular homage, is at considerable variance with Nadelman's usual scale and loses the peculiar warmth, the delicate earthiness, of the papier-mâché-over-plaster original.

Hopper's Polluted Silence

THE 1995 EXHIBITION *Edward Hopper and the American Imagination,* at the Whitney Museum of American Art, consists of two shows: there is a splendid one of fifty-nine of Hopper's best paintings—canvases calm, silent, stoic, luminous, loved—and then there is another, wrapped around it like an engulfing predator, meant to represent "the American imagination." This nebulous excrescence can be heard, while one walks along the elegantly diagonal partitions of the third-foor exhibit space, as the unintelligible overvoice and sudden musical flare-ups of a three-screen video show relating Hopper's imagery to contemporary movies, photography, and art, and it can be read, in the form of large-writ wall mottoes from such exemplary Yankee scribes as Emerson, Frost, and E. B. White.

The thick catalogue, by Deborah Lyons and Adam D. Weinberg, holds, in addition to reproductions of the Hoppers and several curatorial essays, thirteen pieces of poetry and prose we are to take, as Whitney Director David A. Ross states in his foreword, as "a response to and an extension of the exhibition." Five of these literary contributions—by Leonard Michaels, Ann Beattie, Ann Lauterbach, Tess Gallagher, and John Hollander—are dated 1995 and are more or less about Hopper; at least, they mention him. The eight others date from a while ago—a story by Norman Mailer goes back to 1940, a poem by Thom Gunn to 1971, a piece of a novel by William Kennedy to 1979—and relate to Hopper only through being, presumably, "Hopperesque." What the pages of fiction by Mailer, James Salter, and Grace Paley more distinctly seem is Hemingwayesque—stripped-down in style, lethal in atmosphere. The contributions by Kennedy, Paul Auster, and Walter Mosley bring a magic-realist touch to low life, and even the poems, by Gunn and Galway Kinnell, seem to arise from the bleak territory staked out by Hemingway's Nick

Adams stories. One puzzles at the literary emphasis upon the bottom end of the social scale—murderers in Mosley and Paley, bums in Auster and Kennedy, violence in Kennedy and Mailer, near-starvation in Mailer and Auster—as if Hopper were a Gorky in paint. He did paint a man in shirt sleeves (*Sunday*, 1926) and a veteran stripper (*Girlie Show*, 1941), but most of his transfixed, isolated figures seem middle-class. His city streets are the opposite of thronged; his rural landscapes can be stark, but poverty is not one of the issues they raise. If the desire was to locate a literary equivalent of Hopper's mood, the early short stories of John O'Hara would have come closer—snapshots of a gritty, up-against-it Thirties world whose inhabitants yet convey inklings of poetry and beleaguered human dignity. Even such a close match would mostly show us the gulf between the two modes of art, and how tempting yet misguided it is to marry the two.

Hopper himself put the temptation there. A devoted reader and theatergoer, he seems in his paintings to be on the verge of telling a story. The curtain goes up, in *Room in New York* (1932) or *Hotel Lobby* (1943) or *Summer Evening* (1947) on an intriguing tableau. Dramatic tension is in

HOPPER
Room in New York, 1932
Oil on canvas, 29 × 36″
Sheldon Memorial Art Gallery
and Sculpture Garden,
University of Nebraska–Lincoln,
F. M. Hall Collection

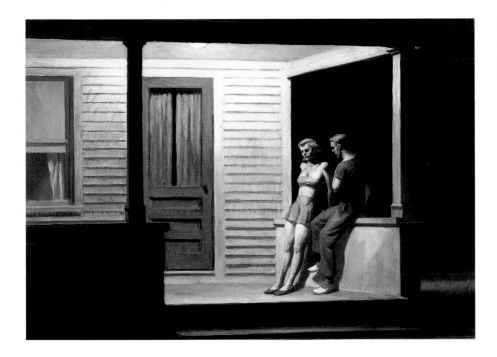

Hopper
Summer Evening, 1947
Oil on canvas, 30 × 42"
Private collection

the air. The illuminated restaurant in *Nighthawks* (1942), the sunstruck house front in *High Noon* (1949), the brightly lit porch in *Summer Evening* suggest stage sets, making us conscious of our spectatorship and curious about past and future action. Yet attempts to spell out the drama, as in Ann Beattie's inventive, good-humored "Cape Cod Evening" in this catalogue, or in Joyce Carol Oates's recent imagining* of interior monologues for the couple in *Nighthawks,* are, however lively on the page, projections that slide off the painting, leaving it just where it hangs. Hopper could have elaborated the anecdotal content of his scenes, and in a few late instances—*Hotel Window* (1955), *Excursion into Philosophy* (1959)—a spelled-out pathos draws uncomfortably near. But in his prime he never gives the tale away; the faces remain proudly blank, and tension and longing are present ambiguously. Hopper had read Freud, and his canvases are models of therapeutic reserve. If the narrative content were not submerged but brought to a humorous or touching point, we would have a period magazine cover—wry for *The New Yorker,* cozy for *The Saturday Evening Post*—which would win a momentary response and

* In the anthology *Transforming Vision: Writers on Art,* selected and edited by Edward Hirsch (Little, Brown, in conjunction with the Art Institute of Chicago, 1994).

HOPPER
Four Lane Road, 1956
Oil on canvas, 27½ × 41½"
Private collection

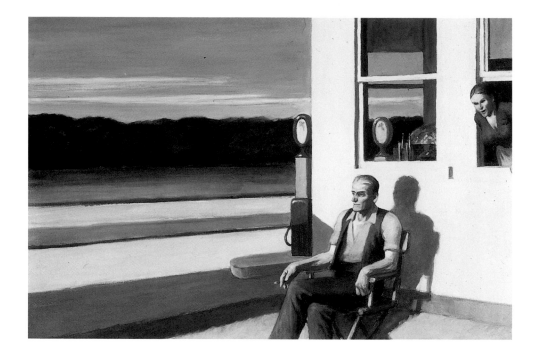

then vanish from the mind's eye. In *Four Lane Road* (1956), the woman
has her mouth open but her mood remains mysterious, as does the imper-
vious attitude of the man presumably mated to her. There is something
close to comedy in their attitudes, and in the doubling, through the win-
dows, of the gas-pump head. But the painting does not clinch any of these
hints, and its abstract pattern remains free to affect us while we puzzle.

Of the many pieces of writing stimulated by Hopper, none is more
coolly and eerily attentive (more Hopperesque, we could say) than Mark
Strand's brilliant small book *Hopper* (The Ecco Press, 1994), analyzing
how we are moved and disquieted by formal elements in the paintings—
isosceles triangles tapering to points beyond the canvas, light sources out
of sight, specifics of spectator vantage which give rise to sensations of
exclusion, of travel or stagnation, of intimacy or its lack. Strand imports,
perhaps, his own darkness and suave nihilism into a formulation like
this one:

> Hopper's paintings are not vacancies in a rich ongoingness. They are all
> that can be gleaned from a vacancy that is shaded not so much by the
> events of a life lived as by the time before life and the time after. The
> shadow of dark hangs over them, making whatever narratives we con-
> struct around them seem sentimental and beside the point.

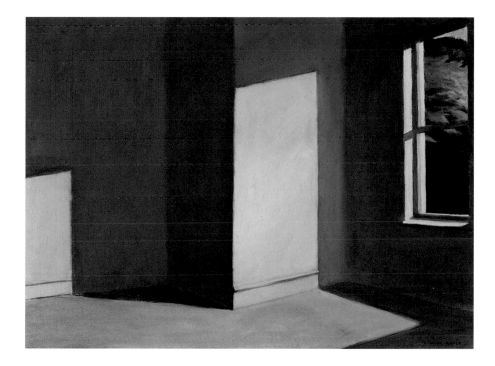

But he articulates the scarcely sayable in a description like this, of Hopper's *Sun in an Empty Room* (1963):

> Done in 1963, it is Hopper's last great painting, a vision of the world without us; not merely a place that excludes us, but a place emptied of us. The light, now a faded yellow against sepia-toned walls, seems to be enacting the last stages of its transience, its own stark narrative coming to a close.

Hopper's silence suggests that of an old-time public library: twelve of his canvases displayed here show a person in the act of reading. Reading is interaction at one remove. Leonard Michaels, in his affectionate prose riff for the catalogue, offers the sociological observations that "there used to be silence, solitude, and thinking. . . . There used to be plenty of time. There used to be day and night. . . . There used to be privacy." He provocatively pairs Hopper with Wallace Stevens: "two philosophical artists with a sensuous eye, committed to monolithic marriages. They loved French culture, and were self-mocking fellows who saw themselves as comedians, and were fascinated by silence and ghostly presences." Both were burly, taciturn fellows who liked to mull the world into its essentials; comfortably born into conservative nineteenth-century towns

HOPPER *Excursion into Philosophy,* 1959
Oil on canvas, 30 × 40"
Private collection

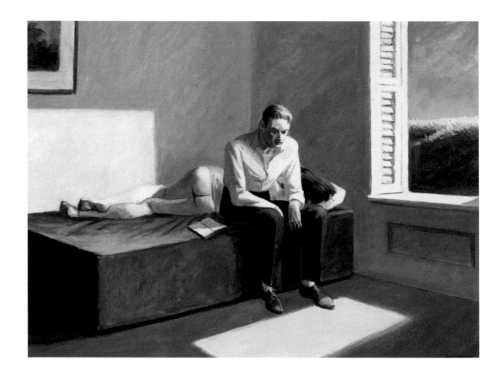

(Nyack, New York; Reading, Pennsylvania), they were haunted by philosophy and the Ideal. Hopper, who generally discouraged attempts to "read into" his paintings, did joke, of the troubled-appearing man in *Excursion into Philosophy,* "He has been reading Plato rather late in life." A woman with an exposed bottom sleeps beside him, and he may be merely pondering the pain of relationships that do not remain Platonic in the sexual sense.

But a quest for Platonic archetypes, for the ultimate forms behind each house and cloud and tree, does seem to simplify and ennoble the shapes in a Hopper. In masterly landscapes like *Cobb's Barn and Distant Houses* (1930–33) and *Lighthouse Hill* (1927), a thrilling absoluteness sweeps in along with the deep shadows carved by the low sun. There is no toylike smoothness and regularity here, as in the stylized landscapes of Thomas Hart Benton and Grant Wood, yet light and air are given a crystalline firmness; one cannot imagine a single brushstroke other than as it is, including the pale hooks of cirrus cloud next to the lighthouse. In this show's *Lee Shore* (1941) and in many of Hopper's other marine paintings we have, with his silky, serried wavelets, less the look of the sea than an idea of the sea, set between, in *Lee Shore,* a green idea of grass and a pale-

(Opposite, top)
HOPPER
Lighthouse Hill, 1927
Oil on canvas, 29¹⁄₁₆ × 40¼"
Dallas Museum of Art. Gift of Mr. and Mrs. Maurice Purnell

(Opposite, bottom)
HOPPER *Lee Shore,* 1941
Oil on canvas, 28¼ × 43"
Private collection

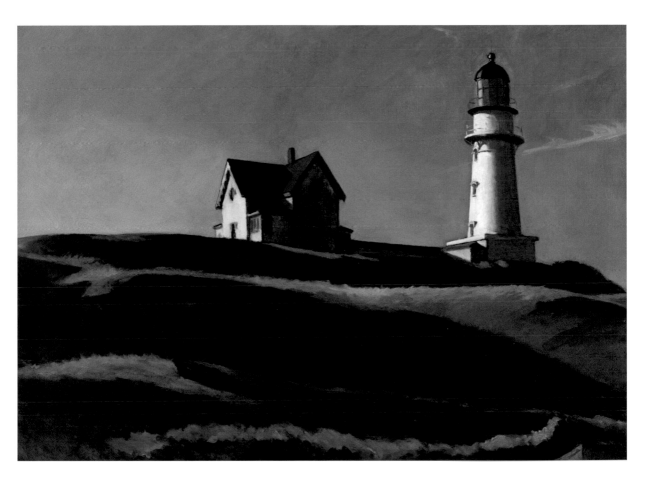

blue cloud-brushed idea of the sky. His skies, perhaps because they can be seen anywhere, even from a studio window, remained the best-observed individual feature of his outdoor canvases.

Hopper, in the early 1920s, as he was turning forty, gave up outdoor easel painting and became a studio painter, constructing scenes from carefully annotated Conté-crayon sketches made on the spot. His career, since youth, as an illustrator, and then, in the very early Twenties, as an etcher, prepared him to break with the plein-air approach that Impressionism had made central to the art of painting. His three visits to Paris and Europe between 1906 and 1910 produced canvases in a subdued and chunky version of Impressionism, and the ten years thereafter were chiefly productive of on-site landscapes executed, with considerable verve and impasto, on Cape Ann and in Maine. He was a slow bloomer; he did not marry until 1924, at the age of forty-two, and that year also brought his first one-man show in a commercial gallery. The show, of Maine watercolors, sold out, and he at last felt able to give up illustration and concentrate on painting. Gail Levin, in her catalogue text for the Whit-

HOPPER
House by the Railroad, 1925
Oil on canvas, 24 × 29″
The Museum of Modern Art,
New York. Given anonymously

ney's great Hopper retrospective in 1980, pegs his arrival at artistic maturity to the year 1925 and his, by now, iconic *House by the Railroad*. Some might have chosen the little *Girl at Sewing Machine* (c. 1921). In both canvases, the theme of sunlit solitariness has been found, along with the mature Hopper technique—precise but not edgy draftsmanship, large planes of fairly flat color, and a way of laying on paint that, without hiding the brushstrokes, tends toward thin layers, sometimes scraped so that the canvas weave shows through. Up close, Hoppers seem less solid, more transparent and scrubby than reproductions make them appear. In 1962, at the age of eighty, he said, "I think I'm still an impressionist."

PROFESSOR LEVIN—whose twenty years of absorption in Edward Hopper bear double fruit, this year, in a three-volume catalogue raisonné, complete with CD-ROM, and a six-hundred-page "intimate biography" to be published by Knopf in October—feels that after this arrival "few significant changes occurred in Hopper's art or in his life. . . . Hence, unlike most artists, Hopper's work cannot easily be divided into early, middle, and late periods." In conformity with this opinion, Hopper's mature paintings are grouped, in Levin's 1980 catalogue, by theme rather than period, and in this present show are arranged, loosely, by affinity rather than date.

Yet this viewer noticed how often, when he checked the date of an especially admirable work, it came from the decade after 1925. To the two abovementioned landscapes—full of plein-air immediacy as well as formal rigor—and the superb *Room in New York* add *Drug Store* (1927), *Automat* (1927), *Captain Upton's House* (1927), *Night Windows* (1928), *Manhattan Bridge Loop* (1928), *Chop Suey* (1929), *Railroad Sunset* (1929), *Early Sunday Morning* (1930), *South Truro Church* (1930), *Hotel Room* (1931), *House at Dusk* (1935), and *Shakespeare at Dusk* (1935). As examples of picture-making (as opposed to stage-setting), they have a venturesome vivacity and fullness of color. *Shakespeare at Dusk* is a Manhattan Monet, the violet of the paths palpably registering the intervening volume of darkening air. Even in a basically factual report like *South Truro Church*, Hopper searches out the dully vibrant tones on the church's shadow side, and takes time with the various green and brown tints of ground cover. *Railroad Sunset* (page 198) is almost lurid; but its melodrama arises from a purely atmospheric blaze and is tamed by the strict parallel between the linear clouds and the glim-

mering railroad tracks. *Manhattan Bridge Loop*—the product, photographs show, of considerable manipulation of the actual scene—strikes an exquisite series of echoes and balances in the service of an utterly nondescript piece of city. *Drug Store,* with its highly legible Ex-Lax advertisement and uncannily empty sidewalks, has the startling directness of Pop Art: a new sense of the pictorial has been brought into painting's universe. Among the scenes of urban life, *Chop Suey* blends an overlapping crowdedness with the static calm of the sunlit tabletop and the two cloche-hatted young women, who both seem to be listening. Hopper's young females in these paintings are not yet aware of their poignance. The woman in the large, ambitious *Hotel Room* (page 178) has scarcely a face; she is entirely given over to the light on her shoulders and thighs and the framing rectangles of flat colors. Gail Levin observed Richard Diebenkorn studying this canvas at the 1980 Hopper retrospective, and one can fancy a kinship between its concentric rectangles and the sunny rectilinear abstractions of the California painter's *Ocean Park* series. A relatively unsuccessful painting of the period, *Barber Shop* (1931), displays, in its insistently parallel diagonals, from oddly furry brass rails to the slash of shadow on the sunstruck wall, and in its precisely bisected clock-face, the concern with tightly organized composition that earned Hopper the (unreciprocated) respect of the Abstract Expressionists.

The paintings of the next decade, which include some of his most famous—*New York Movie* (1939), *Cape Cod Evening* (1939), *Gas* (1940), *Nighthawks* (1942)—turn more illustrative, more deliberately moody. Unlike the

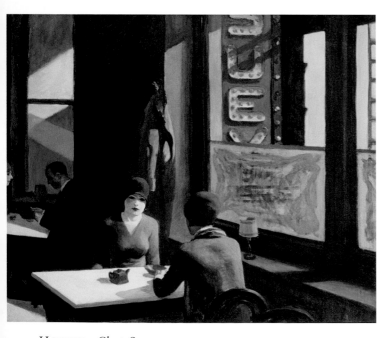

pensive heroine of *Automat* (page 197), the solitary girl bravely waiting on the apartment-house steps in *Summertime* (1943) seems to know she

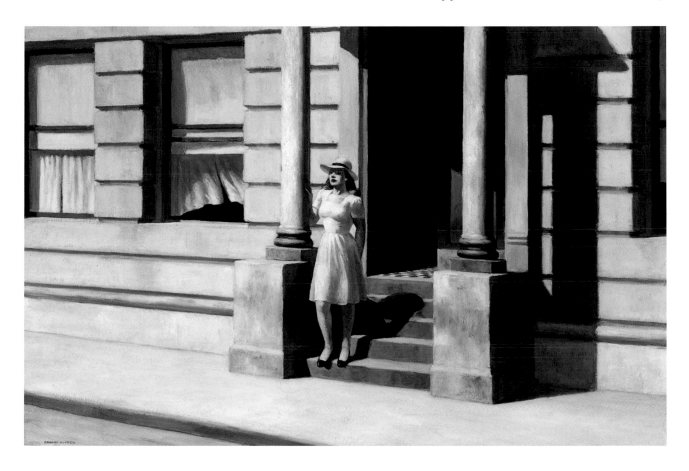

is being watched. With her thigh blooming pink through her gossamer dress, she belongs with Reginald Marsh's lush street girls, rolling their powerful bodies through the urban grid in confidence of a destination. (How much more erotic, I was led to reflect, thin summer dresses are than today's athletic shorts and halters! Old summertime New York was a harem in clinging cotton.)

The human presences in Hopper's later work became more disquieting—disturbances within the peace of blank walls and half-shaded windows. Their faces have a worried and worried-at sharpness; after seeing *Morning in a City* (1944), *Morning Sun* (1952), and *A Woman in the Sun* (1961) in succession, one wishes that Hopper had broken his possessive wife's interdict against his painting any nudes but her and found himself a model with a softer, more pleasing visage than the formidable Josephine Nivison Hopper's. Yet *Morning Sun* is a great painting, Jo's pugnacious profile reduced to a mask, her flesh and chemise a blend of the pale green

HOPPER *Summertime*, 1943
Oil on canvas, 29⅛ × 44″
Delaware Art Museum. Gift of
Dora Sexton Brown, 1962

HOPPER *Morning Sun,* 1952
Oil on canvas, 28⅛ × 40⅛"
Columbus Museum of Art,
Ohio. Museum Purchase,
Howald Fund, 1954.031

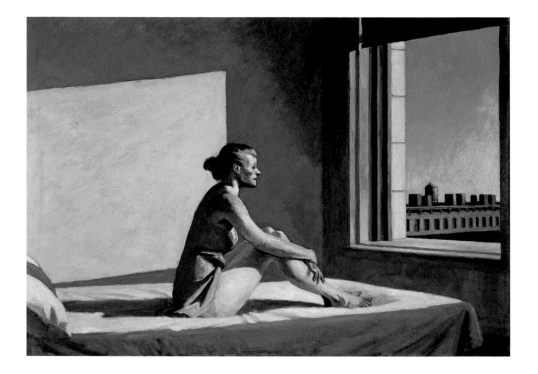

HOPPER
Second Story Sunlight, 1960
Oil on canvas, 40 × 50"
Whitney Museum of American
Art, New York. Purchase with
funds from the Friends of the
Whitney Museum of American
Art

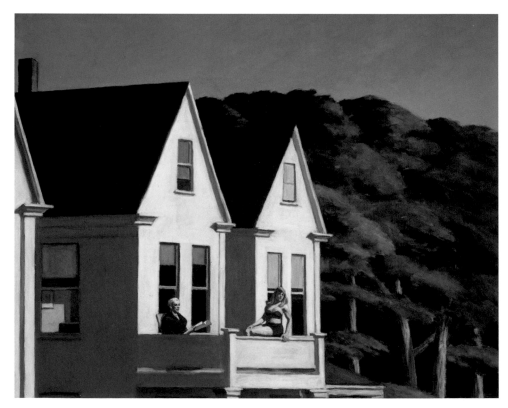

on the wall at her back and the gentle red of the brick row she sees through the window.

Hopper's colors turned cooler and chalkier as he aged; the warm brick- and plush-reds of his New York paintings receded. A Western painting, *People in the Sun* (1960), is almost comically unreal—unreal in the Thirties-style street clothes of the fully garbed sunbathers, unreal in the un-Hopperesque lack of any architectural definition of their porch or platform, unreal in the appliqué-like strips of generalized desert landscape. It has no atmosphere but psychological atmosphere; the people, dressed for a luncheon party, seem to be on the deck of a boat without a glimpse of water, and, placed all on the left side of the canvas, appear to be sliding toward the sun. In *Second Story Sunlight,* painted the same year, the white gables and tall windows and ominous tree-mass are less surreal but feel cardboard-thin, slapped up as a setting for the two actresses, the gray-haired matron and the well-endowed bathing beauty. From their dreaming gazes they might be versions of the same woman, the older remembering the younger as the painter is remembering them both. Reminiscence and self-parody are part of remaining true to oneself. Now in his late seventies, the old conjurer is calling up images with hardly a glance out the window. *Chair Car* (1965) shows not a fleck of scenery through the big glass panes, and its interior, without racks or a door handle and as high-ceilinged as a little chapel, might have been painted by a man who never rode a train. But Hopper for forty years had been doing more than giving the visual news. Gail Levin's essay on Hopper's "legacy for artists" quotes the sculptor George Segal as saying, "What I like about Hopper is how far poetically he went, away from the real world."

He paid a price for his poetic voyaging. Hopper's colors, mixed from notes taken on the spot, are elementary, as unrelievedly local as those of an early-Renaissance fresco. His preliminary sketches in pencil or Conté crayon often have an anatomical rightness and an electric, deep-shadowed singleness of impression which has leaked away in the finished painting: see, in the 1980 catalogue, the sketches for *Morning in a City,*

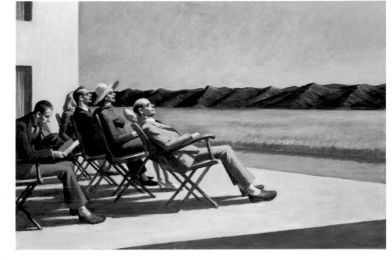

HOPPER
People in the Sun, 1960
Oil on canvas, 40⅜ × 60⅜"
Smithsonian American Art
Museum, Washington, D.C.

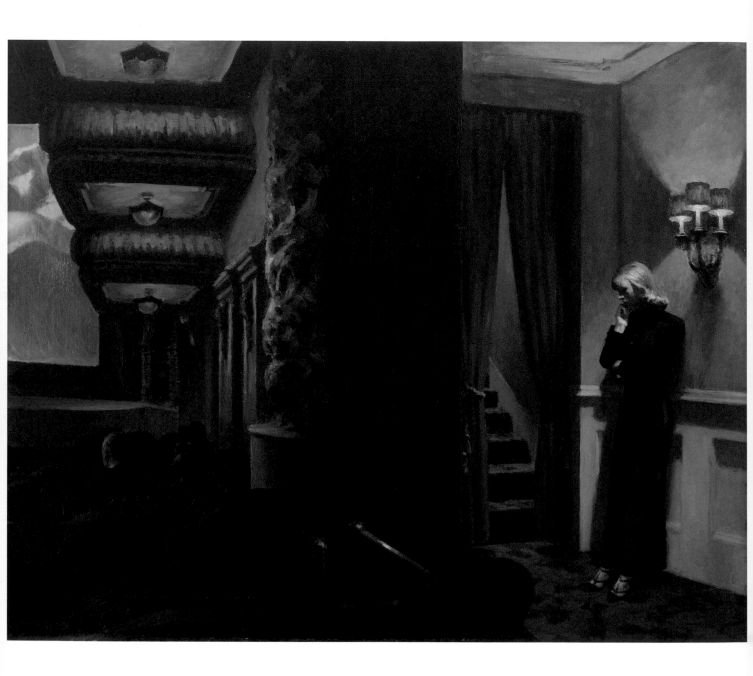

Morning Sun, Conference at Night, and *New York Office.* The painting *New York Movie*—one of his most telling and beloved images—swallows in its shadows several fine Conté-crayon studies of movie-viewers seen from behind, and gives us a golden-haired usherette, in strapped high heels and pseudo-military uniform, much more glamorous than the dowdy girl he carefully sketched. Though he detested the made-to-order dramatics of magazine illustration, his illustrator's skills served him well in the realm of high art. In Hopper's youth, the line between high art and illustration was a fine one, repeatedly crossed by the American Realists— Bellows, Glackens, Luks, Sloan—from whom he learned his craft. One of his notable teachers at the New York School of Art, Robert Henri, stated, "Low art is just telling things, as, there is the night. High art gives the feel of the night. The latter is nearer reality although the former is a copy." Carl Little, in his modest but handsome volume of 1993, *Hopper's New England,* aptly quotes Wallace Stevens: "Reality is not what it is. It consists of the many realities which it can be made into."

Without turning to an inner reality, Hopper could not have created Hoppers. They give us back a now-historic world, with its Automats and empty roads and gilded movie palaces, preserved by a still-potent intimacy. While the centrally housed video at the Whitney unignorably droned and shuffled its iconography of "American imagination," Hopper's quite personal silence spoke. Having stood before each of the fifty-nine canvases displayed on the third floor, this viewer at the elevator door had an impulse to run back in again, as at some lovelorn parting, and make the encounter yield a final word torn from the depths of what Henry James might have termed "the so beautifully unsaid."

HOPPER Study for *New York Movie,* 1939
Conté crayon on paper, 11 × 15"
Whitney Museum of American Art, New York. Gift of Josephine N. Hopper Bequest, 70.272

(Opposite)
HOPPER
New York Movie, 1939
Oil on canvas, 32¼ × 40⅛"
The Museum of Modern Art, New York. Given anonymously

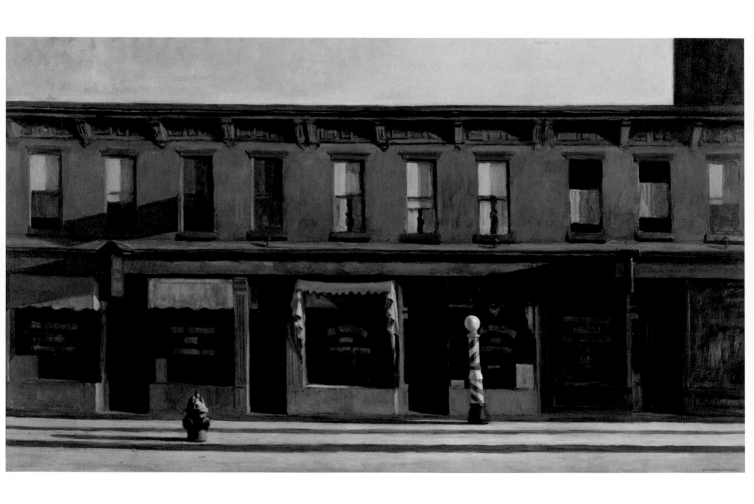

Early Sunday Morning

THE SILENCE and plainness of the best paintings by Edward Hopper repel commentary. What is said is said in a visual language that translates into fussy, strained English. Here, the import lies in the long shadows, the sunlight on the flat and ruddy brick, the band of virtually cloudless sky, the yellow shades bisected by shadow, and the barber pole, whose slight tilt, in this intensely rectilinear canvas, has the odd effect of making the street seem to run downhill, left to right. It comes as a shock to learn that the street was New York's Seventh Avenue, the effect of small-town sleepiness is so strong.

Hopper emerged in about 1920 from the Impressionism, dramatically daubed and burning with light, that he had practiced in Paris and along the Maine coast, into the calm, stolidly rendered, yet haunting realism that is uniquely his. Resolute in his pursuit of mundane appearances, he painted stark rows of windows in *Williamsburg Bridge* (1928) and, through the bay-window panes, *Room in Brooklyn* (1932); the starkest city windows of all, those in high-rise apartment buildings, figure in *Apartment Houses, Harlem River* (c. 1930), and *City Roofs* (1932). The former is almost as bluntly frontal as *Early Sunday Morning*, but from a riverine distance that conveys little of the warmth and intimacy of Seventh Avenue. One of the subliminal sources of *Early Sunday Morning*'s otherworldliness is the peculiar vantage: we and the painter seem to be suspended at the level of the second-story sills, too close to be across the street and yet higher than street level. Hopper was always ready to demystify his work; the painting's original title was *Seventh Avenue Shops*, and Hopper protested that "it wasn't necessarily Sunday. That word was tacked on later by someone else." Yet often in his work he creates a Sunday mood, of vacant buildings and minimal human activity; *Sunday* was the title of a 1926 oil showing a man sitting idle on the

(Opposite)
EDWARD HOPPER
Early Sunday Morning, 1930
Oil on canvas, 35 × 60"
Whitney Museum of American
Art, New York. Purchase with
funds from Gertrude Vanderbilt
Whitney

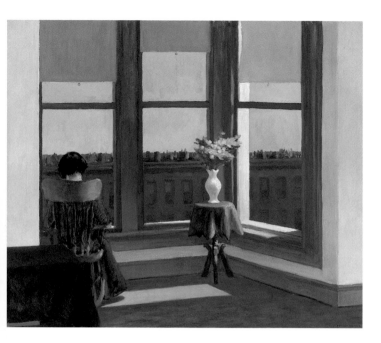

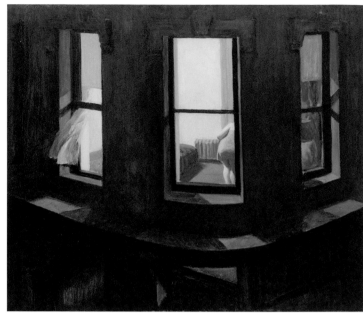

(Left)
HOPPER
Room in Brooklyn, 1932
Oil on canvas, 29⅛ × 34″
Museum of Fine Arts, Boston,
The Hayden Collection. Charles
Henry Hayden Fund, 35.66

(Right)
HOPPER
Night Windows, 1928
Oil on canvas, 29 × 34″
The Museum of Modern Art,
New York. Gift of John Hay
Whitney

wooden sidewalk before a row of empty shopwindows. A human figure
in one of the windows was painted out of *Early Sunday Morning;* the
canvas is already dramatic enough. There is a theatricality here that may
have been borrowed directly from the set of Elmer Rice's *Street Scene,*
designed by Jo Mielziner; Hopper's wife, also Jo, mentioned it in a letter
as "that Street Scene set we loved so much."

One can imagine the barber pole and the fire hydrant about to break
into a courtship dance. The chorus line of apartment windows may sud-
denly lift its curtains in musical unison, while the black panes below flood
with an artificial light to rival the daylight stretching along the sidewalk
and presiding in the bright sky. The brick row shows no more depth than
a stage set. The Hoppers were keen theatergoers. When one looks for
what makes Hopper's paintings, so apparently ordinary in their subject
matter, so extraordinary in the tension they evoke, the secret is often in
their staginess. *Room in New York* (page 180) and *Night Windows* catch
the drama of those city rooms whose silent inhabitants, unwitting actors
and actresses in a bright-lit space, arrest our attention as we pass. The
celebrated *Nighthawks* was worked up as a movie set, in the neo-noir
Pennies from Heaven. Hopper's earlier *Drug Store* (page 188), without
a cast of characters, also renders the poignance of a commercial spot

hospitably lit in the darkness of the city. *Automat,* with its brooding young woman, mirrors the receding interior ceiling lights in the opaque black night outside, and *Summer Evening* (page 181) holds its melancholy couple in a box of harsh brightness cut from the inky country air. Our human enclosures are not just illumined stages for our dramas; there is a theatrical gesture in shelter itself, dividing light from dark, inside from outside. The architecture in Hopper *acts,* even when, as in *Early Sunday Morning,* it is unpopulated and calm.

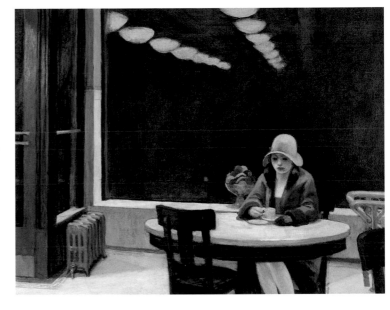

From stage light, and from the klieg lights of the early movies, Hopper took a chiaroscuro that gives his most characteristic paintings— *House by the Railroad* (page 186), for instance, and *Lighthouse Hill* (page 185)—their accent; his shadows are darker than most, and blacker. He subdued the gaudy impasto of his pre-1920s plein-air paintings to a soberer, less restless palette. The color in a mature Hopper names itself, broad patch by patch, and, though based on sketches and watercolors done on the spot, the final product has a monumental simplicity worked up in the studio. In *Early Sunday Morning* the dawn comes rakingly from the right. It arrives stealthily, while the windows still sleep, and we think of the inhabitants behind those curtains, dreaming or groggily stirring as the day, like an ambitious merchant, is already setting up shop.

HOPPER *Automat,* 1927
Oil on canvas, 28⅛ × 36″
Des Moines Art Center
Permanent Collection, Iowa.
Purchased with funds from the
Edmundson Art Foundation,
Inc., 1958.2

The time of day is usually present in a Hopper, as the distinctly shown slant of sun. The chronic solar arc overhead, which makes of each angular object a sundial, is not just the context of our human adventure but, to an extent, its content. Again and again in Hopper his figures, usually female, seem to be doing nothing but observing the day, and opening themselves—sunlight on skin—to time's inexorable, faithful, fatal passage. Another horizontal picture from this same period, *Railroad Sunset,* takes the *end* of the day as its focus; here the color is unrestrained, and focuses the drama away from the lonely railroad-signal station in the foreground. In his record book, before delivering this painting to his gallery, Hopper wrote, "Signal station in silhouette. Late sunset, red &

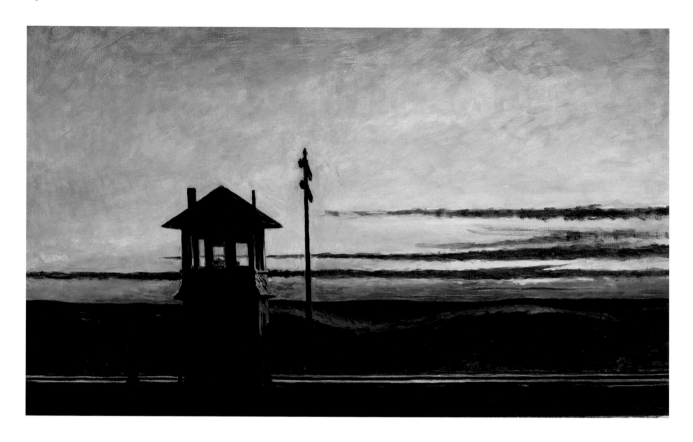

HOPPER
Railroad Sunset, 1929
Oil on canvas, 29¼ × 48″
Whitney Museum of American
Art, New York. Josephine N.
Hopper Bequest

gold horizontal clouds. A real beauty this one." An exceptional beauty in that it comes forth as a painterly feat, a spread of color loudly celebrating natural glory, with the human element minimized—though that element is present as, in Hopper's notation, the "pale gleam on R.R. tracks" which gives the blazing sky back a little of its light.

Humanity was Hopper's usual topic, though he did not paint people very well. They are often stiff and expressionless; the most convincing are those with lightly indicated faces, like the brooding women in *Hotel Room* and *New York Movie* (page 192). Yet we find his portraits of the human condition more moving and resonant than those of more exuberant draftsmen like Reginald Marsh and Thomas Hart Benton. Hopper was in comparison cautious; rather than use his subjects to make a statement—in favor of our animal energy, like Marsh, or in summary of the American panorama, like Benton—Hopper seems to wait for people to disclose their own meaning, which their reverie is seeking to discover. Even the inanimate objects in a Hopper appear to be in a reverie. As

with Vermeer, a mystery seeps in and saturates the most modest levels of activity.

In a letter to Lloyd Goodrich, Hopper spoke of a painting being "pieced together from sketches and mental impressions of things in the vicinity." Mental impressions: the painter was not just an eye but a mind. If one asks what elevates Hopper above the relatively programmatic and clamorous art of his contemporaries, the quality might be called largeness—a largeness of patience and peripheral vision, a largeness that includes on the canvas the data of time and of elemental, generally unmet need. His human islands are suspended against an original wilderness: see the oddly frightening *Gas*, with its menacing twilit trees, or the disturbing, faintly hectic *Cape Cod Morning* (1950), of which Hopper said that "it comes nearer to what I feel than some of my other paintings. I don't believe it's important to know exactly what that is."

Early Sunday Morning is a literally sunny picture, with even something merry about it: bucolic peace visits a humdrum urban street. We are gladdened by the day that is coming, entering from the right, heralded by the shadows it throws. The glow on the sidewalk is picked up by the yellow window shades. The barber pole is cheerful, the hydrant basks like a sluggish, knobby toad. But the silent windows, especially the darkened big shopwindows, hold behind them an ominous mortuary stillness. The undercurrents of stillness threaten to drag us down, even as the day dawns. The diurnal wheel turns, taking the sun on one of its sides. But the other side, the side where sun is absent, has its presence, too, and Hopper's apparently noncommittal art excels in making us aware of the elsewhere, the missing, the longed-for. He is, to use a phrase generally reserved for writers, a master of suspense.

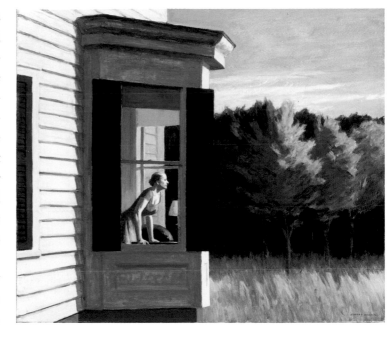

HOPPER
Cape Cod Morning, 1950
Oil on canvas, 34⅛ × 40¼"
Smithsonian American Art
Museum, Washington, D.C.
Gift of the Sara Roby
Foundation

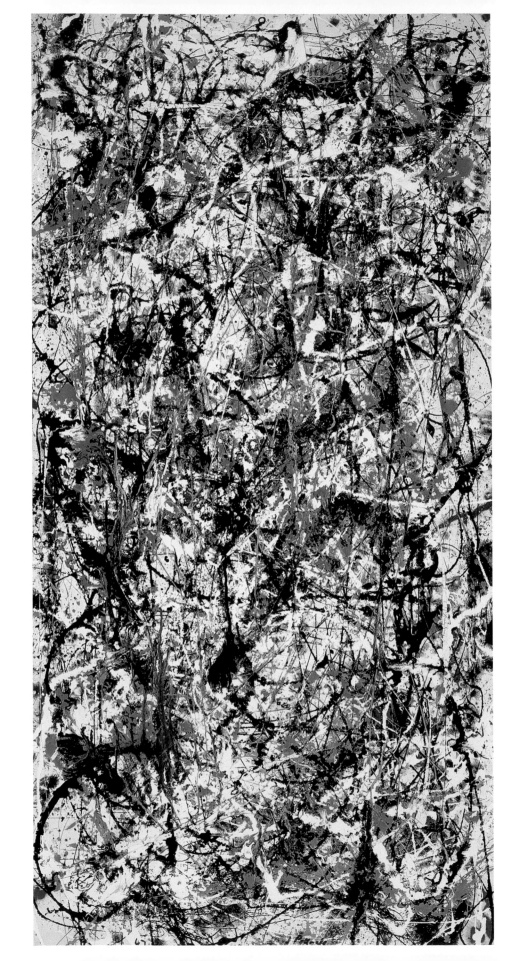

Jackson Whole

AMERICA LOVES an emblematic life, and the Pollock show at the Museum of Modern Art, from All Saints' Day 1998 to Groundhog Day 1999, is arranged to tell a tale of long struggle, high triumph, and swift fall. The category of "the heroic," no longer applicable to political figures (mendacious bean-counters) and soldiers (dull tools of wicked warmongers) and athletes (overpaid steroid addicts), can still be applied to artists, especially Abstract Expressionists. They worked on a heroic scale, and made heroic breakthroughs into sublime simplifications—Rothko's hovering rectangles of color, Kline's sweeping bars of black, de Kooning's infernos of flickering, flashing strokes, and above all Pollock's epic drips.

Fortunately, Pollock, though a terrible abuser of his body with alcohol, was mostly on the wagon and in good trim in the years 1948 to 1950, when the eyes of the publicity machine turned upon him. The photographic images, captured by Martha Holmes for an August 1949 article in *Life* and by Hans Namuth in 1950 for *Harper's Bazaar*, of a handsome, intent, hard-bodied man in blue jeans and muscle shirt, with a bald pate, a cigarette dangling from his lips, and a dimple in the center of his chin, prowlingly, dancingly dripping and splashing paint upon a canvas on the floor of his studio, defined "action painting" and planted an image, to be jeered or cheered, in the national imagination. His sudden death by automobile, at the age of forty-four, the year after James Dean's fatal crash, cemented the romantic fable: a beautiful, reckless rebel perished of—well, what? Of success and the attendant self-disgust. According to the biographical chronology at the back of curator Kirk Varnedoe's sumptuous and instructive (but indexless) catalogue, Pollock took his first drink in two years on the Saturday that Namuth, who made movies of the painter at work as well as stills, had at last ceased his filming. The weather had turned cold, this outdoor exercise in publicity had turned

(Opposite)
JACKSON POLLOCK
Cathedral, 1947
Enamel and aluminum paint
on canvas, 71½ × 35 1/16″
Dallas Museum of Art. Gift of
Mr. and Mrs. Barnard J. Reis

uncomfortable, and Pollock, ever angrily alert to the possibility of phoniness, poured himself a belt, and then another. It was a quick skid downward thereafter.

But this gets us ahead of the story, to the last, sad room in the show. The first galleries show struggle, the struggle of a stubborn artistic vocation with a brooding, tangled temperament and a largely hidden talent. "Pollock, though he lacked any evident talent, fixed early on his vocation," the wall placard tells us. He was the youngest of five sons of a peripatetic, poverty-prone family who moved around the West, from Wyoming to Arizona and California, under the guidance of a depressive, alcoholic, and, finally, absentee father. Yet this hardscrabble household produced two other artists—Charles, the eldest, and Sande, the brother closest to Jackson. They, and the art teacher at the Manual Arts High School in Los Angeles, "a fatherly and theatrical eccentric" with the flamboyant name of Frederic John de St. Vrain Schwankovsky, offered the young Pollock most of the little tutelage he received. Jackson, who was always perhaps more interested in being an artist than in practicing art, took up theosophy, communism, and long hair, and in 1930 he came to New York. For a dozen years he remained thoroughly obscure. Varnedoe sums it up:

> A perpetual student, he lived from hand to mouth, mostly in shared or borrowed apartments, and shuttled from one forgiving support system to another. While New York and the nation staggered through the Depression toward the onset of global war, Pollock waged a losing battle against alcoholism and failed to make much headway as an artist.

He said that Albert Pinkham Ryder was the only American master who interested him. He studied under Thomas Hart Benton, and admired both the work and the leftist politics of the Mexican muralists Rivera, Orozco, and Siqueiros. When war came, he was classified as 4-F on psychological grounds. His psychiatrist at the time, Dr. Violet Staub de Laszlo, personally believed that "the army would be good for Jackson, that it would make a man of him," but at Pollock's panicky urging she wrote the draft board that her patient was "a shut in and inarticulate personality of good intelligence, but with a great deal of emotional instability," and that "there is a certain schizoid disposition underlying the instability." The kindest slant on this ignominious episode is that it was not foreign battle that Pollock dreaded but domestic military discipline.

What works survived the Thirties make a spotty, unpleasant impression. His untitled self-portrait (c. 1931–35?) looks like a lost soul from the nether portions of Michelangelo's *Last Judgment,* and his little excursions into American Scene landscape have a Ryderesque nighttime feeling; black is the ground note. *Harbor and Lighthouse* (c. 1934–38) shows the wriggling restlessness of line present in his teacher Benton. Pollock later saw Benton's influence as entirely negative (Benton's anti-abstract Regionalism + Pollock = anti-realistic abstraction), but critics since have noted many points of affinity, from the hard-drinking, braggart manner both men affected to the way Benton diagrammed a representation's underlying armature of pattern and rhythm. Benton could have been anticipating the mature Pollock when he wrote that "the creative process is a sort of flowering, unfolding process where actual ends, not intentions but ends arrived at, cannot be foreseen. Method involving matter develops, whether the artist wills it or not, a behavior of its own." Pollock's paint begins to develop its own behavior in such clumsy but gloomily expressive works as *The Flame* (c. 1934–38) and, from the same murky years, an *Untitled [Overall Composition]* which fills the canvas evenly with thick wriggles of white, black, red, and yellow, describing nothing but themselves.

By 1942, Pollock at last made a mark on the art scene. *Birth* (c. 1941)

POLLOCK *Untitled (Self-Portrait),* c. 1931–35(?)
Oil on gesso on canvas mounted on fiberboard, 7¼ × 5¼"
The Pollock-Krasner Foundation

POLLOCK
The Flame, c. 1934–38
Oil on canvas mounted on composition board, 20½ × 30"
The Museum of Modern Art, New York. Enid A. Haupt Fund

POLLOCK *Birth*, c. 1938–44
Oil on canvas, 45 11/16 × 21 13/16"
Tate Gallery, London

attracted attention in a show at McMillen, Inc., on Fifty-fifth Street, organized by Pollock's new mentor, John Graham. Via Graham, Pollock's sights were lifted from Mexican murals and WPA patronage to Picasso, Miró, the European Surrealists, primitive art, and the society of rich New York collectors. *Birth* still makes a forceful impression; it is as if Picasso's *Girl Before the Mirror* were further fractured and made to writhe in pain. Another, slightly earlier work, an *Untitled [Naked Man]* (c. 1938–41) that portrays a male nude with a globular owlish head, seems less derivative in its tortured effect; the flesh is rendered with a scrabbling brushwork, cream and brown, that shows the painter forgetting himself almost happily in the application of paint. Picasso became the great rival in Pollock's mind. Even a relatively airy work like *Stenographic Figure* (c. 1942), which aroused the interest of the exiled Piet Mondrian when displayed at Peggy Guggenheim's "Spring Salon" in 1943, owes much to the great Spaniard in his sketchier, ceramic mode. We have here, the catalogue points out, "the dissociation of line from the task of binding," but line had been already thus dissociated by Miró, Masson, Klee, and the Surrealist theory of automatism, and Pollock was not yet ready to pursue this direction. The most ambitious canvases of this period—*The Moon Woman* (1942), *Male and Female* (1942), and *Guardians of the Secret* (1943)—are ferociously ugly, the cluttered amalgams of a man putting brush to canvas in wild hopes that a picture will emerge. *The She-Wolf* (1943), presciently acquired by the Museum of Modern Art for $650, is the most coherent of the lot, though it looks more like a cow than a wolf. In this wartime period Pollock attracted the attention

(Left)
POLLOCK
Stenographic Figure, c. 1942
Oil on linen, 40 × 56″
The Museum of Modern Art,
New York. Mr. and Mrs. Walter
Bareiss Fund

(Below)
POLLOCK
The She-Wolf, 1943
Oil, gouache, and plaster on
canvas, 41⅞ × 67″
The Museum of Modern Art,
New York. Purchase

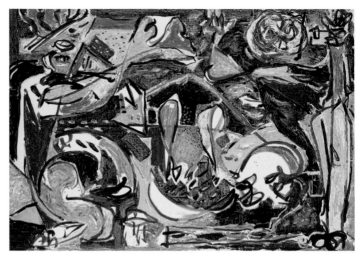

(Above)
POLLOCK
Untitled (Composition with Pouring II), 1943
Oil and enamel on canvas,
25⅛ × 22⅛"
Hirshhorn Museum and Sculpture Garden, Smithsonian Institution, Washington, D.C. Gift of Joseph H. Hirshhorn, 1966

(Right)
POLLOCK *The Key (Accabonac Creek Series),* 1946
Oil on canvas, 59 × 84"
The Art Institute of Chicago. Through prior gift of Mr. and Mrs. Edward Morris

of Clement Greenberg, who would tout him; of Peggy Guggenheim, who would display and patronize him; and Lee Krasner, who would marry him, promote him, tame him a bit, and move him, in 1945, away from the bars and overstimulation of New York to bucolic East Hampton.

His course was set. The epic moment when he would begin to drip in pure earnest was still two years away, but in 1943 he had already done three drip-paintings, acting on an earlier hint from Siqueiros. In the huge *Mural* (1943–44) that he hastily executed for Guggenheim and in such lesser canvases as *Night Mist* (c. 1944–45), *Gothic* (c. 1944), and *There Were Seven in Eight* (c. 1945), he had gravitated away from his totemic, Jungian images to an overall abstraction, covering the canvas in rhythmic arabesques and dimly demarcated panels, executed with a hard-driving freedom that includes some smears and spills of paint. A gouache like *Painting* (c. 1944) represents *some*thing (an apple?), and the engravings of 1944–45 are Picassoesque in their entwining, bulbous flow, but not even Pollock's delight in Long Island's open-air scenery, which prompted the colorful and ebullient *Accabonac Creek* series of 1946, can distract him from his destiny. That same year's *Sounds in the Grass* series, executed in part with paint directly squeezed from the tube, has his full gestural vocabulary, without the drips.

THE CURATORS of the show have done a cute thing by including an exact replica of the rather small "barn," more accurately a shed, in which Pollock began to work with canvas tacked to the floor. To stand in the space, which lacks for fidelity only paint-bespattered floorboards and icy winds through the walls (the space was unheated), is to be reminded of how humble were the circumstances, physical and financial, that cradled the giants of Abstract Expressionism in the late Forties and early Fifties. The curators have done another cute thing by providing, on the tape one can rent as companion, some of the jazz and swing numbers that Pollock used to play to himself, on black wax 78s, while he swooped and dabbled at his canvases. A total stranger to me had insisted that I wear one of these auditory devices, if only to hear the raspy wise-girl voice of Lee Krasner reminiscing, and I somehow garbled its controls so that it re-wound and went back to the start. As I tried to get myself on track again, I wandered from canvas to canvas in the pre-drip galleries, as disoriented as Pollock himself in this period, while curatorial voices smoothly intoned appreciative phrases: ". . . totemic meaning . . . burst the bonds of traditional brushwork . . . larger and more dynamic . . . kind of congested intensity . . . liquid enamel housepaint . . . aluminum paint . . ." Then an even more majestic voice impersonated that of Pollock himself, intoning, "I deny the accident. . . . The result is the thing." By the time I got the tape back in sync with what I was seeing, the post-war drips had begun and beauty had dawned.

Beauty: how strange to come upon it, after all that mannered, heavy, clotted wrestle with the wraiths of Ryder and Picasso and Orozco. *Galaxy* (1947) was as much brushed as dripped, and mostly with aluminum paint, and *Full Fathom Five* (1947) embodies nails, buttons, matches, and coins, as if indeed dropped to the bottom of the sea. In the kindred *Sea Change* (1947) pebbles are mixed with the paint; Pollock's process is still tied to collage, in a kind of earthy transference. But *Cathedral* (1947), one of the taller of these generally vertical early drip-paintings, has taken off into air; its topmost lines, on the layered surfaces of paint, are as fine as pen strokes, or those curving lines that trace on a sensitive plate the flight of atomic particles. The first large horizontal, *Lucifer* (1947), arrays the full web of filaments, with still a reliance on aluminum as a ground note and a dominance of heavy, blobby black threads. Pollock often, even in these magical three years, withdrew his

faith in an unalloyed, utterly non-pictorial drip method: *Alchemy* (1947) incorporates white daubs like the blackboard numbers of his Surrealist period, and the white diagonal of *Comet* (1947) feels, once we have been introduced to the bliss of pure dripping, like a cheap representational shot.

Several modest works hung in the small gallery that used to be the head of the MoMA first-floor stairway seemed notably lovely in their scrawled and spattered radiance: *Number 30, 1949: "Birds of Paradise"* spins its black to the density of a star's heart, and the proximate *Number 31, 1949* deploys an unusual palette of moss-green, green-blue, rust-red, and bright yellow—all bought ready-mixed, we assume, at the local hardware store. I liked, too, the relatively minimalist *Number 23, 1949* and the distinctly calligraphic *Number 12A, 1948: Yellow, Gray, Black* and *Number 17, 1949;* my Chinese impression related, perhaps, to a recent trip to China, where the startlingly free brushwork of such painters as Xu Wei (Ming dynasty) and calligraphers as Huai Su (Tang dynasty) demonstrated the antiquity of gestural expressionism.

The gallery beyond the old stairhead gathered many of the big canvases of 1950—as big as the floor of his little barn could hold—and the voice in my ear urged me to tread with reverence. We are invited to regard the three largest—*One: Number 31, 1950; Number 32, 1950;* and *Autumn Rhythm: Number 30, 1950*—as "monumental," Pollock's combination of Sistine Chapel and Lascaux Cave, but only the first seemed to me to earn its size. *Autumn Rhythm* looked coagulated and *Number 32* glutinous; the latter, in black on canvas, creepily approaches the figural with a spidery dance of elongated concentrations reminiscent of the small oil-and-enamel works on paper of 1948, in which Pollock shakily attempted to drip-draw Calderesque human forms. Only *One: Number 31, 1950,* the centerpiece of MoMA's Pollock collection, gave me, with its swirl upon swirl of black, white, brown, and gray, a sense of infinite activity spread evenly across a field of timeless stillness—an image, in dots and lines and little curdled clouds of dull color, of the cosmos. As good if not even better, though smaller, is *Lavender Mist: Number 1, 1950.* Finespun, shot through with blurs of salmon and nebulae of gray mist, it was the only painting that sold (for a meagre fifteen hundred dollars) out of the Betty Parsons Gallery show which offered to the art buyers of 1950 walls crowded with the great canvases, now worth millions, of Pollock at his peak.

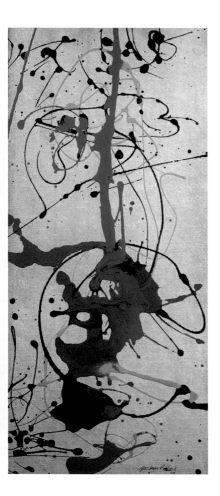

POLLOCK
Number 23, 1949, 1949
Oil and enamel mounted on fiberboard, 22½ × 28⅛″
Collection of Mr. and Mrs. Eugene V. Thaw

It was a high peak, but a perilously narrow one, sharply falling off on every side. The advantages of the drip technique for Pollock were manifold: the absence of brushwork eliminated any expectation of figuration, surreal or otherwise; his clumsiness and muddiness as a painter were wiped away in bursts of muscular action and pure industrial color. But, being so subjective a way of working, with hardly any guidelines to be found in the history of art, drip-painting leaves the viewer with his own subjectivity. In my case, I seem to prefer the scratchy to the goopy, the quiet palette to the garish. And whenever Pollock, fearing self-repetition, varies the drips with some other technique, such as the canvas cutouts of *Out of the Web: Number 7, 1949* or the attached wire lathe mesh of *Number 29, 1950,* the work feels violated and intolerably watered down. Having invented dripping (or pouring, or splatting—he used various tools including a turkey baster) and secured a critical if not financial triumph with it, Pollock was trapped in it. He lacked the serenity and discipline of, say, a Rothko patiently varying his soft rectangles, or a Barnett Newman chirpily turning out his vertical "zips." Pollock—in the grip of alcoholism and a brain chemistry that might have benefited from the neuroleptic drugs developed since 1950—fell into a depression and a nonproductivity as spectacular, in their way, as his brief but prolific prime.

The show's last galleries rehearse the groping of the earlier ones. Small blotty inks and prints. Big black furry doodles on unsized canvas

POLLOCK
One: Number 31, 1950, 1950
Oil and enamel paint on unprimed canvas, 8′10″ × 17′5⅝″
The Museum of Modern Art, New York. Sidney and Harriet Janis Collection Fund (by exchange)

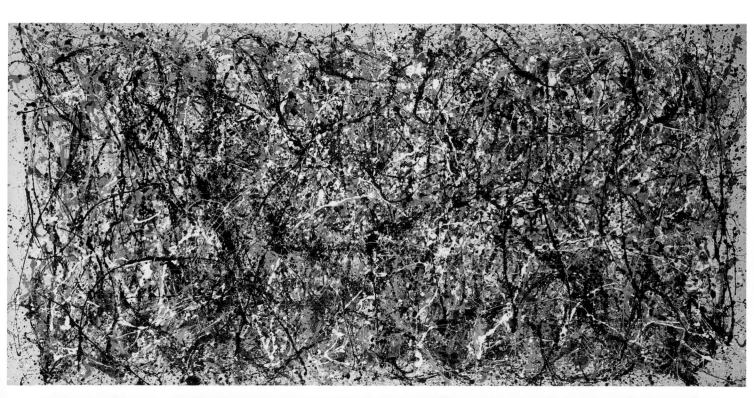

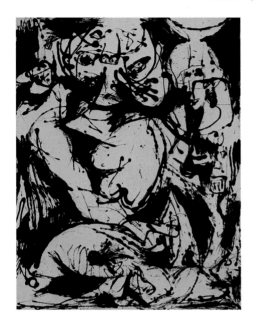

POLLOCK
Number 22, 1951, 1951
Oil and enamel on canvas,
58⅛ × 45⅛ ″
Collection Denise and
Andrew Saul

like enlargements of inky Picasso scrawls. The hideous (though much-studied) attempt to revive the drip mode, *Blue Poles: Number 11, 1952.* This intensely awkward canvas, with its unhappy discovery of orange paint, found its way to Canberra, Australia, whence its harsh expanse will come but rarely to trouble American museum-goers. Not only the leaning poles of blue-tinged black that subdivide the canvas but the uncharacteristically rectilinear grid of drips suggest that Pollock is groping for a restraining order, the unifying principle that his flashing instinct provided a few years earlier.

The last room of all, holding virtually all the canvases Pollock finished between 1953 and his death in 1956, contains some good paintings, though, as the wall panel points out, each seems "a separate experiment." The largest, *Portrait and a Dream* (1953), enlarges and colors in a head such as schoolgirls draw. The scrubbily brushed *Ocean Greyness* (1953) is a creditable abstraction, reminiscent of the concentric, cabbagelike orb that forms the head of the 1938–41 untitled male nude. *The Deep* (1953) offers an interesting exercise in erasure, as white, both brushed and poured, encroaches upon all but an abyssal core of black. *Easter and the Totem* (1953) reconjures, with an elegance suggestive of Tanguy, Motherwell, and Matisse, the primal symbolism of Pollock's Surrealist days. *White Light* (1954) covers the canvas with a desperate outpour of paint, gobs of white sucking up the color, and in *Untitled (Scent)* (c. 1953–55) the density has the wormy, dabbled texture of a Soutine or later Monet. The last painting, *Search* (1955), seems unfinished and, weakly dripping paint on blobs like oil spills, takes us back to the choked, half-formed look of his apprenticeship. The search was over.

Pollock now receives old-master treatment. Not only has MoMA reconstructed his exiguous studio, but the Metropolitan Museum of Art has issued, in a poshly boxed limited edition, exquisitely faithful facsimiles of his unremarkable art-student notebooks. Varnedoe in the catalogue extols him as the creator of performance art, the father of earthworks artists and of all who make art of piling up, of splashing down, of knotting and wrinkling, of repeating patterns out of exuberance or protest. Such posthumous glorification aptly rewards the California dreamer who wanted to be an artist before he had a clue to the creative process and its craftsmanship. He is a heroic American, no doubt, in creating himself from scratch; what this inclusive show makes clear is how close he came

to leaving just scratch behind. But perhaps in the limp humanism of this day and age the works themselves are the least of it. Who cares which number drip-painting looks better or worse than another? The artist is the thing; the works are just the shadow he casts to signify that he is in the room. "Along with Walt Whitman and a few others . . . Pollock stands in an entirely different class, as someone powerfully understood, at home and abroad and for better and worse in his grandeur and in his misery, to represent the core of what America is," claims Varnedoe in the catalogue. Is-ness is all. There is an American tendency to see art as a spiritual feat, a moment of amazing grace. Pollock's emblematic career tells us, with perverse reassurance, how brief and hazardous the visitations of grace can be.

POLLOCK *The Deep,* 1953
Oil and enamel on canvas, 86¾ × 59⅛″
Musée National d'Art Moderne, Centre de Création Industrielle, Centre George Pompidou, Paris. Donated by The Menil Foundation, Houston

Iconic Andy

IN BECOMING an icon, it is useful to die young, and Andy Warhol managed this in the nick of time, at the age of fifty-eight, with the help of life-long frailty and some negligent post-operative care at the New York Hospital. Celebrities notoriously distract usually methodical caregivers, but in this case the nurse supposedly watching over him was reading the Bible and did not know her patient was a famous artist. Warhol, who coined the classic epigraph on modern fame—"In the future everybody will be world-famous for fifteen minutes"—became nothing if not famous; for a time he seemed to preside over Manhattan; he donned a silver wig the way Mark Twain wore a white suit. Having risen from the abject obscurity of an immigrant coal miner's sickly, timorous youngest son, he elevated the lowliest, most obscure printed matter—nose-job ads, dance diagrams, tabloid photographs—into the glamour of museum art. His fifteen minutes are still stretching; there is an uncanny, unearthly beauty and rightness to his work, especially the gaudy polymers and silk-screens done from 1960 to 1964, of Marilyn Monroe, Campbell's soup cans, Green Stamps, dollar bills, Coke bottles. He was a paradox: a painter who less and less touched paint to canvas and relied increasingly on the work of associates; an avant-garde painter who extolled money and boasted of his "business art"; an ill-educated dyslexic who became the wittiest image-maker since Duchamp and the wittiest voice in American art since Whistler.

After his premature death, MoMA—a reluctant convert to his magic—gave him a retrospective exhibition, in 1989. At the back of the heavy-weight catalogue we find these self-definitive aphorisms:

ANDY WARHOL
S & H Green Stamps, 1962
Silkscreen ink on canvas, 20 × 16″
Collection Betty Asher

(Opposite) WARHOL
Gold Marilyn Monroe, 1962
Silkscreen ink on synthetic
polymer paint and oil on
canvas, 83¼ × 57″
The Museum of Modern Art,
New York. Gift of Philip
Johnson

If you want to know all about Andy Warhol, just look at the surface. . . . There's nothing behind it.

The reason I'm painting this way is that I want to be a machine.

I like boring things. I like things to be exactly the same over and over again. . . . Because the more you look at the same thing, the more the meaning goes away, and the better and emptier you feel.

Never so empty, though, that he stopped working, as Duchamp did, in a final gesture of Dada subversion. Warhol's was a protest-free Dada; the machine, organized into a Factory, kept churning out product. A certain deadpan rapture lurked in such productivity, though the later devices—camouflage blobs, coloring-book outlines, Rorschach blots, Catholic imagery with its kitsch value doubled—seemed clunky compared with the concentrated innocence of the early-Sixties breakthrough, when he so serenely proved the rhetoric of action painting to be uncool.

Warhol's movies, his books (like those of Gertrude Stein) need audiences with the patience of saints; the wall art conveys a funerary stillness and glitz in one electric glance, and the only saint needed in the room is St. Andy—St. Andy, the benign, wan apostle of surface and nullity, reconciling us to a cluttered world emptied of more than superficial content. He didn't appear to have normal feelings, but maybe this was the new normal. His heritage is all around us, whenever reality feels like television snow and art like a silk-screened Wegee.

(Above)
WARHOL *Big Campbell's Soup Can, 19¢, 1962*
Synthetic polymer paint and pencil on canvas, 72 × 54½"
The Menil Collection, Houston

(Right)
WARHOL
Camouflage Self-Portrait, 1986
Silkscreen ink on synthetic polymer paint canvas, 80 × 80"
The Estate of Andy Warhol

Index

Page numbers in *italics* refer to illustrations; numbers in **boldface** denote a chapter where the artist is the main subject

Photographic Credits

Page x ALICE W. DAVIS. *Untitled [Cape Cod Dune].* Photograph: David Caras

2 WILLIAM FISK. *George Catlin.* Photograph: National Portrait Gallery, Smithsonian Institution / Art Resource, New York

3 JOHN SINGLETON COPLEY. *Andrew Oliver.* Photograph: National Portrait Gallery, Smithsonian Institution / Art Resource, New York

4 GEORGE PETER ALEXANDER HEALY. *John C. Calhoun.* Photograph: National Portrait Gallery, Smithsonian Institution / Art Resource, New York

AUGUSTUS WASHINGTON. *John Brown.* Photograph: National Portrait Gallery, Smithsonian Institution / Art Resource, New York

CHARLES SPRAGUE PEARCE. *Paul Wayland Bartlett.* Photograph: National Portrait Gallery, Smithsonian Institution / Art Resource, New York

5 JOSEPH SIFFRED DUPLESSIS. *Benjamin Franklin.* Photograph: National Portrait Gallery, Smithsonian Institution / Art Resource, New York

LISETTE MODEL. *Louis Armstrong.* © The Lisette Model Foundation, Inc. (1983). Used by permission. Photograph: National Portrait Gallery, Smithsonian Institution / Art Resource, New York

6 THOMAS HART BENTON. *Self-portrait with Rita.* © T. H. Benton and R. P. Benton Testamentary Trusts / UMB Bank Trustee / Licensed by VAGA, New York. Photograph: National Portrait Gallery, Smithsonian Institution / Art Resource, New York

7 CLARENCE SINCLAIR BULL. *Jean Harlow and Clark Gable.* Photograph: National Portrait Gallery, Smithsonian Institution / Art Resource, New York

THOMAS EAKINS. *Talcott Williams.* Photograph: National Portrait Gallery, Smithsonian Institution / Art Resource, New York

8 JOHN SINGLETON COPLEY. *Watson and the Shark.* Image: © 2005 Board of Trustees, National Gallery of Art, Washington, D.C.

10 COPLEY. *Reverend William Welsteed.* Photograph: © 2005 Museum of Fine Arts, Boston

11 COPLEY. *Theodore Atkinson, Jr.* Photograph: Museum of Art, Rhode Island School of Design, Jesse Metcalf Fund

COPLEY. *Mrs. James Warren (Mercy Otis).* Photograph: © 2005 Museum of Fine Arts, Boston

12 COPLEY. *Mrs. Thomas Gage (Margaret Kemble).* Photograph: The Putnam Foundation, Timken Museum of Art, San Diego, California

COPLEY. *Epes Sargent.* Image: © 2005 Board of Trustees, National Gallery of Art, Washington, D.C.

COPLEY. *Mrs. John Winthrop (Hannah Fayerweather).* Photograph: © 2005 The Metropolitan Museum of Art

COPLEY. *John Bours.* Photograph: Worcester Art Museum, Worcester, Massachusetts

14 COPLEY. *Portrait of the Artist.* Photograph: National Portrait Gallery, Smithsonian Institution / Art Resource, New York

15 COPLEY. *Joseph Green.* Photograph: © 2005 Museum of Fine Arts, Boston

17 COPLEY. *Boy with a Squirrel (Henry Pulham).* Photograph: © 2005 Museum of Fine Arts, Boston

18 COPLEY. *Mrs. Clark Gayton.* Photograph: © 1986 The Detroit Institute of the Arts

COPLEY. *Portrait of Major Hugh Montgomerie, Later Twelfth Earl of Eglinton.* Photograph: © 2005 Museum Associates / LACMA

19 COPLEY. *Baron Graham.* Image: © 2005 Board of Trustees, National Gallery of Art, Washington, D.C.

20 COPLEY. *John Quincy Adams.* Photograph: © 2005 Museum of Fine Arts, Boston

21 COPLEY. *Mrs. Daniel Denison Rogers (Abigail Bromfield).* © President and Fellows of Harvard College. Photograph: Photographic Services, Harvard University Art Museums

22–3 COPLEY. *The Death of Major Peirson, January 6, 1783.* Photograph: Tate Gallery, London / Art Resource, New York

25 COPLEY. *The Three Youngest Daughters of George III.* Photograph: The Royal Collection © 2005, Her Majesty Queen Elizabeth II

26 ASHER BROWN DURAND. *Kindred Spirits.* Photograph: The New York Public Library / Art Resource, New York

29 FREDERIC EDWIN CHURCH. *The Icebergs.* Photograph: Art Resource, New York

31 THOMAS COLE. *Landscape.* Photograph: Museum of Art, Rhode Island School of Design, Walter H. Kimball Fund

32 COLE. *A View of the Mountain Pass Called the Notch of the White Mountains (Crawford Notch).* Photograph: © 2005 Board of Trustees, National Gallery of Art, Washington, D.C.

33 COLE. *The Course of Empire: Desolation.* Photograph: Collection of The New-York Historical Society

37 CHURCH. *Twilight in the Wilderness.* Photograph: © The Cleveland Museum of Art

38 CHURCH. *Sunset across the Hudson Valley.* Photograph: Ken Pelka

39 JOHN FREDERICK KENSETT. *Eaton's Neck, Long Island.* Photograph: © 2005 The Metropolitan Museum of Art

41 FITZ HUGH LANE. *Becalmed off Halfway Rock.* Image: © 2005 Board of Trustees, National Gallery of Art, Washington, D.C.

42 ALBERT BIERSTADT. *Rocky Mountains, "Lander's Peak."* © President and Fellows of Harvard College. Photograph: Katya Kallsen

45 BARNETT NEWMAN. *Vir Heroicus Sublimis.* 2005 Barnett Newman Foundation / Artists Rights Society (ARS), New York. Digital image © The Museum of Modern Art / Licensed by SCALA / Art Resource, New York

50 MARTIN JOHNSON HEADE. *Approaching Thunder Storm.* Photograph: © 2005 The Metropolitan Museum of Art

51 HEADE. *Storm Clouds on the Coast.* Photograph: Melville D. McLean

52 HEADE. *Approaching Storm, Beach Near Newport.* Photograph: © 2005 Museum of Fine Arts, Boston

53 HEADE. *Shore Scene, Point Judith.* Photograph: © 2005 Museum of Fine Arts, Boston

54 HEADE. *Magnolia Grandiflora.* Photograph: © 2005 Museum of Fine Arts, Boston

55 HEADE. *Hummingbirds and Orchids.* Photograph: © 1991 The Detroit Institute of Arts

56 WINSLOW HOMER. *Undertow.* Photograph: © Sterling and Francine Clark Institute, Williamstown, Massachusetts

60 HOMER. *A Rainy Day in Camp.* Photograph: © The Metropolitan Museum of Art

61 HOMER. *Beach Scene.* Photograph: © Carmen Thyssen-Bornemisza Collection on loan at the Museo Thyssen-Bornemisza, Madrid

62 HOMER. *The Sick Chicken.* Image: © 2005 Board of Trustees, National Gallery of Art, Washington, D.C.

HOMER. *An Adirondack Lake.* Photograph: Richard Nicol

64 HOMER. *On the Stile.* Image: © 2005 Board of Trustees, National Gallery of Art, Washington, D.C.

HOMER. *Mending the Nets.* Image: © 2005 Board of Trustees, National Gallery of Art, Washington, D.C.

65 HOMER. *A Good Pool, Saguenay River.* Photograph: © Sterling and Francine Clark Institute, Williamstown, Massachusetts

A Note About the Author

John Updike was born in 1932, in Shillington, Pennsylvania. He graduated from Harvard College in 1954, and spent a year in Oxford, England, at the Ruskin School of Drawing and Fine Art. From 1955 to 1957 he was a member of the staff of *The New Yorker,* and since 1957 has lived in Massachusetts. He is the father of four children and the author of fifty previous books, including collections of short stories, poems, and literary criticism. His novels have won the Pulitzer Prize, the National Book Award, the National Book Critics Circle Award, and the Howells Medal.